"My friend Mako Fujimura is one of the most thoughtful, sensitive and eloquent artists of this generation. Like his otherworldly and luminous paintings, his book *Silence and Beauty* is at once glorious and profound, an exquisite exploration of truth and beauty, silence and suffering. Give yourself and others the immeasurable gift of this gentle, inspiring treasure."

Eric Metaxas, author of *Bonhoeffer: Pastor, Martyr, Prophet, Spy*

"Fujimura's book is a brilliant blend of investigation and reflection. The reader learns about the compelling history of Christianity in Japan and its strangely enduring influence there, while at the same time being led into a profound meditation on the relation of Christian faith to contemporary culture. A truly impressive achievement."

Gordon Graham, Henry Luce III Professor of Philosophy and the Arts, Princeton Theological Seminary, author of *The Re-enchantment of the World*

"How can we live in a world where we encounter suffering every day? Where is the voice of God when we doubt his goodness? It takes a very specific perspective to write beautiful prose about these questions, but in this book Mako does just that—exploring the themes raised by Endo's novel and their continuing resonance across our difficult, anxious times. *Silence and Beauty* is a gift for us as we try to be the fragrance of Christ in a suffering world."

Alissa Wilkinson, chief film critic, *Christianity Today*, assistant professor of English and humanities, The King's College

"Fujimura's *Silence and Beauty* is a truly remarkable spiritual, theological and intellectual autobiography for our time. It will be of interest to a broad readership, not least of all those who still hear the disorienting and potentially transformational call to intercultural mission in the way of Jesus. Fujimura's musings on the Christ-hidden culture of Japan, his own story and contemporary culture are revelatory, and his layering of the Ground Zero theme functions like a Rembrandt primer out of which a sublime beauty and grace emerges."

Thomas John Hastings, research fellow, Kagawa Archives and Resource Center, former professor of practical theology, Tokyo Union Theological Seminary

"Mako Fujimura offers us a moving and illuminating series of reflections on one of the most powerful novels ever written. He helps us to understand how Endo's tale of martyrdom lives in the tensions between East and West, faith and doubt, trust and betrayal. Above all, Fujimura enables us to sense that grace can live—and inspire new life—even in the midst of suffering."

Gregory Wolfe, Editor, *Image*

"Shusaku Endo's novel *Silence* makes us eyewitnesses to the brutality of Japan's seventeenth-century persecution that forced Christians to choose between silence and death. In his reflection *Silence and Beauty*, Makoto Fujimura masterfully appropriates that painful history for the challenges Christians face in this time between times—whether it be death in Syria and Iraq or increasing hostility in the West. Fujimura asks us to face our own silences and emerge understanding both the suffering and the beauty that silence calls forth."

Roberta Green Ahmanson, philanthropist and journalist

hidden faith born of suffering

SILENCE

AND

BEAUTY

MAKOTO FUJIMURA

FOREWORD BY PHILIP YANCEY

IVP Books
An imprint of InterVarsity Press
Downers Grove, Illinois

InterVarsity Press
P.O. Box 1400, Downers Grove, IL 60515-1426
ivpress.com
email@ivpress.com

InterVarsity Press® is the book-publishing division of InterVarsity Christian Fellowship/USA®, a movement of students and faculty active on campus at hundreds of universities, colleges and schools of nursing in the United States of America, and a member movement of the International Fellowship of Evangelical Students. For information about local and regional activities, visit intervarsity.org.

All Scripture quotations, unless otherwise indicated, are taken from THE HOLY BIBLE, NEW INTERNATIONAL VERSION®, NIV® Copyright © 1973, 1978, 1984, 2011 by Biblica, Inc.™ Used by permission. All rights reserved worldwide.

Cover and interior design: Cindy Kiple
Author photo: Brad Guise

ISBN 978-0-8308-4459-3 (print)
ISBN 978-0-8308-9435-2 (digital)

Printed in Canada ∞

Library of Congress Cataloging-in-Publication Data
A catalog record for this book is available from the Library of Congress.

P 21 20 19 18 17 16 15 14 13 12 11 10 9 8 7 6 5 4 3 2 1

Y 34 33 32 31 30 29 28 27 26 25 24 23 22 21 20 19 18 17 16

CONTENTS

FOREWORD

Philip Yancey

Christian martyrs regularly make the news. From places like Nigeria, Iraq and Syria, the media report on believers persecuted and killed by the Islamic State and other radical groups. And who can forget the scene of orange-clad Egyptian Christians kneeling by the Libyan surf, mouthing prayers, just before jihadists slash their heads from their bodies. All these join a host of martyrs from the twentieth century, which produced more martyrs than all previous centuries combined.

"The blood of the martyrs is the seed of the church," wrote the early church father Tertullian, and indeed in many places persecution gave rise to times of remarkable growth. But what of those who recant? In Rome, in Nazi Germany, in Stalinist Russia and Maoist China, some pastors and ordinary believers either publicly renounced their deepest beliefs or stayed silent. Who tells their stories?

In Japan the blood of the martyrs led to the near annihilation of the church. Francis Xavier, one of the seven original Jesuits, landed there in 1549

and planted a church that within a generation had swelled to 300,000 members. Xavier called Japan "the country in the Orient most suited to Christianity." Before long, however, the Japanese warlords grew wary of foreign influence. They decided to expel the Jesuits and require that all Christians repudiate their faith and register as Buddhists. To dramatize the change in policy, in 1597 they arrested twenty-six Christians—six foreign missionaries and twenty Japanese Christians, including three young boys— mutilated their ears and noses, and force-marched them some five hundred miles. Upon arrival in Nagasaki, the focal point of Japan's Christian community, the prisoners were led to a hill, crucified and pierced with spears. The era of persecution had begun, on what became known as Martyrs Hill.

Japanese culture deemed suicide an honorable act, and rulers feared that too many martyrs might enhance the church's reputation and spread its influence. Instead, in a society that values loyalty and "saving face," the warlords gave priority to making the Christians renounce their faith in a public display. They must trample on the *fumi-e*, a bronze portrait of Jesus or Mary mounted on a wooden frame, and thus deface their most revered symbols. Not just once, they had to step on the fumi-e every New Year's Day in order to prove they had decisively left the outlawed religion.

The Japanese who stepped on the fumi-e were pronounced apostate Christians and set free. Those who refused, the magistrates hunted down and killed. Some were tied to stakes in the sea to await high tides that would slowly drown them, while others were bound and tossed off rafts; some were scalded in boiling hot springs, and still others were hung upside down over a pit full of dead bodies and excrement.

Mako Fujimura writes of standing on Martyrs Hill, a mile from Nagasaki's Ground Zero. In one of history's cruel ironies, the second atomic bomb exploded directly above Japan's largest congregation of Christians, many of whom had gathered for mass at the cathedral. (Clouds obscured the intended city, forcing the bombing crew to select an alternate target.) In the end, more Christians died in the atomic

destruction of Nagasaki than in the centuries of persecution that followed the deaths of the twenty-six martyrs in 1597, for over the years by far the majority of believers had apostatized.

In the 1950s a young writer named Shusaku Endo visited a nearby museum to begin research on his next novel, which he planned to set in the devastation of postwar Nagasaki. He stood gazing at one particular glass case, which displayed a fumi-e from the seventeenth century. Blackened marks on the wooden frame surrounding the bronze portrait of Mary and Jesus, itself worn smooth, gave haunting evidence of the thousands of Christians who had betrayed their Lord by stepping on it.

The fumi-e obsessed Endo. *Would I have stepped on it?* he wondered. *What did those people feel as they apostatized? Who were they?* History books at his Catholic school recorded only the brave, glorious martyrs, not the cowards who forsook the faith. The traitors were twice damned: first by the silence of God at the time of torture and later by the silence of history. Instead of writing his intended novel, Endo began work on *Silence*, which tells the story of the apostates of the seventeenth century.

Shusaku Endo went on to become Japan's best-known writer, his name making the short list for the Nobel Prize for Literature. Graham Greene called him "one of the finest living novelists," and luminaries like John Updike joined the chorus of praise. Remarkably, in a nation where Christians comprise less than 1 percent of the population, Endo's major books, all centering on Christian themes, landed on Japan's bestseller lists. Now a major motion picture directed by Martin Scorsese will bring *Silence*, his most powerful story, to a worldwide audience.

ᔕ ᔕ ᔕ

Bicultural in upbringing and sensibility, Mako Fujimura understands the nuances of Japan, and his knowledge of the language sheds light on Endo's original source material. At the same time, Mako's years of living in New York have given him a contemporary, global perspective. On

that visit to Nagasaki, he could not help reliving another Ground Zero experience, for on September 11, 2001, Mako was working in his studio a few blocks from the World Trade Center. And on the very day he stood on Martyrs Hill, news outlets were featuring photos of two Japanese journalists kneeling before sword-wielding jihadists, shortly before their executions. One of the two, Kenji Goto, was an outspoken Christian. Though the perpetrators may change, the age of religious martyrdom endures.

Informed by both East and West, Mako guides the reader on excursions into Japanese art, samurai rituals, the tea ceremony and Asian theology, even while relying on Western mentors such as Martin Luther King Jr., Nelson Mandela, J. S. Bach, Vincent van Gogh and J. R. R. Tolkien. Much like Shusaku Endo, Mako feels caught between two worlds, conversant with both, though not fully at home in either.

In *Silence and Beauty*, Mako is not so much presenting a thesis as he is following the strands of Endo's writing that intimately engage him. From his experience as an academic, an artist and especially as a Japanese American Christian, Mako identifies with the sense of an "alien" identity that plagued Shusaku Endo all his life. Endo traveled to France for university training, one of the first Japanese to do so after World War II. He encountered racism and rejection, yet returned from Europe to his own country feeling a stranger there as well. Mako made a similar journey, only in reverse.

Born in Boston to Japanese parents, Mako became the first nonnative to study in a prestigious school of painting in Japan that dates back to the fifteenth century. While earning a Master of Fine Arts he learned the ancient Nihonga technique that relies on natural pigments derived from stone-ground minerals and from cured oyster, clam and scallop shells. Rather than painting traditional subjects such as kimonos and cherry blossoms, Fujimura applied the Nihonga style to his preferred modern medium of abstract expressionism.

Mako's paintings now hang in major museums in Japan, Europe and the United States, and his work commands respect and high prices. Tokyo honored him with a career retrospective before he turned forty, and as a presidential appointee to the National Council on the Arts he served as an American ambassador for the arts. A thoughtful Christian, he also founded the International Arts Movement to help nurture artists, and in 2014 received the Religion and the Arts Award from the American Academy of Religion. Recently he accepted an appointment to direct the Brehm Center at Fuller Seminary, thus splitting his time between studios in Pasadena and Princeton.

The core identities of an artist and a Christian create an ongoing tension. As Mako explains,

> I have noticed, as an artist with a Christian faith, that if we are explicit about your faith in the public sphere—if we even mention our commitment to live a Christian life—we are dismissed right away in the art world. I have been told by influential critics that if I was not so explicit about my Christian identity, I would have had a far more mainstream career. The worst thing you can do in promoting his or her art career is to be public about how faith motivates their art. To invoke the transgressive, the cynical, the elusive may be the only way to become a respected artist; needy, shock-filled, ironical work gets attention as "serious."

Mako believes that art can heal as well as disturb, and in contrast to some modern artists he refuses to abandon the ideal of beauty. To a single work he may apply as many as a hundred layers of paint, ground by hand from such substances as gold, silver, platinum, cinnabar and malachite. He approaches Shusaku Endo's work in a similar fashion, probing among the multiple layers of *Silence* and other novels to uncover three main themes: hiddenness, ambiguity and beauty.

Hiddenness. Partly because of isolation and partly because of the periodic outbreaks of persecution, Japanese learned to bury their most treasured thoughts and emotions. Ask any Japanese the difference between *honne*, what takes place on the inside, and *tatemae*, what others see on the outside, and they will nod knowingly. Ask any American, for that matter, or any European or African. We all "put on a face" for the outside world, concealing our innermost selves.

By dwelling on acts of betrayal, Endo exposes the fault lines that every person lives with and seeks to hide. In the process he shines new light on the Christian faith—at once a harsh light that bares hypocrisy and also a soft light that dispels the shadows of guilt. From his time in the West, Endo had gained an openness to individualism, doubt and self-reflection— so different from the emphasis on conformity, ritual and repressed emotions that he knew from Japan.

Reading Shusaku Endo's work, I am reminded of Søren Kierkegaard: a misfit, haunted by his past, struggling with parent issues and unfulfilled desires. Endo's novels speak to the inner person, where lie buried the feelings of shame and rejection that the average Japanese must mask in a culture that exalts appropriate and proper behavior. A Japanese businessman may have a secret life—extramarital affairs, sexual perversions, domestic violence, drunkenness—while carrying on a perfectly respectable life in public.

Apostates may step on the fumi-e in public, but what goes on internally? Not just apostates but all of us: How do we deal with the dissonance of betraying the One who died for us? Americans, known for individuality, have our own culture of conformity—to fashion and consumer goods, to educational and career success—and likewise bury shameful secrets in unseen corners of the self.

Ambiguity. Visitors to Japan come away impressed by the politeness they encounter. When the plane taxies up to the gate, baggage handlers and cleaners all bow in greeting. At the hotel, bellhops rush to carry your

suitcase, then politely decline all tips. You pull into a service station and white-gloved attendants, often women, surround your car to fill it with gasoline and wash your windows and headlights. When you leave, they bow deeply and wave goodbye as if you have done them a great favor by allowing them to serve you. You hear few car horns even in a congested city, as drivers patiently take turns at intersections.

Then you read an account of the Bataan Death March or see a movie like *Unbroken*, and you walk out aghast at the unmitigated cruelty of the Japanese. My uncle, who served with the American occupation force in Japan, told me that he and his fellow soldiers expected ambushes from snipers around every corner. Instead, the nation that had launched a surprise attack on Pearl Harbor and had flouted the Geneva Convention in their treatment of POWs turned subservient overnight, in obedience to their emperor's command.

Japan absorbed the only two atomic weapons ever used in war, and fire-bombing destroyed the majority of buildings in other cities. War, tsunamis, earthquakes, nuclear reactor meltdown, economic collapse—Japan has shown an almost superhuman ability to respond to catastrophe with equanimity. After the 2011 tsunami, Japanese survivors stood without complaint in long lines to be served rice and to get assigned a sleeping mat on the floor of a gymnasium.

The pressure of social conformity produces this kind of response. A Japanese person dare not bring shame on the community by misbehaving, by responding like the Americans who may protest or even riot after a natural disaster destroys their neighborhood or cuts off power and water supplies. As psychology has taught us, though, pain repressed does not go away. It leaks out: in alcoholism, in Japan's high suicide rate, in the rare but shockingly brutal crime.

Mako points to the oddness of Shusaku Endo's characters as a way of lancing the cultural ambiguity. "In the New Testament of the Bible, in the Gospel of John 8:32, Jesus says, 'You will know the truth, and the truth will

set you free.' [Flannery] O'Connor added her inimitable twist: 'You shall know the truth, and the truth will make you odd.' In Japan, such oddness is perceived as threatening the entire society." Yet therein may lie the path to honesty and inner health, a way of loosening the bonds of denial.

Mako's autobiographical insertions point the way toward transparency and healing. Like Endo, he is a cultural stepchild vulnerable to rejection and misunderstanding by either side. He writes openly of depression and despair, and the allure of suicide. Beauty and death, honor and shame, pain and stoicism, ritualism and disbelief—Mako has lived with these ambiguous Japanese pairings and he helps Endo's readers untangle them.

> Endo's unique gift was in identifying the wounds of the Japanese soul and exposing the air that Japanese are breathing in; it was as though he had a therapeutic and clinical purpose in his identification of the deep trauma that is a constant invisible companion to the Japanese. His illnesses and many failures in life had stirred him to empathy, and by depicting the raw anguish of the Japanese past, he was indeed defining a Japanese perspective, and beauty, toward suffering.

Beauty. Japan savors beauty. The humblest hostess serves tea in delicate china cups, never Styrofoam or plastic, and fresh flowers usually grace the table. Some Japanese homemakers spend an hour each morning preparing bento lunch boxes for their schoolchildren, arranging the portions of seafood, rice, meat and vegetables in colorful patterns to resemble cartoon characters, animals or famous monuments. A Japanese homeowner fortunate enough to have a yard usually finds a place for a tiny garden or goldfish pond. And Christmas cards from Japan, which often feature pop-up flowers or kimono designs, are exquisite works of art.

In Japan's reverence for beauty Mako sees a reflection of God, for beauty mirrors God's own self. The New Testament book of James declares, "Every good and perfect gift is from above, coming down from the Father of the heavenly lights, who does not change like shifting shadows." Mako adds,

"It is my conviction that God expresses his great love through Japanese beauty, just as refractive light permeates the broken, prismatic surface of Nihonga paintings." The delicate aesthetics of Japan, a form of common grace, fed Mako's own growth as a Christian and enrich his work now.

According to Flaubert, the artist inhabits his or her work as God does: present everywhere, but visible nowhere. Endo helps to identify signs of that presence, working (in Mako's words) as a kind of archaeologist, "scooping up the elements of broken shards of the culture of Christianity in Japan." Much of the essential humanity and beauty in Japan traces back to the era of failed faith. Godlikeness —compassion, joy, love— refracts qualities of God whether they are recognized as such or not. Mako proposes that Japan is a Christ-hidden culture, haunted by a past that has left indelible historical marks, like the blackened footprints on the wooden frame of a fumi-e.

Mako uses an analogy from art classes to suggest the imprint of Christianity on Japan: in design, open space or "negative space" surrounds the "positive space" of the central, highlighted object. A skilled artist knows that negative space, though in the background, makes a subtle but indispensable contribution to the overall effect. Mako sees in contemporary Japan a background laid down by the Christianity that its ancestors rejected. "So while the Tokugawa era successfully purged Christians from Japan, an unanticipated outcome was that in banning Christianity, they created an imprint of it, a 'negative space' within culture. In a culture that honors the hidden, the weak and the unspoken, Christianity became a hidden reality of Japanese culture." Cultural values long suppressed may manifest years later.

Painting in the Nihonga style, Mako must anticipate how the minerals will change over time, for his paintings will look very different in fifty years or a hundred. Silver tarnishes to charcoal black; copper oxidizes to green. Hiddenness, ambiguity, beauty: the three themes he identifies in Endo's writings also pervade his own paintings. The product of long, painstaking work gets hidden beneath scores of layers and may remain

hidden for years, or even forever. Mako's style, like that of all modern art, evokes a response of ambiguity, with no precise "message" to each viewer. Yet beauty emerges—rooted in tradition, yes, while also set free.

ꙅ ꙅ ꙅ

Shusaku Endo described Japan as a swampland for Christianity, and missionaries who have served there tend to agree. Other Asian countries have seen explosive growth—the megachurches of the Philippines and South Korea, the massive unregistered church in China—while in Japan, the average church numbers fewer than thirty. A nation that copies nearly everything Western, from management practices to McDonald's, baseball and pop music, curiously avoids religion. Most puzzling, as Mako mentions, is that so many values in the culture already reflect the way of the New Testament. Why, then, do so few Japanese convert?

That question troubled Shusaku Endo too, who ultimately concluded that the failure stemmed from the Western emphasis on God's fatherhood. Mother love tends to be unconditional, accepting the child no matter what, regardless of behavior. Father love tends to be more provisional, bestowing approval as the child measures up to certain standards of behavior. According to Endo, Japan, a nation of authoritarian fathers, has understood the father love of God but not the mother love.

On my trips to Japan I have heard accounts of authoritarian fathers who never apologize, who remain emotionally distant, who show nothing resembling love or grace, who offer criticism but little encouragement. One woman told me that, at the age of thirteen, she had actually plotted to kill her father after he sexually abused her.

For Christianity to have any appeal to the Japanese, Endo suggests, it must stress instead the mother love of God, the love that forgives wrongs and binds wounds and draws, rather than forces, others to itself. ("Jerusalem, Jerusalem, you who kill the prophets and stone those sent to you, how often I have longed to gather your children together, as a hen gathers

her chicks under her wings, and you were not willing!") "In 'maternal religion' Christ comes to prostitutes, worthless people, misshapen people and forgives them," says Endo. As he sees it, Jesus brought the message of mother love to balance the father love of the Old Testament. A mother's love will not desert even a child who commits a crime. Endo mentions the transformation of the disciples once they realized that Christ still loved them even after they had betrayed him. To be proven wrong was nothing new; to be proven treacherously wrong and still loved—that was new and radical.

This insight helps answer a common question about *Silence*: Why did Endo express his own deeply felt faith through a story of betrayal? When *Silence* first appeared in 1966, many Japanese Catholics responded with outrage. Protective of their martyred forebears, they objected to the romanticization of apostates. How easily we forget that the church was founded by disciples who also betrayed their Master. At his moment of greatest need, Jesus' disciples fled in the darkness. The boldest of the lot, Peter, was the very one who cursed and denied him three times before the cock crowed. It was for traitors that Jesus died.

Endo explains that he centers his work on the experiences of failure and shame because these leave the most lasting impact on a person's life. Jesus' most poignant legacy was his undying love, even for—*especially* for—those who betrayed him. When Judas led a lynch mob into the garden, Jesus addressed him as "friend." On Calvary, while stretched out naked in the posture of ultimate disgrace, Jesus roused himself to cry out for his tormentors, "Father, forgive them." To those scandalized by the apparent apostasy of his characters Ferreira and Rodrigues, Endo points to the two great founders of the Christian church: Peter denied Christ three times, Paul led the first persecution of Christians.

The entire Bible can be seen, in fact, as a story of betrayal, beginning with Adam and proceeding through the history of the Israelites, culminating in the cross. In an astonishing reversal the Romans' cruelest

execution device became the ubiquitous Christian symbol. "And I, when I am lifted up from the earth, will draw all people to myself," Jesus had predicted. John adds by way of explanation, "He said this to show the kind of death he was going to die." At the cross, hiddenness, ambiguity and strange beauty converge.

Every one of Jesus' followers, from the first disciples down through history to the present day, knows the feeling of betrayal. Sharp-edged gossip, the stab of envy, that colleague we humiliated, the racist comment that drew a laugh, a sudden and inexplicable cruelty, apologies to our children deserved but never made, a furtive fantasy, a stolen kiss, callousness toward another's misery, an addiction to what demeans or even destroys—in ways small and large we too step on the fumi-e. Our only hope is the forgiving gaze of the betrayed Savior, the still point of Endo's novel.

And now Martin Scorsese, director of movies such as *The Wolf of Wall Street* and *The Last Temptation of Christ*, has in his old age chosen this picture of Christ as his subject. When Mako Fujimura spoke on silence and beauty at Hiroshima City University, a professor who stands as one of Japan's greatest painters commented, "Fumi-e is the best portrait of Christ I've ever seen."

Only Mako Fujimura could have written this book. It sheds light on a wealth of topics—a classic novel, Japanese culture, Martin Scorsese's filmmaking, the fine arts, theology, the enigmas of East and West—and leaves the reader with a startlingly new encounter with Christ.

INTRODUCTION

A Pilgrimage

I write this in my red barn studio in a converted horse barn in Princeton, New Jersey. This morning I made a fresh mixture of *nikawa* (Japanese hide glue), which smells mildly sweet, and I stirred the glue with malachite pulverized by hand. I will apply this pigment to Japanese *kumohada* paper, using a traditional Japanese painting technique called *nihonga*, to create semi-abstract works. I am preparing for my next exhibits by creating multiple 7-foot-by-11-foot works. My art is considered contemporary, but it also is rooted in the ancient history of Japanese aesthetics. I spent more than six years in Japan studying the current form of nihonga as a National Scholar. As a Japanese American I was fortunate to be part of a lineage program based in the mentoring model of Japan's artistry and crafts tradition, fortunate to be invited into the heart of Japanese culture, to be given access to the best inside sources. During this experience, which focused my attention on the great inflection point of Japanese history in the late sixteenth and early seventeenth centuries, I discovered

the history of Japanese Christianity. My journey of faith took a turn then as well. God took me to Japan, a country of my roots, to become a Christian. Thus, my aesthetic journey overlapped with my faith journey. This book reflects on both those pilgrimages, through the lens of my encounter with Shusaku Endo's postwar masterpiece, *Silence*.

The nihonga process, which flows out of a thousand-year refinement, overlaps as a metaphor for the journey of faith that is refining me. Malachite and azurite are strikingly beautiful in the form of rock, but to use them for nihonga one must pulverize them, shatter them into small, prismatic pieces. They are to be layered, sometimes over sixty layers, to create a refractive surface. It is a laborious, slow process—I like to call nihonga "slow art." The layers take time to dry, and in the act of waiting an image is revealed. Nihonga is, by nature, also a collaborative art form, a generational process of learning and working with crafts folks who create handmade paper, delicate brushes and woven silk. Transformative faith is collaborative too, with elements that are communal and also intergenerational. Like precious natural resources, these craft forms of Japanese art are endangered and disappearing from the world today. My art, then, is also a lament for eroding cultural forms and the fragmentation of nature and culture in Japan.

The surface of my "slow art" is prismatic, so at first glance the malachite surface looks green. But if the eye is allowed to linger on the surface—it usually takes ten minutes for the eye to adjust—the observer can begin to see the rainbow created by layer upon layer of broken shards of minerals. Such a contemplative experience can be a deep sensory journey toward wisdom. Willingness to spend time truly seeing can change how we view the world, moving us away from our fast-food culture of superficially scanning what we see and becoming surfeited with images that do not delve below the surface.

The term *nihonga* was coined during the late Meiji era (1868–1912) to distinguish between the traditional Japanese way of painting and the yoga

style based on oil painting techniques of the West. Japanese paintings began with Buddhistic works, including mandala paintings, but starting in the thirteenth century Japanese artists began to incorporate multicultural influences, and a new, distinct style developed. Scrolls such as the *The Tale of Genji*, *The Tale of Heiji* and popular *Choju-giga* of frogs and rabbits sumo wrestling (as a satirical look at Buddhist priests), as well as Zen-influenced calligraphy and paintings, began to pave a distinctive Japanese aesthetic. The lineage continued in the early fifteenth century with the Kano school, masters of Japanese art who include Tohaku Hasegawa (whose work has had a great impact on mine) and his son Kyuzo. I also admire many other artists of the same period, such as the bold and fluid work of Tawaraya Sotatsu and consummate artisans such as Honami Koetsu and Ogata Korin. The flourishing of Japanese visual language reached its height during the era that coincided with the influx of Christian missionaries and continued through the 250 years of persecution of Christians and the 230 years of the official closing of Japan, known as *sakoku*.[1]

I befriended both Hiroshi Senju and Takashi Murakami, two notable contemporary Japanese artists, during my years at Tokyo University of the Arts. I worked for Hiroshi as an interpreter and translator when he was a doctoral student and I was a research scholar, and later assisted him in establishing his studio in New York City. With his close connection to the Sen no Rikyu school of tea (as he is a tea master as well as a nihonga master) and his historic installation at the Venice Biennale and Daitokuji Jukoin commission (which were executed while I served to establish his studio in New York City), Hiroshi had a seminal influence on me as I grew as an artist. Takashi Murakami's brother Yuji, a fine artist himself, was my studio mate at Tokyo University of the Arts. I also got to know Takashi and was impressed by his ambition and desire to become the "Andy Warhol of Japan." He took part in English conversation classes I held in the nihonga department in the early days. Many years later, his impeccable color and design sense in his translation of Japanimation

themes into contemporary art have indeed made him the rightful heir of Andy Warhol. Both of these artists are modern-day incarnations of the Japanese past, Hiroshi finding his voice through the Kano school and Takashi invoking the *ukiyo-e* (floating world) woodcuts of the Edo past.

There is for me a deep mystery to the surface created by nihonga layering. I am deeply influenced by Sen no Rikyu, the sixteenth-century tea master of Daitokuji who collaborated with Tohaku Hasegawa, the master painter. Both of these artists spent much of their careers reflecting on cultural and personal trauma, and chose to create indelible works that define Japanese aesthetics. Rikyu's tea houses, and a famed black lacquered bowl, and Hasegawa's *Shorinzu Byobu* (famed pine forest screens) are aesthetic counterpoints to my work, and prepare the aesthetic path to Shusaku Endo's novel *Silence*.

Three themes that relate to Rikyu and Hasegawa kept surfacing as I wrote this book and as I journeyed deep into Endo's writings. The three critical themes in understanding *Silence* are *hiddenness, ambiguity* and *beauty*.

All three values have deep resonance in Rikyu's aesthetics. Hiddenness deals with how in Japanese culture, partly because of persecution and isolationism, people developed a habit of hiding their most treasured thoughts. *Ambiguity* (in Japanese, *aimai*) is one of the core essences of Japanese culture being birthed as a necessity of *hiddenness*. By *beauty* I mean a specifically Japanese understanding of beauty connected with death and sacrifice, a definition slightly different from Western concepts of beauty. Those who know Endo's writings may be surprised to find the word *beauty* associated with his writings. Endo is known for shockingly honest depictions of pain, torture and comical failures. I hope to show that this perhaps audacious link between silence and beauty significantly adds to the understanding of Endo's work.

In this book these three themes are intertwined with the trauma described in *Silence*. They are intertwined as well with my own experience, such as becoming a Ground Zero resident along with my family on 9/11,

and such as hearing my mother tell of her father's 1945 visit to Hiroshima, the true Ground Zero, just a week after the atomic destruction. These are layers of dark realities through which my work is made, layers that Endo's work helped to reshape. Through these bleak conditions—what I often refer to as the "ever-expanding Ground Zeros of the world"—we need to peer into the future. This book is a way for me to communicate about the mystery of Christ working in our Ground Zero journeys. Endo's *Silence* is a fitting backdrop. This novel about persecution of seventeenth-century Portuguese missionaries is really about facing the Ground Zero realities of any age and in any culture. Endo intuited the schism in modern cultures that flows out of trauma, and saw seventeenth-century Japanese history as a basis of his inquiry into how doubt, shame, betrayals and trauma affect human experiences and faith. I see my role as an artist as recovering and reintroducing to our age the mystery of the Japanese contemplative aesthetic, the aesthetics of Rikyu and Hasegawa, and perhaps now Endo.

This book begins with my first encounter, as a graduate student, with images of past Japanese persecution of Christians; it ends with consideration of our missional journey toward the world. The *fumi-e*—literally, "stepping images," relief bronze sculptures sometimes set into wooden frames—that I encountered as a graduate student are to me, and to Endo, symbols of trauma and of betrayal of our own ideals. The transformation we each are called to is broader than a Christian mission (although it starts there); it entails all those in search of humanity's potential to become, as Hans Rookmaaker so memorably put it, "fully human" because of Christ's intervention in human history.[2] Mine is a story of my own discovery of faith in an unexpected setting—Japanese culture, a soil inhospitable to Christianity. Shusaku Endo's *Silence* flows out of his own encountering of fumi-e in what he repeatedly called "the mud swamp" of Japan. As I consider my own faith walk and my literal path from Tokyo to New York City to Princeton, places where I have been living and working as an artist for over twenty years, I will look back through

the lens of what Endo writes in *Silence*.[3] As I do so, I hope to convey my love for Japanese culture, a culture that has rejected Christianity as a "foreign religion."

One reason I want to unravel this journey is to point out significant markers of God's presence in Japan. They are revealed in that nation's own cultural expressions and interests, and in how Japanese people respond to works done by Christians. It is my conviction that God expresses his great love through Japanese beauty, just as refractive light permeates the broken, prismatic surface of nihonga paintings. In the 250 years of Japanese suppression of Christian faith during the Tokugawa Period (1603–1868), and then in the nationalism that spawned the wars that culminated in Hiroshima and Nagasaki, Japan has become a culture of groupthink guided by invisible strands of codes of honor. Through visible and invisible forms this can cause many forms of *ijime*, bullying. It has excluded those who do not fit in. I coin the term *fumi-e culture* in this book to describe these ijime cultural conditions. Yet the pursuit of the Japanese concept of the beautiful, expressed even in fumi-e worn smooth by repeated trampling, encourages us to move beyond betrayals and trauma. Our deeper contemplation into Endo's work may even lead to a greater understanding of Japanese culture, and its beauty and ambiguity, as a key element of how we recover our humanity; it may unlock the hidden potential of the biblical message, what Christians call the gospel. This improbable and surprising twist is the thesis of this book.

My personal encounter in the late 1980s with fumi-e displayed at the Tokyo National Museum led me to read Endo's masterpiece, *Silence*. As I write this, the novel is being made into a major motion picture by the master filmmaker Martin Scorsese. A good friend of mine introduced me to Scorsese, and my conversation with him compelled me to write this book. The timing of my writing seems foreplanned by imperceptible and deliberate divine guidance, and as I write this, I am simply peeling away at my own experience to the core of such providence. My journey of faith,

like the surface of my paintings, is multilayered. Deep contemplation, and holding onto a point of stillness, will be required if the reader desires to fully benefit from this book. My writing will seem refractive in nature too, with prismatic light of beauty, art and faith emerging from many thematic layers: current events, life practices and stewarding what I call the "ecology of culture toward culture care."[4]

Readers, especially Japanese readers, may wonder what Mr. Scorsese would find of interest in Shusaku Endo's writings, so much so that he would spend decades making this film one of his life works, his pet project, acquiring the rights to the story in the early 1990s and waiting nearly thirty years to make the film. As part of the mystery being revealed in this book, I want to pursue why *Silence* has had a profound effect on postwar American intellectuals, perhaps just as profound as its impact on their Japanese counterparts. Some of the director's earlier films sparked culture wars reactions, and this book may serve as a guide to those who desire to move beyond the boycotting of culture Christians are known for, a guide toward deeper reflections on culture and a guide to the deeper reading of *Silence*. I do not assume that my readers are Christians or familiar with theology or the church. So as I go along, a few chapters will explain important terms, and, I hope, convey my understanding of the gospel, which Christians call the "good news."

I do assume that the readers have read *Silence*, or at least—perhaps through the film—know of the basic plot. If you desire to know the basic plot without reading the novel or watching the movie version, you can turn to a synopsis at the end of this book. But I highly recommend that readers of this book read *Silence* (including the most important appendix), whether before continuing in this book or later, after absorbing my reflections on it in my writings here (including my advice about how to go about reading *Silence*). But as I will note, what began as an inquiry to facilitate our understanding of *Silence* ended up becoming a deeper discovery that peers into the mystery beyond, the mystery expressed in the title *Silence and Beauty*.

I also write from a perspective of enormous appreciation of both my Protestant heritage and my marriage to a Catholic believer. I believe that the core message of the Bible connects all of the major branches (Catholicism, Eastern Orthodoxy and Protestantism) of the church today. My wife's uncle, a Catholic priest, had a significant impact on my spiritual journey; Judy, a Catholic from southern New Jersey with roots in Ireland and England, encouraged my newfound path as a Christian, even bringing me to Protestant churches so I could grow in my faith. For those unfamiliar with the distinction between Catholic and Protestant faith, I write these chapters not to explain my position on what the church is and ought to be, but from my perspective as a bicultural artist of faith who values both traditions. My grandparents and ancestors on my mother's side were Christians many generations back, a rare thing in Japan. I did not know of my spiritual heritage until after my faith in Christ grew, and part of this book tells of my discovery of my past. My wife grew up knowing that her parents' generation was forbidden to marry across the Protestant–Catholic divide. Her choice to become a psychotherapist had much to do with finding language that would reconcile relationships, and it had much to do with values instilled in her by her parents' involvement in the civil rights movement and her father's leadership of affirmative-action hiring in a major Philadelphia bank. Her care for my soul was a catalyst for my growing Christian faith. Ours is a mixed marriage: a Protestant married to a Catholic, a Japanese American married to an Anglo-Irish girl from south Jersey. We have chosen to intentionally straddle these gaps as a way to acknowledge God's providence over the divisive history of the church and culture, and that will no doubt play a role in the way that cultural reality and the gospel of Jesus are presented here.

I also write from a deep appreciation of Japanese art and its potential for the world. When I went to Japan as a graduate student, I knew that something was drawing me back to the culture of my roots. When I became a Christian during that time, I wondered why God would take me back to Japan to reveal God's presence to me. Why not have me come to

Christian faith in America, where there are so many churches, or in Europe with its rich Christian tradition? As I write this, I am beginning to understand that my journey of faith is intrinsically tied to Japanese aesthetics, and that God indeed planned my reconnecting with the heart of Japanese culture to draw me to the origin of my creativity. The nature of the gospel is to speak through the language of the culture and context that one is placed in. In this book this gospel of Jesus is seen refracted through the art and literature of Japan, and I hope to guide you in the mystery, so that the "eyes of [our] heart may be enlightened" (Ephesians 1:18).

❧ ❧ ❧

Reading Endo is like reading a mystery novel in which many of the clues prove to misdirect the reader. When Endo published *Silence*, some religious authorities wanted to ban their parishioners from reading the book; this turned out to reveal Endo's scheme to take readers deeper into some of these embedded mysteries. I believe Endo anticipated—even welcomed—those negative responses. They served as a way to expose the dark realities behind religious convictions, and ultimately they cause us to experience more deeply, through his books, the presence of grace in dark, traumatic times.

As a mystery journey it would be helpful for the reader unfamiliar with Japanese literature to get a map of the cultural context Endo wrote and worked in. Thus, in this book I take two Nobel prize–winning authors, Yasunari Kawabata (1899–1972) and Kenzaburo Oe (born 1935), to guide the reader. Their respective Nobel Prize acceptance speeches are perfect windows through which we can peer into the mystery of Endo's design. This book is by no means a comprehensive guide to Japanese literature, and Endo stands unique in the masters of the twentieth-century Japanese past, and quite possibly in the history of Japanese literature. But Kawabata's lyricism brought into the context of postwar Japan, much as my mentor Matazo Kayama's bold attempt to bring the beauty

of Rinpa screens into the barren, gray world of postwar Japan, creates a context for a Japanese view of beauty that amplifies Endo's work, and Oe's language devoted to creating ambiguity is a perfect contrast to, and overlaps with, Endo's descriptive language of trauma.

In the Christian calendar Good Friday (commemorating the death of Christ on the cross) is celebrated before Easter Sunday (which celebrates the bodily resurrection of Christ). There is another holy day between Good Friday and the color of Easter Sunday that most people, including Christians, do not pay much attention to. It is Holy Saturday, a day of darkness and waiting. This book is about the movement of our souls into Holy Saturday, waiting for Easter Sunday. Endo, in many respects, is a Holy Saturday author describing the darkness of waiting for Easter light to break into our world.[5]

The question that haunts the reader of *Silence* is this: Christian missionaries went to "the ends of the earth" (as described in the New Testament, Acts 1:8) to spread the news of Jesus in the sixteenth and seventeenth centuries. Japan, as the end of the Silk Road, is literally "the end of the earth." The mission, as Endo depicts it, ended in utter failure by any human standards. This book traces the journey into the heart of such a darkness by a Holy Saturday experience of waiting through the lament and trauma toward Easter Sunday. To Endo, the failure of seventeenth-century missionaries was not the end, but the beginning of another journey toward compassion, a painful gift for all of us.

A JOURNEY INTO *SILENCE*

Pulverization

I entered the darkly lit exhibit room alone.

The studio given to me as a National Scholar was a few blocks away from the Tokyo National Museum at Tokyo University of the Arts. In between painting layers I often wandered into the museum, an imposing building with a Western façade and a Japanese roof, reflective of the nineteenth-century Meiji restoration period combining the Japanese past with influences of the West in what is called the Imperial Crown Style. I was studying the Tokyo National Museum's collections of Rinpa (seventeenth-century) and nihonga byobu screens. After spending time in the main hall where these majestic pieces were exhibited, I entered one of the smaller exhibits to one side. The display cases were full of what seemed like tablets laid flat. I read the description and learned that these were from seventeenth-century Japan, a collection of fumi-e (literally "stepping blocks").

Fumi-e were created during the seventeenth-century Tokugawa shogunate Christian persecution. They are images of Jesus, or of the Virgin

with a child, carved on wood or cast in bronze. Villagers were asked to line up on the beach and one by one renounce Christianity by stepping on these blocks. Later on, it was the custom of the New Year's celebration, with villagers lining up to pay tributes to the temple and, for those suspected, to step on the fumi-e. Individuals who refused or even hesitated were arrested and most likely jailed and tortured.

I had just come to embrace faith in Christ at the age of twenty-seven, after several years of spiritual awakening. Now I faced, literally, the reality of Christian faith in Japan. I had just been baptized in a missionary church in Higashikurume, but this fumi-e encounter was my true "baptism" into being a Christian in Japan.

What haunted me, and continues to haunt me to this day, is that all of the fumi-e images were worn smooth. The cast or carved images were hardly recognizable due to so many people walking over them. The image of Christ, hidden beneath the smooth surface of the fumi-e, serves as an emblem of Japanese faith to this day. And the worn surface of fumi-e also captures Japanese beauty enduring trauma.

<p style="text-align:center;">∽ ∽ ∽</p>

Pursuing the aesthetics of Japan, I studied as a National Scholar for six and a half years, apprenticing under several masters of nihonga—in particular, Professor Kazuho Hieda and Matazo Kayama. After being invited to continue my studies as a master of fine arts student, I became the first outsider to be invited into the university's doctoral-level lineage program, which is linked to the seventeenth century. (Tokyo University of the Arts receives over four hundred applications for its undergraduate class of twenty, and rarely is an outsider of the university system, let alone a foreigner, allowed to study there.) By the time I encountered the fumi-e, I had realized that my path would be quite different from other nihonga students. While I deeply affirmed Japanese tradition and beauty, I had to assimilate my earlier training in

American abstraction and minimalism. Further, I now had to live out my newfound faith in Christ.

I had just been led to Christian faith by my wife. My account of my faith transformation, and my transfer-of-allegiance experience of becoming a follower of Christ drawn out by the poetry of William Blake, is depicted in my first book, *River Grace*, and is reprinted later in this book. It was then that God began to immerse me in the history and aesthetics of Japan.

I began to work in response to Endo's writing and my own encounter with fumi-e. My first series of works, exhibited at Tamaya Gallery in Tokyo and later installed at Yokohama Citizen's Gallery (curated by Kenji Kitazawa), was called the *Ju-nan* (*Passion*) panel series. These small, square, minimalistic works were simple layers of pulverized pigments, layered over and over and distressed by rubbing them with sandpaper and other materials. In my doctoral thesis I created an installation using a series of narrow panels on the floor to "quote" fumi-e works. I used nihonga methods, but the delicate surfaces were precariously installed right on the floor. I called the installation "The Resurrection."[1]

STRUGGLING WITH SHUSAKU ENDO'S WORKS

I read Shusaku Endo's *Silence* soon after this encounter with fumi-e at the Tokyo National Museum. I knew it was one of the most important novels of the twentieth century, and I had frequently noted Endo's name even as an undergraduate in the United States. As a new follower of Christ, I found it fascinating that this Japanese Catholic writer had become an important, popular cultural voice worldwide.

Reading *Silence*, though, was an excruciating experience, especially as a new believer in the Christian faith. Understanding Christ's suffering for our sake is one thing, but a gruesome and graphic depiction of his followers' torment is never easy to digest. After the first reading, my foremost

questions were about the timing and motive of the missionaries' trek to
Japan. Why did they choose to go to Japan knowing that they might be
captured and killed? Was their motivation a martyr complex, a type of a
death wish to make themselves significant? Did they sense a divine call
to come to a closed country hostile to faith, or did they make the journey
because of foolish ambition? What is the nature of the faith that mis-
sionaries of the past and present desire to bring to a foreign context? And
why did the Tokugawa feudal authorities decide to persecute only Chris-
tians? What threats did they perceive that made them single out the
Christian faith?

I deal with these uneasy questions in this book. Not all of them will
be answered satisfactorily, but they do open up a larger set of questions
about faith, betrayal and the question of evil and suffering, which theo-
logians call "theodicy."

But one fact remains jarringly clear to me as I write: this book is proof
of the remarkable impact *Silence* has had on the world and certainly in
my life. Testament to a writer's impact may not lie in how successfully a
book sells or even in whether the author wins a Nobel Prize. The true
testament is the generative impact the work has over time and how the
work seems to expand with each age. *Silence*, in that sense, is proving to
be an extraordinarily enduring and generative work of art.

ENDO'S ART OF PERSEVERANCE

Endo was born in Tokyo in 1923 but spent some of his early childhood
years in Manchuria. After his parents divorced, his mother returned to
Japan with him in 1933. He was brought to a Catholic church in Kobe by
his mother and his aunt, and was eventually baptized as a child. Even in
his early days as a student he knew his future path would be tenuous. His
Catholic identity meant that he was a misfit in the broader society of
Japan. This was not simply an issue of faith, of being a Christian in a
country of Buddhism and Shintoism; bound up in it too was the cultural

perception of Christianity as a foreign import. Leading up to the Pacific War, Christians were thought to be suspect: if they valued foreign religion and customs, the thinking went, they therefore were aligned with enemies of the state. This stigma became even more complicated in postwar Japan: Christianity became equated with the push for cultural reconstruction in dependence on American powers. An added burden was the identity of postwar Japan—modern, yet still vacillating between adopted aspects of the Western past and the onslaught of modernist secular values also introduced by the West.

Endo felt early that his commitment to faith was not his own, but that he was adopted into faith by others. Philip Yancey explores this in his in-depth analysis of Endo's career:

> "I became a Catholic against my will," he now says. He likens his faith to an arranged marriage, a forced union with a wife chosen by his mother. He tried to leave that wife—for Marxism, for atheism, for a time even contemplating suicide—but his attempts to escape always failed. He could not live with this arranged wife; he could not live without her. Meanwhile, she kept loving him, and to his surprise, eventually he grew to love her in return.
>
> Using another image, Endo likens his Christian pilgrimage to a young boy squirming inside a suit of clothes. He searches endlessly for a better-fitting suit, or perhaps a kimono, but cannot find one. He is constantly, he says, "re-tailoring with my own hands the Western suit my mother had put on me, and changing it into a Japanese garment that would fit my Japanese body."[2]

Endo's resumé is filled with setbacks. Throughout his youth, he attempted to fit in by retailoring. Life was harsh no matter what cultural cloth he wore. It was not just his Catholicism that made him a misfit. Though clearly gifted, he often avoided schoolwork, frequently ending up in a movie theater instead of going to classes. He later would call his

student self *rakudai-bozu*, meaning an abject and comical failure. During those days his mother was often his only support, encouraging him to write; as a gifted violinist herself she saw something unique in Shusaku's storytelling skills.[3] Later, he was fortunate to find friends who were part of the intellectual circle of postwar Tokyo. One of those friends/mentors, Yoshihiko Yoshimitsu, had a profound influence, as Yoshimitsu saw the gift inside a verbose, gregarious young thinker. Yoshimitsu, who studied in Paris under Catholic philosopher Jacques Maritain, made an indelible mark on Endo's future path. Endo's many attempts to enter a university ended up in disappointments. He applied to nine schools and was rejected by them all, but after three tries he was accepted into the literature department at Keio University. After graduation he was among one of the first postwar groups of Japanese students to study abroad in France; he traveled to France by boat, buying the cheapest ticket possible.[4]

He thought that his Catholic faith would finally find a cultural home in France. He later joked that much of what he knew about French culture came from watching French movies, but in reality his early linguistic acumen allowed him a serious and ample look into French literature and culture; he identified with writers such as Georges Bernanos and François Mauriac. However, upon arriving in Lyon in the fall of 1950 he experienced the tenuous reality of Catholic faith during the war years. He expected to find a new connection toward building his identity and his faith, but he found instead the increased cultural apathy toward faith and racial discrimination against him as a Japanese. He fell in love with a French philosophy student, Françoise Pastre, but both of them knew their relationship across racial and cultural barriers would be unacceptable to their parents. He ended the relationship abruptly before leaving France, and later he noted that he was most happy that they did not consummate their relationship sexually. What he does not say is how deeply affected he would be; he was haunted by the experience for the rest of his life. He perhaps saw in his girlfriend an innocence that was not to be violated—and he saw

in her virginity an increased sense of a sacred bond to the Virgin Mother of Jesus. But the confounding story behind the story is that the breakup was far more significant and messy than Endo gives credit.[5]

This longing to reach beyond cultural barriers and the frustration of not being able to fit in are recurring themes in his novels. At home in Japan he did not fit in because he was Catholic; abroad he found himself alone because he was Japanese. Compounding his isolation was his poor health; he received treatment for several bouts with tuberculosis. This eventually required thoracoplasty surgery, and the illness forced him to end his study in Paris early, abandoning his desire to stay to complete his PhD in French literature from the University of Lyons.

Shusaku Endo's life symbolizes Japan's psychological journey after the World Wars. As one single writer, uniquely Catholic, he can be seen as a macro lens on the postwar Japanese experience. Endo belongs to a generation of Japanese males who were not drafted, often because they were deemed physically unfit to be soldiers. They were left behind at home, watching their peers and relatives join the march toward blind nationalism on the battlefield, and then dealing with the void of most of them not returning. Many who did survive the war did not survive the ensuing depression and alcoholism; Endo's diary is filled with notes about fellow intellectuals and writers who endured health problems, and many names of those who ended up committing suicide.

Endo's generation was also the direct product of intellectual ferment that had begun during the Meiji restoration, when intellectuals' learned gaze could finally be lifted to go beyond the oceans into a wider world. They were thrust into carrying out the postwar reconstruction, still traumatized by the war, in many cases without paternal influence, or, in some cases, having been completely orphaned. Endo's encounter with fumi-e, therefore, does not just recount the experience of seventeenth-century Japan; it invokes an encounter with a symbol of stigma, of one's orphaned heart. Such a symbol of rejection and persecution can expose a deep sense

of alienation he experienced as a male Catholic in Japan. But in Japanese culture these wounds are deeply hidden and only surface in a work of art or literature.

Endo's mother, a violinist, supported and nurtured the family. Endo always placed her picture in front of him as he wrote, even carrying her picture as he traveled. This feminine influence in Japanese culture affects deeply the orphaned psyche of culture, and beauty is tied to feminine sacrifice and the feminine fragrance. Such a relational reality points to the faith Endo embraced, the feminine God expressed through the Virgin Mother. For someone like Endo, it would have been even harder to step on the fumi-e of the Virgin Mary than to step on the image of Jesus. His concept of God is clearly more feminine than masculine, as he notes in many of his interviews.[6] It is a quite significant detail, then, that the fumi-e that Father Rodrigues is asked to step on at the end of *Silence* is an image of Jesus and not the Virgin.

<p align="center">෨ ෨ ෨</p>

Shusaku Endo had never seen an image of fumi-e until a friend brought him one, on paper, when he was recuperating in a hospital ward.[7] And then a fateful trip to Nagasaki, as he was recovering from one of his many surgeries, brought him to a small municipal museum near the bay of Nagasaki, where he encountered an object that would shape his life. He began to conceive of writing *Silence* from that encounter.

> In the dark display hall, what made me stand still was not the (bronze) fumi-e itself, but the wooden base surrounding the (round) fumi-e which had several blackened footprints impressed upon it. It's clear from the mark that this indentation was not made by one person, but by many who stepped upon it.[8]

As Endo began to write *Silence* as a result of his encounter with this fumi-e, he became particularly obsessed with the failures of faith—with

those Christians who stepped on the fumi-e to betray Christ, perhaps multiple times. Looking back, the writing of this book began with my encounter of fumi-e at Tokyo National Museum, paralleling, many years later, the way that Endo's writing of *Silence* began with his encounter of fumi-e in Nagasaki. He based his narrative about the fictional early seventeenth-century Portuguese Jesuit missionary Father Rodrigues on the historical figure of Giuseppe Chiara, who arrived in Japan when it was forbidden to do so, only to be captured and tortured. *Silence* won the prestigious Tanizaki Prize and became a bestseller in Japan, unexpected in a country with a Christian population of less than 1 percent. *Silence* was translated into English three years later and ultimately became a global bestseller. To this day many point to this book—and not Yasunari Kawabata's or Kenzaburo Oe's Nobel Prize–winning work—as the twentieth-century Japanese masterpiece. Scholars praise Endo's later novel *Samurai* as his highest achievement, but it is *Silence* and his late work *Deep River* that he is noted for globally. It continues to appear on many college reading lists, even at non-Catholic universities. Among Catholics, Endo's work has become one of the consistent resources of twentieth-century imagination, alongside Flannery O'Connor and Endo's main influence, Graham Greene. These authors, divided across the oceans, paint a consistent image of the alienation and endurance of twentieth-century Catholic writers.[9]

ENDO AS THE NOVELIST OF PAIN

Paul Elie has elegantly assessed four influential Catholic figures of the twentieth century: Thomas Merton, Dorothy Day, Walker Percy and Flannery O'Connor. What Elie writes of O'Connor illuminates Endo as well:

> For O'Connor independence is instinctive and effortless, a point of departure. She is a prodigy, born fully formed, or so it seems, and

determined to leave her mark on whatever she touches, so that nothing she will write—stories, novels, essays, letters—could have been written by anyone else.[10]

If Catholic writers must pave an independent path in the context of modernism, and if O'Connor was "fully formed" from birth, Endo was, by contrast, shaped by his keen awareness of his *malformed* condition in his faith through which he had to find an independent voice. But behind this awareness was also a fierce drive to write so that nothing he touched "could have been written by anyone else." Like many of his characters, Father Rodrigues in *Silence* or Otsu in *Deep River*, Endo himself was filled with doubt about his own mission as a writer; yet in his writing, something always intervenes as a forceful element of grace.

Flannery O'Connor had a well-known struggle with lupus. Endo endured a similar struggle with poor health throughout his life, and he was convinced early on that he had a very limited time on earth. I imagine his early experience as a student in France, when he was forced to be hospitalized, had a profound effect on his language as a writer. Endo is a novelist of pain. He writes to try to overcome the barriers and limits of language by understanding human suffering. A person is never more vulnerable than when hospitalized alone in a foreign culture. What can communicate beyond cultural, racial reality? What communicates between his suffering self and the French doctors and nurses?

As I pondered Endo's writings, it became clear to me over and over where Endo found his language: in the precision of the diagnostic terms of medicine and in the vulnerability of the experience of trauma. Endo must have experienced the clear, concise communication of medical terms that transcends cultural and linguistic barriers, and he experienced trauma as a universal language that can connect cultures. Vulnerability and awareness of physical limitations lead to short, compressed, anguished expression in O'Connor's memorable, violent short stories, but reading

Endo's work is like being tortured with slow drips of precise poison, but with a certain compassion—expression of obsessive and prolonged agony, with ample details of that trauma, revisited over and over in the character's mind in a purgatorial but ultimately generous way.

Then a diagnosis is dealt, a possible cure—but there is no guarantee of success. Further, a tuberculosis diagnosis will result in being isolated physically from even the rest of the hospital. Imagine being a foreign student, struggling with cultural and linguistic barriers, and then being hospitalized in an isolation ward. Living under these conditions, and in a country haunted by war, led Endo to explore his personal trauma, and through that reflection he discovered a universal condition. Endo's language became a map of traumas; betrayals, pain and doubt suffuse *White Man/Yellow Man*, *The Sea and Poison*, *Deep River* and *Silence*. All of Endo's setbacks—his many surgeries, his lack of academic credentials, his vacillating and seemingly ambivalent faith, his experience of being a misfit at home and abroad—are turned into struggles through which his characters in these stories are transformed, either to their destruction or to their unexpected growth as human beings. In the process of that transformation, Endo depicts a delicate grace, like a skillful brain surgeon who sees an operation not only as necessary for survival but also as an exercise in precision and ultimately beauty.

CHRIST-HIDDEN CULTURE AND FAILURES OF FAITH

In *Silence* Endo brilliantly focuses on a Portuguese missionary, an outsider, to tell the story of the Japanese past. The young Father Rodrigues crosses the border into Japan by traveling for over two years, entering what Endo called the "mud swamp" of Japan inhospitable to Christian faith. It is a story the Japanese themselves may not be able to tell objectively. Only a rejected outsider can uniquely amplify the descriptive language Endo desired to develop and portray the orphaned mindset birthed out of

persecution. Such a vantage point can communicate beyond the failures of faith in Japan, making the experience universal through the common curse of trauma. Endo can *hide* the true reality of the orphaned Japanese heart *through* Father Rodrigues, the reality of a culture traumatized and unable to tell its own story. Like O'Connor, Endo writes as both an insider and an outsider. O'Connor is noted for having written in the "Christ-haunted South" as a Catholic, which made her a foreigner of sorts in the Protestant American South even though she was a native of Savannah, Georgia.[11] Endo, too, wrote in a country haunted by Christ, and this historical mark, like the footprints in the wooden frames of a fumi-e, remains indelible—but it is concealed, *hidden* within the Japanese psyche; this explains the psychological and sociological reality that affects Japan today. Further, I present here the most radical notion: Japan is still a Christ-hidden culture, haunted by the past, with a developed sense of hiding well what is most important. Endo, an archaeologist of cultural trauma, begins to dip into the mud, scooping up the elements of broken shards of the culture of Christianity in Japan, and discovers, in my mind, the essential humanity and beauty of Japan.

Endo notes in a memoir,

To me, there is only one reason why I am interested in the hiddenness. [Japanese Christians] were children of failed faith. These children were, as with their ancestors, unable to completely walk away from their faith, and as they lived out their lives, lived with utter shame, regret and the dark pain of their past constantly.

As I wrote my stories of Japanese Christians, I found myself drawn more and more to these children of failed faith. They had lived a double life, putting up a facade, never to reveal their true selves, living out their faith in secret. In that life-long struggle, I saw my own self. I, too, operate that way, hiding my deepest of secrets; secrets that I dare not disclose and will carry beyond the grave.[12]

Silence depicts such failed faith found in Japanese history, and Father Rodrigues describes Kichijiro, initially seen as a Judas character in *Silence*, as a betrayer of faith:

> Men are born in two categories: the strong and the weak, the saints and the commonplace, the heroes and those who respect them. In time of persecution the strong are burnt in the flames and drowned in the sea; but the weak, like Kichijiro, lead a vagabond life in the mountains.

While setting up this dichotomy of the strong and the weak, Endo skillfully arranges these clues in the same way that a mystery novelist would embed clues that misdirect the reader. The clues, the traps, are set so that the reader agrees with the observer of the failed persons, reacting in derision and judgment. At the time Father Rodrigues makes the previous observation he is quite confident of his faith, which in many ways carries with it the imperialistic confidence of the Western God of Christianity, triumphantly set to overcome the "pagan" religions of Japan. A casual reader will find it easy to judge Kichijiro, a Japanese who has betrayed his family and his Christian community by stepping on the fumi-e, denouncing his faith and surviving the persecution. Endo invites the reader to judge Kichijiro in the same way that Father Rodrigues does. We have a tendency to extol heroes of faith; our textbooks and our sermons are filled with the heroic. In doing so, we fall into a false dichotomy of seeing faith only in terms of victory or failure, which leads us to dismiss and discard the weak. Endo stands with those sitting in the pews who feel inadequate and uncertain, who doubt whether they can be strong, heroic and faith-filled. Endo, therefore, sets up ways in which his confident characters are forced to go through ambiguity, trauma and failures. Rodrigues is forced to find another way to understand his faith, and Kichijiro turns out to be a transformed person in the end. In order for a careful reader to understand this unraveling of clues and transformation of characters, he or she must read to the end of *Silence*, including the appendix.

In the Japanese version of *Silence* the last section, which in English translations is split off as an appendix, has no such heading. Near the end of the book the story goes right into the "Diary of an Officer at the Christian Residence." In the English version of *Silence*, in other words, a blank page separates the diary from the story with the clear denotation of the word *Appendix*. No Japanese edition I've seen has such a separation. Endo considered this diary to be part of the arc of the story of *Silence*. When I recommend *Silence* to people, I always advise them to read to the end, and to make sure to read the so-called appendix as an essential element of the story.

Endo called himself "Kichijiro" in many of his lectures and his writings. In *Silence* the character Kichijiro represents all of the "children of failed faith" and the centerpiece of Endo's attempt to redefine the concept of the hero. Kichijiro is orphaned, his past was traumatic, and he is rejected by the community and his family. His witness is miserably nonexistent. Yet to Endo, Kichijiro is also the counterpoint to the male imperialism of the Christian West, brought into Japan symbolically through Father Rodrigues; Kichijiro is Endo himself, vacillating, hiding his true motives, but finding inexplicably the deeper reality of beauty, the beauty born of sacrifice. Fumi-e, an emblem of Kichijiro's failure, becomes in Endo's hands a Japanese critique of Western triumphalist faith.

Ultimately, *Silence* is more than a critique of Western faith. Endo intended to write a story that would be universally resonant, like a new medical discovery, toward dismantling the trauma of the twentieth century and beyond. To Endo the "mud swamp" of Japan is still beautiful, an antidote to the world of trauma, torture and religious persecution. Endo's Japan is a "Golden Country"—the title of the play Endo wrote as a companion to *Silence*.

As Endo spent time in hospitals, he might have intuited that in order to find a cure, he must be willing to live with the disease. An immunization is an intentional, modulated, controlled introduction of a disease into a

body. When a child is immunized, the nurse injects a small quantity of a vaccine into the child's body. Then the child's body can develop immunity through the body's natural efforts to fight the very illness from which the child needs to be protected. Endo's writings work like a successful vaccination: for us to develop immunity to the crushing impact of traumatic, dark realities of persecution and irreversible losses, we must experience those realities. Endo's stories set readers on complex journeys into the twenty-first century, toward a world divided by religious and cultural tensions in which Ground Zero conditions expand each day, and in which many religious minorities find themselves persecuted. In order to get to such a place of healing, Endo's journey begins by describing the "muddy" soil of Japan, which seems inhospitable to Christianity but upon closer inspection tells quite a different story.

FRANCIS XAVIER'S JAPAN, THE BEGINNING OF TRAUMA

When the Portuguese Jesuit missionary Francis Xavier entered Japan through Kagoshima in 1549, he told the priests who accompanied him that Japan was quite different from the other countries they had visited to evangelize. Endo notes in *Silence*, "Japan is undoubtedly, as Saint Francis Xavier said, 'the country in the Orient most suited to Christianity.'" Xavier noted the high level of literacy among the Japanese, and he began translating the Bible into the native language, which he did not attempt to do in other countries.[13]

At least initially, missionaries' work in the sixteenth to seventeenth centuries met with great success. Revival broke out in Kyoto (the imperial capital at that time) with over 130,000 converts; later the number grew to nearly 300,000. Sen no Rikyu, one of the most influential cultural figures of that era, had one of his wives convert to Christianity, and he is said to have attended mass. The art of tea that he refined takes on the form of the "passing of the cup," with sweet morsels that will be

broken and tasted before the tea is taken. Many of his seven disciples were exiled due to their faith in Christ.[14]

There are many examples of Christianity influencing the culture of Japan, including the noted Hasegawa clan of painters who created vibrancy in the Kyoto artisan culture. (Chapter five will go more deeply into the significance of Sen no Rikyu and his connection to the Christian community in Kyoto.)

Such success, no doubt, and an influx of foreign missionaries having enormous influence, would have been a threat to any dictator. But this was true especially of Hideyoshi Toyotomi, who consolidated feudal power that later was inherited by Shogun Ieyasu Tokugawa, ushering in the Tokugawa era of Japanese history. Hideyoshi ordered the initial spark of Christian persecution, a persecution era that began in 1597 with the martyrdom of twenty-six Christians. By that time some warlords and shoguns, most of them enemies of Hideyoshi, had converted to Christianity. But when it became evident that many mission efforts were in fact covert efforts to bring foreign goods and weapons into Japan, Japanese ports were closed to missionaries, and in 1614 Ieyasu signed an edict to eradicate the Christian faith from Japan.

What ensued after Ieyasu's edict to ban Christianity is one of the darkest periods in the history of the Japanese Christian church. The depth of cruelty, the "refined" design of torture techniques and the prolonged suffering of the faithful rival any time in history, including the early church. The depth of evil—what can only be described as a genius for innovative torture techniques that equaled or even surpassed any modern torture methods—led many Japanese Christians, even the greatest of priests, to recant their faith. The darkness would mar the psyche of the country and define its aesthetic, even to this day. This is the wound that Shusaku Endo captures in *Silence*.

Over two hundred years of isolation followed, and when that isolation ended in the mid-nineteenth century, a visiting priest discovered a group of underground Christians, called "Kakure Kirishitan" (Hidden, or

Hiding, Christians). Remarkably, they had maintained their faith and rituals generation after generation, praying to a hidden altar or creating what seemed to be Buddhist statues but were actually the Virgin and Child, and they practiced Communion with sake and rice, chanting vague references to the Bible in what over centuries became an unrecognizable dialect that combined Latin, Portuguese and Japanese.

MARTYRS HILL, "SHOW ME THE CROSS"

On a bright morning in December 2002, I had the privilege of standing on the spot called Martyrs Hill in Nagasaki. It overlooks that city's Ground Zero from a distance of about a mile. That bright morning I visited the memorial to the bombing of Nagasaki and the museum with friends, and took a video piece in the pond at Ground Zero. (I later used this in my New York exhibits, calling it *Nagasaki Koi.*) The first thing one sees upon entering the museum is the façade of a church building, white with ashes—perhaps the type of church that many missionaries would have visited. Its windows are skeletons; their stained glass is melted into beads on the ground.

With that fresh in my mind, I then stood in front of twenty-six figures lined up as a horizontal wing of a bronze cross marvelously crafted by sculptor Yasutake Funakoshi. The cross is outdoors on Martyrs Hill; Nagasaki is to one side, and the ocean is at the other. My eyes went almost immediately to the two shortest figures, one slightly higher than the other. The two short crosses belonged to Saint Ibaraki and Saint Anthony, twelve-year-old and thirteen-year-old believers.

Twenty-six men and three children were paraded some 480 miles from Kyoto to this hill to be crucified. It was the magistrates' logic that it would embarrass them to be taunted throughout their journey. Some bled as they walked; their ears or noses had been cut off in Kyoto.[15] On a busy road in Kyoto today—right by a hospital, one of the first that was established in Kyoto by Christian missionaries—there is a stone that marks where the march began.

The story of their arrival at their destination is one of a remarkable display of faith. When they arrived at the hill in Nagasaki, crosses were already lined up. As the story goes, one of the two boys said, "Show me my cross." Then the other echoed, "Show me mine."

I stood there, trying to imagine what they experienced, and for a moment their suffering seemed incalculable to me. Like the beaded stained-glass windows, droplets of a melted church on the ashes of Ground Zero, these two small crosses point to the stoic surrender of the Japanese souls that is reflected in the deaths of the martyrs. I thought about the chaos and uncertainty of my own Ground Zero experience in New York City, but this, obviously, was the beginning of a great trauma that went beyond any of my own experiences.

<p style="text-align:center">o o o</p>

"Show me my cross" may be a statement that every Christian needs to say to the world. In chapter 16 of the Gospel of Matthew, Christ warns his followers, "If anyone would come after me, let him deny himself and take up his cross and follow me" (Matthew 16:24 ESV). For each follower to "carry his own cross" means to expect persecution, betrayals and exile from the world.[16] The values of the "world" conflict with the key message of Christianity. Yet Jesus instructs his followers, "You have heard that it was said, 'Love your neighbor and hate your enemy.' But I tell you, love your enemies and pray for those who persecute you, that you may be children of your Father in heaven" (Matthew 5:43-45).

I call this command to love one's enemies the "impossible command." It makes it clear that Christian life cannot be attained simply by being moral and upright. C. S. Lewis notes that being a Christian is not an effort-based journey; it does not consist of fulfilling a checklist of moral demands: "It is not like teaching a horse to jump better and better but like turning a horse into a winged creature."[17] Christ demands that we say, "Show me my cross," and that we be willing to walk in the streets

being ridiculed for saying so. The faith displayed by the martyrs goes beyond what we assume faith requires; they carried a supernatural force with them that goes beyond our ordinary understanding of what it means to be religious. Such a transformation of our core belief system requires that we know the greater love of the One calling us; it requires a personal relationship with that One, giving us the strength to carry out that call. But it's not just in walking up a martyr's hill that this "impossibility" is demanded of us.

In a much smaller parallel, I have noticed, as an artist with a Christian faith, that if we are explicit about our faith in the public sphere—if we even mention our commitment to live a Christian life—we are dismissed right away in the art world. I have been told by influential critics that if I were not so explicit about my Christian identity I would have had a far more mainstream career. The worst thing a person can do in promoting his or her art career is to be public about how faith motivates their art. To invoke the transgressive, the cynical, the elusive may be the only way to become a respected artist; needy, shock-filled, ironical work gets attention as "serious."

Being a "Kichijiro," hiding your faith, is a way for a believer to survive what is often a conflicted journey in such a setting. Any artist of faith may chose to play a game, a game with rules set by the status quo of the establishment. One path, as Endo notes, is to lead a "double life," being aware of faith internally but never revealing that faith to the outside world. Many of us would identify with Endo's character Kichijiro; it may be easier to be a crypto-believer in modern life. Many Christians today live as if their Sunday faith never bleeds into their everyday reality at work or at home. It would be difficult for many, despite their deep desires to identify with Christ, to live openly true to what their faith demands. But Endo's candid admission of his many failures and lack of strong faith is never to be taken at face value: beneath the surface *Silence* and many of Endo's stories are stubbornly faith centered. Writing a book like *Silence*, based on Japanese

torture of seventeenth-century missionaries, is a bold and unexpectedly
courageous act for a postwar Japanese writer. Endo plays a game with
those who taunt faith, and with the world that denies God: he first con-
vinces us of a violent, corrupt world in which faith cannot possibly
survive—but he also artfully weaves into his writing the possibility of
another reality in which faith, like a deeply scarred mystery embedded in
between the words, resurfaces over and over.

The betrayal of one's conscience and faith on one hand, and heroic
public proclamations of faith on the other: these two reactions seem con-
tradictory, even paradoxical. Yet I have found, as I have journeyed with
Endo's writings, that they are two sides of the same coin. Like St. Peter
in chapter 18 of the Gospel of John, we are denying our Lord three times
at the critical moment in Jesus' path toward the cross. But in the biblical
story this betrayal is revealed to be a pivotal moment of a faith journey. It
requires audacity on the part of a writer to present such a double-edged
sword to the world, which is still hostile to faith.

Flannery O'Connor also faced an elite establishment who would not
entertain the notion of a serious Catholic writer. O'Connor wrote,

> The novelist with Christian concerns will find in modern life distor-
> tions which are repugnant to him, and his problem will be to make
> these appear as distortions to an audience which is used to seeing
> them as natural; and he may well be forced to take ever more violent
> means to get his vision across to this hostile audience. When you
> can assume that your audience holds the same beliefs you do, you
> can relax a little and use more normal ways of talking to it; when
> you have to assume that it does not, then you have to make your
> vision apparent by shock—to the hard of hearing you shout, and for
> the almost blind you draw large and startling figures.[18]

Endo and O'Connor shared in having to shout in a culture of denial of
the past. In Endo's case, he depicted the silent emblem of fumi-e to get

this vision across to this hostile audience. Endo chose to identify himself as a child of what in Japan was regarded as a failed faith of the past. He recognized fully that he too could not live up to the ideals of his faith— but like O'Connor, he also knew how to communicate *through* the dark cynicism of his day.

ENDO'S ANTIDOTE

Earlier, I compared Endo's writing to an inoculation, but *Silence* can also be regarded as an antidote. Providing resistance to an imperialistic narrative of faith while cloaked behind the modernist's stare into dark despair, *Silence* works as a powerful antidote to the modernist reductionism that entirely rejects doubt—as if we, in our limited minds and knowledge, can know everything God and the universe offer to us. If we can accept our limitations, *Silence* then can be seen as a book about faith and grace, about redemption of the fallen reality that is intentionally and effectively flying under the radar of the modernist establishment.

Endo's method of communication assumes that in a traumatized culture, any attempt to communicate will be limited, that every reader holds wounds that will undermine a deeper realm of communication. At the same time, he writes against the reductionism of the industrial age, a mechanism of efficiency and industry, that views God only as a taskmaster. Thus, the author's attempt to communicate nuanced truth about a God who is greater than propositions of mechanism is often met with a demand to clarify. Endo, both in his interviews and in his writings, obfuscates against such modernist tendencies, again like a mystery writer hiding his clues. Endo, O'Connor and Greene wrote deeply layered, conflicted language in order to gain traction in this cynical and faithless world. To these authors, to write was to communicate the deepest values of humanity and faith; to write was to stubbornly resist the world without faith, to inject such a world with subtle beauty; to write was to live out their faith.

In the New Testament of the Bible, in the Gospel of John 8:32, Jesus says, "You will know the truth, and the truth will set you free." O'Connor added her inimitable twist: "You shall know the truth, and the truth will make you odd." In Japan such oddness is perceived as threatening the entire society. Endo knew this and instinctively created characters with whom the Japanese can empathize—yet characters who are so odd that the experience of empathy with them vaccinates the reader against the illness of groupthink that excludes anyone with any sign of an anomaly. When we identify with less than noble characters like Kichijiro in *Silence* or Mitsu in *Deep River*, or failed priests like Father Rodrigues or Otsu, or comical failures like Gaston Bonaparte in *Wonderful Fool*, we are being injected with that vaccine that makes us realize, if we allow ourselves to be honest, that we actually resemble these weak, sometimes comically failed, characters. Endo's books expose our true selves. In the truthfulness of our own reality within, and in being explicit about our faith commitments, we will all find that knowing the truth does indeed make us odd. But this awareness can liberate us, Endo suggests, toward compassion, an antidote to a fear-filled world.

That Endo, a Catholic writer, succeeded at communicating such a transgressive message to the Japanese is notable. To have communicated it globally just as effectively is beyond remarkable. As much as Endo denies in his lectures and his essays any nobility as a person and as a Christian, in his own way he asked, "Show me my cross," and he carried it to the end of his life. The cross he bore was rejection by religious authorities and skeptics alike. But his marginal identity freed him to write what he desired, which was also true of O'Connor.

MODERNITY'S CHILDREN

There is another lens through which Endo should be seen, other than simply as a Catholic writer of postwar Japan. Though he wrestled against modernist reductionism, he was, at the same time, a writer of global

modernity, a product of education influenced by the Meiji restoration that began after the gun-boat diplomacy of the United States forced an end to the more than two hundred years of self-imposed isolation (sakoku), and after the official lifting in 1872 of the edict banning Christianity. Beginning in 1868, Meiji-era Japan looked outside the country's borders for the first time in centuries. It acknowledged that foreign countries were viable cultural realities, and began to import ideas and goods from other cultures once again. Writers, artists, scientists and intellectuals inherited post–WWII Japan as their domain. They were given the opportunity to redefine Japan, and they approached this task in a new way: looking at Japan from outside as well as from within. Such experiences are at the heart of much of what Endo wrote. As an exile in his own culture he had a unique lens, an ability to objectively observe Japanese culture. As an exile in foreign cultures he was also given a unique lens, an ability to observe other cultures with objectivity. As I have noted, *Silence*—narrated by Father Rodrigues, a Portuguese Jesuit—is as much a view of Japanese culture seen from the outside as it is about the inner workings of Japanese culture. Perhaps more than any other postwar writer of his generation, Endo had the capacity to live inside the "other" with empathy—as Atticus Finch of *To Kill a Mockingbird* would have it, "to climb into someone's skin and walk around in it."[19]

In reading of Endo's life I have been struck by the similarity of Endo's experience and my own father's postwar experience. My father was too young to be drafted. Because of his scientific acumen he worked for a military facility. Endo was not drafted either, and worked instead at an ammunition factory. My father's mother was killed in one of the Tokyo bombings; Endo lost many of his books and early writings in the same bombing. My father, like Endo, was one of the early scholars to study overseas after the war.

My father's journey as a scientist overlaps with Endo's journey as a writer. A scientist pursues objective reality, bound by material data; in the

same way, Endo's particular way of writing was to bind *himself* to the particular reality of data in front of him. In Endo's process of creativity there was a commitment to the objective, the anatomical and historical; my father's acoustics research proceeded from the same premise.

My father, though not religious, placed high value on what Christians honor: truth, beauty and goodness, three values emanating from the Meiji restoration and also from Confucian teachings of ancient Asia. I realize now that my faith, my art and my writing have much to do with the world my father desired to create through scientific research. My father, the scientist, and Endo, the writer, both laid foundational blocks to my life now. Their pulverized postwar generation faced obstacles and insurmountable challenges. Endo's writings, my father's scientific research—so much of the postwar Japanese journey—were, in essence, efforts to draw those pulverized splinters together again.

- 2 -

A CULTURE OF BEAUTY

Cultural Context for Silence

I spent much of my grade school years in Kamakura, a thirteenth-century capital of Japan. I grew up playing on the Inamura-gasaki beach, where centuries earlier Christians were forced to line up to renounce their faith by stepping on fumi-e blocks. The cove of Kamakura, and the beaches that face the Pacific, are famous in Japan. Because Kamakura was the former capital, I am sure that even in the time of persecution that *Silence* speaks of, it was a hub that drew many cultural luminaries.

I used to play baseball there as a child, and look for sea shells, and watch the fishermen draw up and cast nets and draw them up again. Beyond the peninsula of Enoshima to the south, on a clear, January day, Mount Fuji's snow-capped body would appear. Even in January, I re-member, the wind was not frigid but moist and balmy. My feet made footprints in the light gray sand, and I would look at the waves coming and retreating and erasing my footprints as I walked about during my New Year's vacation. The sands of time had worn smooth, like the fumi-e,

the reality of Japanese persecution. Not many Japanese, even knowing
something about the book *Silence*, would meditate too deeply on their
own land's history of anguish and death. Our earth hides the blood of the
past. I certainly did not think of such things as a child. In the hot, humid
summer days of August, in innocence I went to watch fireworks with my
mother and my brother, shielded from the painful past but enjoying the
pyrotechnic abstractions in the sky.

Kamakura, nestled between small mountains facing a cove, is filled with
ancient temples and shrines, and is considered one of the birthplaces of Zen
Buddhism in Japan. The Hachi-mangu shrine built in 1063 is one of the
meccas of the Shinto religion, and it was the heart of the Minamoto sho-
gunate that made Kamakura the capital of Japan from approximately 1185
to 1333. On my way to Fuzoku Elementary School, I walked past the shrine
through the peonies and cherry blossoms of the Dan Katsura path to the
temple. The Great Buddha of Kamakura (Daibutsu) still stands, a bronze
statue some forty feet high; it weathered several tsunamis and now attracts
many tourists. It did not occur to me as a child that Kamakura also has
many churches, both Protestant and Catholic. Some American Christians,
thinking of me as a Japanese citizen, have asked me whether I grew up
Buddhist. Many Japanese may list their faith affiliation as Buddhist or
Shintoist, but in reality this has very little to do with their everyday lives.
These extraordinary artifacts of past faiths are not life-defining religious
affiliations to most Japanese but only shades of the past kept alive in con-
temporary life. For the most part Japanese people remain agnostic re-
garding religion, even though if asked they would identify themselves as
Buddhist-Shintoist, usually in a syncretic blend of faiths.

In Kita (north) Kamakura there is a small Buddhist temple called
Ko-sho-ji. When I visited, climbing steep but dainty steps up to the
wooden temple gate, yellowing willows greeted me, swinging in the late
summer breeze. On the gate itself, worn with weather but beautifully kept,
is what is now known as Nakagawa-kurusu: an emblem of the temple, one

that seems to be made to look like a Christian cross. This, an inscription at the entrance explains, is where it is said that many Christians found refuge during the era of persecution. A Buddhist priest, I reckon, must have risked his own life to shelter Christians there.

Such amalgams of cultural influence made up the aesthetic of early Japan. The nation is not as homogeneous as many—even the Japanese—believe. In his revealing book *What Is "Japan"?* historian Yoshihiko Amino writes, "It would not be an overstatement to say that the idea of Japan as 'homogeneous tribe, homogeneous country' is a myth that has been proven to be false."[1]

Kamakura, like Japan's other ancient cities of Nara and Kyoto, was once a cultural endpoint of the Silk Road. As merchants imported silk and other goods from the Middle East, India, China and Korea to Japan, they also imported many cultural and religious forms. Japan has been a depository of all those cultures—in Nara, in Kamakura and then in seventeenth-century Kyoto. I call this infusion of various cultures a "cultural estuary"; it creates diversity and refinement, and in my early childhood I was immersed in it.

An estuary is where fresh water mixes with salt water; an estuary produces the most abundant ecosystem. The Hudson River, Chesapeake Bay and Tokyo Bay are all estuaries that once hosted extraordinarily diverse ecosystems.[2] Estuaries are delicate and crucial for the thriving of the ocean ecosystem. Recent environmental history has shown that the destruction of estuaries affects the entire ecosystem. I apply this principle to culture. As I explored in my book *Culture Care*, Japanese culture can be viewed as a cultural ecosystem. In a recent conversation with an expert in the ecology of estuaries, I discovered that their ecosystem is not homogenous but heterogeneous. In other words, healthy biodiversity depends on many pockets of homogenous units competing against one another. To envision Japan as a cultural estuary is to recognize that it is a fantastic mixture of cultures assimilated and refined. In Kamakura and Nara, the

early settlements of Japan, the developing cultural estuary created margins where Christians found a way to thrive and, later, to hide, even in the nearly 250 years of persecution, as evidenced by Nakagawa-kurusu.

Kamakura's cultural diversity, small mountains and the ocean gently asserted themselves in my aesthetics. I could not have guessed, growing up in Kamakura in the shadow of the Great Buddha, that my life would turn toward the discovery of faith in Christ. That this path of faith was prompted by my return to Japan to study sixteenth- and seventeenth-century Japanese art and the art of nihonga that rose out of ancient Japan may seem ironic, but as I trace my influences I see the fingerprints of Japan on my childhood, a childhood of privilege.

A professor at Tokyo University is regarded as an elite member of Japanese society. My father was a professor there when we lived in Kamakura. He was born in 1926, which made him three years younger than Shusaku Endo. My father's generation experienced the war directly. After losing his mother in the Tokyo bombings, my father devoted himself to science. His natural ability to learn and speak many languages earned him unique access to a world of acoustics research, an area of research just beginning to take shape in the postwar years. My bicultural journey began when I was born in Boston while my father was a postdoctoral researcher at Massachusetts Institute of Technology, working with Noam Chomsky to explore what Chomsky called "generative grammar" theory. Later my father introduced this as a dimension of early research efforts in acoustics in Japan. During our time in Kamakura I met many of the pioneers of acoustics and linguistics research as my father hosted them at our house. Thus, growing up in Kamakura for me also was a place of integration, not only of cultural heritages and natural heritages but the integration of sciences and the arts.

Both of my parents must have intentionally protected me from the effect of nationalistic biases that hamper creativity and imagination. I was brought up in a nonreligious but not atheistic realm, aware of the

important link between multiple cultures, aesthetics, religions and languages. But I also experienced the schism, the gap, between these arenas. My father, as a bright, young scholar, faced his own battle against the established Japanese culture that does not value free thinking; he discovered that because at that time speech sciences were considered to be unproven, much of the work in this field drew no support in Japan. Japanese culture does not easily accept outside influences and often rejects new ideas as too unsettling to the harmony of the group.

I did not realize until I began to write this book the extent to which my father's journey—like Endo's—was predicated on the framework of Japan fortified in the 250 years of persecution of Christians. Even my non-Christian father concedes that occidental scientific progress could not have taken place without a Christian foundation in an ordered, created universe. Free thinking can only occur if individual conscience is freed from oppression, and Jesus of Nazareth valued individual creativity and gave courage to stand up against the oppressors of humanity. Jesus did not take up swords or spears; he walked without violence or weapons into the heart of darkness, into the most gruesome realities of human experience. Science and the arts are avenues of nonviolent resistance to dictatorial forces. In the West they grew in tandem, like twin sisters, but in Japan, one sister—the arts—became the sole path through which individual expression could be valued, until the nineteenth century. And even then an artist's expression could not violate the forbidden zones of dictatorial forces. Inevitably, the art of the hidden became woven into the language of the aesthetic in Japan. While the dictatorial forces may have eroded over time, the culture of submission to homogeneity—which I have come to see as fumi-e culture—remains.

Of course, one must remember that the human capacity for advancing the sciences also led to atomic weapons. Human imagination can create beauty or weapons; it can improve and destroy our lives at the same time. The arts train our imagination toward restoration and reconciliation, but the arts can also cause us to lose hope; we can become persuaded that the

only path is to live trapped within despair. Endo's imagination, at first, *seems* to take the latter route. He is, after all, describing a despair-filled condition in all of his books. But in spending much time with his books, I've come to believe that Endo's genius is not just to look starkly into the darkness but to create characters and language that somehow inexplicably move beyond it. He mounts a nonviolent resistance to trauma by describing violence; he trains our imagination to desire freedom, to love humanity even at its lowest points, to find beauty in its nadir.

YASUNARI KAWABATA'S BEAUTY

The Nobel prize–winning author Yasunari Kawabata lived two doors down from one of my childhood homes in Kamakura when I was in first grade. Kamakura became Kawabata's favorite stage as a basis of his lyrical novels. My love for Japanese art and beauty took me back to Japan and led to my encounter with fumi-e; Kawabata provides an important contrasting backdrop to my journey into *Silence*. Japanese beauty came out of the refinement of culture that preceded the isolationist eras, but it was refined and redefined in that period of darkness. In other words, there is a connection between the beauty of Japan and dark, hidden journeys.

Kawabata noted in his Nobel Prize acceptance speech, "Japan, the Beautiful and Myself," that there is an implicit imprint of the beautiful, and the longing for beauty, operating in Japanese culture (see appendix one on Kawabata). Kawabata's speech is seminal for understanding Japan and the cultural environment in which Endo wrote and in which my father researched. As I note in the documentary that captures my experience as an artist, Kamakura, as a place, is deeply etched in my inner self and often comes to the surface even as I work in my New Jersey studio today.[3] Such a sentiment is well reflected in Kawabata's words:

> When we see the beauty of the snow, when we see the beauty of the
> full moon, when we see the beauty of the cherries in bloom, when

in short we brush against and are awakened by the beauty of the four seasons, it is then that we think most of those close to us, and want them to share the pleasure. The excitement of beauty calls forth strong fellow feelings, yearnings for companionship, and the word "comrade" can be taken to mean "human being." The snow, the moon, the blossoms, words expressive of the seasons as they move one into another, include in the Japanese tradition the beauty of mountains and rivers and grasses and trees, of all the myriad manifestations of nature, of human feelings as well.[4]

Kawabata insists on connecting the beauty of the senses ("beauty of the full moon" or "beauty of the cherries in bloom") and the inner experience of the beauty inherent in relationships ("want them to share the pleasure"). He notes that "the excitement of beauty calls forth strong fellow feelings, yearnings for companionship, and the word 'comrade' can be taken to mean 'human being.'" He sees in beauty an integrative power that can awaken, heal and restore. In Kawabata's mind, culture is deeply, harmoniously connected with nature. This quintessentially Japanese vision equating culture with nature comes alive as one walks the narrow streets of Kamakura. (See appendix one for more complete analysis of Kawabata's writings to Endo.)

MY INNER JAPANESE ESSENCE

When I studied art as an undergraduate, I came to realize that I had a distinctly Japanese sense of the world. When I drew an object, I seemed to try to capture its essence—something I felt that the object possessed in its inner soul, although at the time I could not articulate exactly what that meant. Instead of trying to outline its shape, I would intuit the object's weight and feel. I was more process driven than product driven; I felt attuned to the evanescence of natural realities. My professors encouraged me to reexamine my roots. I understand now that those distinctively Japanese sensibilities were developed in Kamakura.

But at that time, as a first step in my reexamination of my roots I traveled to Boston, my birthplace, to look at the Japanese paintings on display there.

Boston's Museum of Fine Arts has a remarkable collection of Japanese art. Prior to the rumblings that led up to the Great Wars, to protect great masterpieces of Japanese art the Japanese author and tea connoisseur Okakura Tenshin teamed up with Harvard University professor Ernest Fenollosa to secretly donate many of them to the MFA. (Their efforts to preserve the arts and heritage of the latter part of the Meiji era also led to the establishment of the nihonga curriculum at Tokyo University of the Arts, once known as Tokyo Imperial University, the very program in which I enrolled many years later as a National Scholar. Thus one might say Fenollosa paved the way for my journey toward *Silence* and my eventual integration of art and faith.)

As I stood in the Museum of Fine Arts on a cold January day, the aroma of the cherry blossoms that as a child I had enjoyed along the famed Dan Katsura path in Kamakura seemed to float all about me once again. I marveled at many of the masterpieces there, but paintings from the sixteenth and seventeenth centuries particularly drew me. I was fascinated by the exquisite but simple calligraphic strokes in the work of Hasegawa and master artists of the Kano school. So it was natural for me, upon being offered a fellowship as a National Scholar, to focus on the period of Japanese history of the sixteenth and seventeenth centuries, a period of intense ferment and innovation in Japanese aesthetics.

❧ ❧ ❧

When we cross borders culturally, we experience some alienation from our own culture and gain an objective perspective toward our own culture at the same time. A bicultural individual comes to identify home as a culture outside his or her original identity, and may vacillate in commitment and loyalty to both cultures. Endo experienced this as a

foreign student studying in Paris in his twenties. As a student without much money, he could only afford a steerage ticket on a ship to France. (He would joke later about his fifth-class quarters, though technically he traveled fourth class at the bottom of the ship, journeying with American soldiers for thirty-five days from Japan to France.) He experienced in Paris how the world saw the Japanese and was often disappointed by the indifference and racism that he encountered. If his adventure to France started with a steerage ticket, his debilitating illnesses made him feel all the more fifth class at the end of his journey.

Endo's frailty and vulnerability made tenderness part of his vocabulary. Even in the trauma-filled world of *Silence*, the language Endo uses comes across—especially in the original Japanese—as tender gestures.[5] For instance, there is an aesthetic notion called *wabi sabi*, which was refined by tea master Sen no Rikyu. The Japanese word *wabi* speaks of things wearing away, and *sabi* can literally mean "rust." But when used metaphorically they both speak of the pathos of life, and the notion that in death and the ephemeral, enduring beauty can be found. Yet the Japanese rarely use these terms; in Japan the most important reality is to be *hidden*, and it is not to be categorized with precise definitions. Kawabata's writings are filled with such sentiments. Endo, however, seemed determined to carve a unique path between the aimai (ambiguities) of Japanese culture and its lyrical beauty. Thus, to read Endo's books in Japanese seems, especially to a Japanese person, as if one is reading some novel by a foreign author. His language is not at all like Kawabata's; it is too precise and descriptive for a Japanese. Yet it would also be a mistake to regard Endo as a foreign writer. His writings still have distinct Japanese definition and aroma, but overlaid with a new language of hiddenness, of empathy and visual beauty. He wrote from the vantage point of an outsider peering into his own culture and his own heart; he accepted the exile inherent in such an identity. Endo's liminal life can be seen as consistent with notions of what is distinctly Japanese and at the same time consistent with rejecting those notions.

An integral aspect of the Japanese mindset is that if something is categorized or named, then it is of less value. In twentieth-century Japan there was a shift from the traditional ways of seeking beauty to dwelling in a zone of ambiguity or terror. Yasunari Kawabata represents the former, and the more recent Nobel laureate Kenzaburo Oe represents the latter (see appendix two on Oe). Endo's work lies between the two, a misfit oddity in the historical arc of Japanese literature. Yet Endo's descriptive and prescriptive power to describe such terror, while keeping an empathetic eye toward the outcast, allowed *Silence* to become a worldwide bestseller, outflanking the other writers. It is precisely as a misfit and as an outcast that Endo is able to speak clearly to the Japanese and non-Japanese at the same time, including the filmmaker extraordinaire Martin Scorsese.

SUICIDE

Kawabata's Nobel speech expressed the yearnings and longings that a Japanese sense of beauty evokes. The "feelings" and "pleasures" of the beauty of the mountains recall and invoke our "yearnings for companionship." But such feelings are often betrayed. In his speech Kawabata quoted his literary hero, Japanese writer Ryunosuke Akutagawa (1892–1927), who significantly influenced many modern Japanese writers—and whom Endo would have looked up to as well. (In fact, Endo named his only son Ryunosuke.) Kawabata recalls Akutagawa's suicide note, stating,

> It is the phrase that pulls at me with the greatest strength. Akutagawa said that he seemed to be gradually losing the animal something known as the strength to live, and continued:
>
>> I am living in a world of morbid nerves, clear and cold as ice. . . . I do not know when I will summon up the resolve to kill myself. But nature is for me more beautiful than it has ever been before. I have no doubt that you will laugh at the contradiction, for here

I love nature even when I am contemplating suicide. But nature
is beautiful because it comes to my eyes in their last extremity.[6]

Akutagawa died by suicide in 1927, at the age of thirty-five. Kawabata
continues,

In my essay, "Eyes in Their Last Extremity," I had to say: "However
alienated one may be from the world, suicide is not a form of en-
lightenment. However admirable he may be, the man who commits
suicide is far from the realm of the saint." I neither admire nor am
in sympathy with suicide. I had another friend who died young, an
avant-garde painter. He too thought of suicide over the years, and
of him I wrote in this same essay: "He seems to have said over and
over that there is no art superior to death, that to die is to live." I
could see, however, that for him, born in a Buddhist temple and
educated in a Buddhist school, the concept of death was very dif-
ferent from that in the West. "Among those who give thoughts to
things, is there one who does not think of suicide?"

When I was in sixth grade, going to a school in Kamakura, my
homeroom teacher sat us down to inform us that Kawabata, one of the
greatest writers ever to have come out of Japan, had killed himself. Since
we lived just two houses from him, I remember the great commotion and
agitation in the streets of the usually placid town. I also remember my
teacher's grave face telling us that suicide is not to be seen as noble or
courageous. The message mirrored what Kawabata expressed in his Nobel
speech. "The Japanese sense of beauty . . . is always connected with death."
In a culture in which the suicide ritual of seppuku is beatified as coura-
geous, as a moral way of dealing with injustice, it is hard to convince a
Japanese that suicide is not noble. In the quoted acceptance speech Kaw-
abata quoted Ikkyu (1394–1481), the great priest of Daitokuji temple:
"Among those who give thoughts to things, is there one who does not
think of suicide?"

These words of Kawabata, echoing through the history of Japanese literature, reverberate still in my heart. As is often the case of a serious thinker and an artist, I thought of suicide many times as a young person. I went through a period of depression in college and in my youth. It was only my marriage to Judy, her care for my soul, her skill as a psychotherapist and then my faith in Christ that may have saved me from carrying out the unthinkable. Endo crafts his writings and his life in the context of a pattern of many Japanese writers of note choosing the path of suicide. Endo's novels are filled with despair, even sadistic darkness; they are stark and unflinching. His essays, though, are filled with messages of hope to those suffering, and he was determined to live through his many illnesses.

When one is allowed to see the connection between life and art, one notes that even in the most pulverized annihilation of the character's psyche there is a certain hope. Noting this ray of light, however narrow or weak, is critical in understanding Endo. Endo faced the darkness of the human heart head-on, but he did *not* resign himself to it. He rested on God's grace alone. Endo's singular will to live may be the ultimate proof of his faith. He chose to see beyond the darkness and live toward that faint glimmer of hope on the horizon. Kawabata's writing is lyrical, but he did not survive his own lyricism; Endo lived through darkness and illnesses—stubbornly, often with much humor—resisting the temptation to end his own life.

BEAUTY AND SACRIFICE

Yet another aspect of the Japanese psyche is critical in understanding *Silence*. The manner in which the Japanese authorities persecuted Christians was unique in the history of the faith. In other parts of the world, enemies of Christianity viewed the martyrdom of believers as their most fitting end. In Japan it was different. The cross as a manner of execution was unquestionably cruel, but to the Japanese it overlapped with the seppuku ritual, and they could see the noble beauty in death. They also

observed that the more Christians were executed and humiliated in public, the more converts were gained. The North African church father Tertullian famously noted that "the blood of the martyrs is the seed of the church." Japanese authorities cleverly devised a way to poison the seeds before they could take root. They realized that in their culture the deaths of believers would not halt the growth of the church; what would discredit the church most decisively in Japan would be for Christian leaders' failures to be on display. They realized too that the ultimate failure would be for leaders—especially priests—to recant their faith. The path of a martyr is noble, but the path to failure is one of betrayal and shame. Forcing Christians onto that path was the most effective way to prevent other Japanese from converting to Christianity.

<p style="text-align:center">◜ ◜ ◜</p>

The Japanese word for beauty is 美, a Chinese ideogram composed of two ideograms: 羊 (sheep) on top and 大 (great) on the bottom. One of the paradoxes of Japanese culture is its focus on an overlap of sacrifice with natural beauty: decay with permanence, death with life. This aesthetic link between beauty and sacrifice may be one reason that the Japanese could plumb the Christian gospel's narrative of sacrifice and redemption, even very early in their history.

After 9/11, I emailed friends and family members to let them know that we had survived. My email spoke also of the "art of sacrifice" of the first responders who climbed the stairs of the falling towers. An art dealer in Osaka sent an email back right away with these encouraging words by the aesthetic philosopher Tomonobu Imamichi:

> In comparing beauty and goodness, I consider beauty to be the more transcendent of the two. The ideogram of "goodness" (善) is made up of two ideograms; one of a sacrificial "sheep" on top of an ideogram of a "box." To be good, it is only necessary to fulfill pre-determined

(a "box") sacrifice determined by society: paying taxes, or partici-
pating in traditions, rituals and such. The ideogram of "righteousness"
(義) is made up of the ideograms of sacrificial "sheep" on top of the
ideogram of "self." It means to carry the sacrifices yourself. But the
ideogram of "beauty" (美) is made up of the sacrificial sheep on top
of an ideogram for "great," which I infer means "greater sheep." It
connotes a greater sacrifice, a sacrifice that cannot be boxed in by
rituals or self. This greater sacrifice may require sacrifice of one's own
life to save the lives of others. This sacrifice is not enforced by rules
nor is it predetermined, but originates from self-initiative, a willing
sacrifice. This is what is truly beautiful.[7]

In this assessment of beauty, Imamichi is consistent with Kawabata, as
well as with my mentor Matazo Kayama, one of the greatest nihonga
artists of the twentieth century. Kayama notes,

> The Chinese ideogram, birthed in Chinese continent for beauty, is
> made up of two ideograms of "sheep" and "large." The reality behind
> "a large sheep" is the experience specific to the vast landscape of
> China which is tied to blood, meat, hair, leather, smell and taste of
> "beauty." In contrast, Japanese "beauty" is more formalized and yet
> visional. I am convinced that "Beauty" flowed into East and drifted
> ashore [in Japan] as a Totality of all of Humanity.[8]

In their different strands of artistic expression, Kayama and Kawabata,
painter and writer, dared to confront the gray postwar reconstruction of
Tokyo; both spoke boldly into the hearts of Japanese in the Ground Zero
wasteland that lay before them; they reintroduced the Japanese aesthetic of
lyricism and its hidden eros, which Kawabata particularly featured in his
work. Their work, especially Kayama's, recalls and illuminates patterns of
the bygone Rinpa school and dared to confront the reconstruction of Tokyo.

Together, the work of Kawabata (and Oe) in literature and Kayama in
visual art create a context critical to understanding Endo's writings. Endo

is sandwiched between two great writers who expressed Japan's lyricism and cultural ambiguity. Kawabata, one might say, represents the beauty of the Japanese past, and Oe, the ambiguity of Japan's future. Endo's writing is enhanced by these bookends; in contrast to these writers his descriptive language stands out, as if rising from the murky waters of lyrical ambiguity. The stark language Endo uses to express his vision of the "mud swamp of Japan" also markedly contrasts with the resplendent colors of Kayama's paintings. The literary colors Endo chooses are clinical, subtle nuances of black.

Matazo Kayama called the metallic color of gold, silver, aluminum and platinum the "third color." In his memoir *Infinite Space*, he writes,

> To me, gold and silver are the most mysterious of all the materials. ... Initially, I could not see the use of gold and silver in my works. ... I considered it, foolishly enough, pre-modern and inappropriate for our present time. So you might say, my view of gold and silver has changed drastically. Today, as I use considerable amount of gold, having mastered the material, I believe that such uses of traditional materials redefined my view of Nihonga. Uses of gold and silver, in both leaf and powder forms, allowed a development of my own Nihonga expression.[9]

Endo's writing is like the metallic "third color" of silver, which tarnishes to deep charcoal black when exposed to air. As tarnished silver Endo's writings overlaps with the Japanese aesthetic of Sen no Rikyu, a significant influencer of all of Japanese aesthetic. Endo's words deepen over time with the increased exposure to the air of trauma. Endo's unique gift was in identifying the wounds of the Japanese soul and exposing the air that Japanese are breathing in; it was as though he had a therapeutic and clinical purpose in his identification of the deep trauma that is a constant invisible companion to the Japanese. His illnesses and many failures in life had stirred him to empathy, and by depicting the raw anguish of the

Japanese past he was indeed defining a Japanese perspective, and beauty, toward suffering.

As Endo began to conceptualize *Silence* he thought about the experience of seeing a fumi-e, but what haunted him more was that as he lay in his hospital bed, in the next hospital ward a boy was suffering from an illness similar to his own. "Perhaps I can accept my fate of my illness, but what about that boy?" he wrote rhetorically. "What has he done to deserve that kind of fate?"[10]

In the worn-smooth face of fumi-e, and the disappearing face of Christ, Endo found resonance. He found perspective on his confounding question. Endo's writing does not answer the questions about suffering, but it expresses empathy for those who cannot speak or write. Endo found his calling was to speak for them. In exploring the denial of faith, and faith that is hidden from the overwhelming pressure of culture, he opened up a path to probe the mystery of existence.

NEGATIVE SPACES

In a drawing class a student learns to identify positive spaces and negative spaces. *Positive space* is defined by the outline and mass of an object; the *negative space* is the space surrounding the object. In drawing it is critical for the student to learn to navigate and use negative spaces; the flattened two-dimensional spaces are just as important as the positive spaces in creating an image. One might say that Japanese faith developed as negative space around the forbidden faith of Christianity. So while the Tokugawa era successfully purged Christians from Japan, an unanticipated outcome was that in banning Christianity they created an imprint of it, a negative space within culture. In a culture that honors the hidden, the weak and the unspoken, Christianity became a hidden reality of Japanese culture.

Japan has a dual personality that reveals itself only after one has spent a year or two immersed in the culture. A foreigner, a *gaijin*—literally

"outside person"—is treated with respect and hospitality. But a gaijin is rarely accepted as an insider. Having been brought up bicultural, I've personally experienced falling into the strange gap of being both an insider and an outsider. That experience is a window into the ambiguity just below the surface of the Japanese aesthetic and the imprint, the negative space, it creates in Japanese culture. Just as there is a Western perspective on beauty, there is a way to regard ambiguity that can be defined as uniquely Japanese. Both themes, beauty and ambiguity, are critical for understanding the unique Japanese psyche today; those themes constantly run parallel as hidden elements of value to the Japanese. Understanding their cultural concept of ambiguity will further unlock the deeper layer of mystery that runs through *Silence* and the Christian gospel that can liberate us all from the grip of fear, trauma and death.

AMBIGUITY AND FAITH

Japan, the Ambiguous and Myself

After World War II, the United States government commissioned cultural anthropologist Ruth Benedict to publish her many years of study of Japanese culture. In her report she wrote of two prominent symbols of Japanese culture: the *chrysanthemum* and the *sword*.

> Both the sword and the chrysanthemum are a part of the picture. The Japanese are, to the highest degree, both aggressive and un-aggressive, both militaristic and aesthetic, both insolent and polite, rigid and adaptable, submissive and resentful of being pushed around, loyal and treacherous, brave and timid, conservative and hospitable to new ways. They are terribly concerned about what other people will think of their behavior, and they are also overcome by guilt when other people know nothing of their misstep. Their soldiers are disciplined to the hilt, but are also insubordinate.[1]

This paradox still operates. Though the younger generations of the Japanese are influenced more by Western materialism and virtual games

than by a chrysanthemum and seem alienated from the Japanese past, the duality of the sword and the chrysanthemum remains a sociological reality. Adding to the complexity has been the recent growth within the younger generation of a culture of dependence, what the Japanese call *otaku* culture. I believe such dependence flows out of trauma and fear that reside deep within the polarized Japanese psyche. Otaku culture is a psychological heir of the postwar stoic resignation to rebuild; having accomplished the utilitarian, monotonous rebuilding, many Japanese now suffer from a lack of purpose and identity, having lost, in the rebuilding process, their own cultural heritage and beauty. Youth have become aimless; they saw their parents' generation work so hard to prosper, but the meaningless of life, even with material prosperity, eats away at their souls. Otaku culture captures some of the darkness of our times. I will not go into great depth about this cultural phenomenon but will touch on it to create a context for discussion.

The essential tensions in Japanese culture that Ruth Benedict notes amplify its ambivalence and ambiguity. Kenzaburo Oe acknowledged this when he titled his Nobel Prize acceptance speech "Japan, the Ambiguous and Myself." There is a mysterious dance between two extremes: the strong sense of group harmony and of individual desires. Silence is valued more than in other cultures; it is regarded as a form of respect. I've heard Japanese say that the best communication is in silence, and that in the most devoted marriage the couple rarely speak to each other. This certainly creates a problem for marriage therapy, but it is still one of the accepted views of an ideal relationship in Japan.

The beauty of the Japanese past, including its artwork, and the ambiguity and vacillation of the Japanese psyche are key topics that contextualize Endo's *Silence*. Ambiguity dwells deeply in Japanese culture and is critical in understanding Endo's faith. Of course, recognizing this does not in any way diminish the worthiness of martyrs who died by identifying themselves quite unambiguously as believers by refusing to step on

fumi-e. There are many today, all over the world, who submit to persecution willingly and at great cost for the sake of faith. But the "mud swamp" of Japanese culture remains skeptical of clarity. There is comfort in being part of a group, and the Japanese prize it. By assenting to ambiguity a Japanese person can maintain ties with many groups, because he or she does not take a stand that contradicts anyone else's beliefs or commitments. Clarity about matters of faith will make one stand out. Staking out a clear position may result in a Japanese person being ostracized—and to a Japanese that may feel more threatening than even the fate of death. Such is the mud swamp of the Japanese culture of ambiguity. In order to understand this mud swamp, then, we must probe deeper into Oe's terrain.

In his Nobel speech, Kenzaburo Oe commented,

> My observation is that after one hundred and twenty years of modernisation since the opening of the country, present-day Japan is split between two opposite poles of ambiguity. I too am living as a writer with this polarisation imprinted on me like a deep scar.
>
> This ambiguity which is so powerful and penetrating that it splits both the state and its people is evident in various ways. The modernisation of Japan has been orientated toward learning from and imitating the West. Yet Japan is situated in Asia and has firmly maintained its traditional culture. The ambiguous orientation of Japan drove the country into the position of an invader in Asia. On the other hand, the culture of modern Japan, which implied being thoroughly open to the West or at least that impeded understanding by the West [sic]. What was more, Japan was driven into isolation from other Asian countries, not only politically but also socially and culturally.[2]

Here Oe gives an indirect nod to Endo's works; "polarization" defines Endo's career and his writings. "A deep scar" is the schism that exists in Japan as an inflictor of terror and the victim of terror as well. This

polarization is what Benedict credits with creating a paradoxical deeper layer in the Japanese psyche during World War II and in the postwar years. Terror, given or received, creates deep wounds in the psyche—not only in the minds of those who committed or directly experienced atrocities, but for all citizens of that culture, in that time of terror and in the generations that follow. Oe recounts many stories of the dehumanization bound up in the demise of nationalism. Overlaid on the trauma he recounts is his personal journey with his third son, Hikari, who was born with brain damage. Oe is a writer of Ground Zero reality, navigating both the public trauma of postatomic destruction and his personal struggles with Hikari, creating a nuanced personal language filled with ambiguity. His language serves also as fierce resistance to nationalism and deep Freudian reflections of the modern psyche. His response to this "deep polarisation" is to find poetry in between the gaps of the fragmentation, and yet be unflinching in pointing out what he has called "'insanity in enthusiasm of destruction' both on its own soil and on that of the neighboring nations."[3]

Oe admires Yeats (more than Kawabata, he once admitted) and quoted from Yeats's poem "Vacillation" in his Nobel address:

A tree there is that from its topmost bough
Is half all glittering flame and half all green
Abounding foliage moistened with the dew.[4]

Here Yeats creates a natural image of ambiguity. Oe emphasizes the Japanese word *aimai*, ambiguous, to signify psychological and linguistic vacillation. It is the same type of device as Emily Dickinson's dashes, and in Yeats's allusive Irish phrasing, meaning is embedded between words. Dickinson's ambiguous dashes and hyphens were elements an editor would be tempted to remove. Oe's writing defies such editorial heavy-handedness. When he writes of aimai he is referring to the mystery of reality, a liminal zone, what the Irish speak of as "thin places."

In the mud swamp of Japan, however, the ambiguous becomes a dominant, excruciating normative reality, like the psychological realm of a bullied twelve-year-old anticipating the dreaded hours after school. As a culture Japan vacillates between the nationalism of the war days when the entire country was forced to worship the emperor, and the postwar experience of living with the memory of Hiroshima and Nagasaki and defeat. Collective memory cannot be erased by stoic postwar efforts to rebuild or by semisocialist democracy or by participation in the world economy. (For more detailed comparison of Oe's writing with Endo's, please refer to appendix two.)

KAKURE CHRISTIANS AND THE AMBIGUITY OF FAITH

In 1858 Japan and the United States signed the Harris Treaty. Its main purpose was to establish US commercial and diplomatic privileges in Japan, but it also gave Americans living in Japan the right to religious freedom. Earlier, even prior to this historic agreement, in 1831 the Paris Foreign Mission Society began the effort to reach Japan. As soon as Commodore Perry's Black Ships entered Japan, several priests entered through the south ports of Nagasaki. One was Father Bernard Petitjean (1828–1884), who oversaw the building of Oura Tenshudo (Hall of the Lord of Heaven) facing the Nishizaki Hill where the twenty-six martyrs were crucified in 1597. To Father Petitjean's surprise, a group of Japanese followed him into the church. He recounted the experience in a letter:

> At about a quarter past noon yesterday I saw a group of some 15 Japanese men and women standing in front of the gate. As I opened the church door and approached the altar, the group followed me. A woman aged 40–50 came closer to me, placing her hand on her chest and said, "All of us here have the same heart as you." "Really?" I asked

the woman, "then where are you from?" "From Urakami," said she. "All of us in Urakami have the same heart as you." And a question followed, "Where is the statue of Santa Maria?" Santa Maria! Little did I doubt on hearing this holy name. These Japanese people must be the descendants of Japanese Christians from long ago.[5]

The Kakure Kirishitan (Hidden Christians) had preserved the hidden faith of their forebears by creating an elaborate ritual of codes, which morphed into what are now somewhat indecipherable chants that sound Buddhistic, and they placed female Buddhistic deities to disguise their worship of the Virgin. When they were spied on by their neighbors or by the authorities, they could easily say they were a sect of esoteric Buddhism. In his book *In Search of Japan's Hidden Christians*, John Dougill describes their encounters after the Meiji opening of borders:

A Catholic priest had come to convert the villagers (back to Catholicism), but they refused because they didn't want to throw away three hundred years of tradition. "We are the real Christians," they thought. "We're the ones who were persecuted, endured and survived. Why should we give up?" Before us was a panel that gave three reasons for the continuation of Hidden Christians into the modern age.

1) They consider it right to preserve the tradition of their ancestors.

2) They do not want to give up the Buddhist and Shinto aspects of their faith.

3) They were afraid that to abandon their ancestors would be a sin.[6]

The obvious syncretic nature of Kakure Kirishitan places these sects as more Buddhist than Christian. But while a Christian reader's immediate response might be that members of these sects must recant their Buddhist forms to truly be part of the Christian church, we need to understand that

such *ambiguity* of faith is quite valid within Japanese culture. At the same time we also need to recognize that Christian faith is remarkable for how it remained intact and unchanged since the early church. How does one reconcile the tension between these two threads?

Historical consistency is certainly one of the unique marks of Christianity. Christians proclaim the exclusive claims of Jesus as we respond to Jesus' own words: "I am the way and the truth and the life. No one comes to the Father except through me" (John 14:6). I used to wrestle with this statement and with the forceful ways that the church asserted its assumed dominance on culture and its exclusive claims over other religions. But over time I came to realize that this exclusivity came out of the mouth of Jesus first and in the character of Jesus quite consistently. Thus, apart from the church's institutional need to preserve itself, this idea of establishing a personal relationship with Jesus is highlighted uniquely by the historic reality of Jesus. Religions come to us with sets of rules we must follow to please God; Jesus comes to us to dwell within our lives not only to show us the way, but so we will experience, perhaps for the first time, unconditional love and grace. Religions call us to join and support the institution; Jesus calls us to a liberation of hearts and minds, and invites us into a community of radical generosity, inclusion and faithfulness. The Ten Commandments and the law of God are the *result* of what happens when we have Jesus live through us. Even King David, Moses and Abraham of the Jewish heritage looked to a future when these righteous paths would be fulfilled perfectly in a person. St. Paul, a religious Pharisee who had tried to live perfectly within the law, tells us repeatedly in the epistle to the Romans that our efforts to obey the law turn into an enslavement and create a wretched condition of pride, especially if we think we are successful in pleasing God.

Culture is a complex ecosystem of often-conflicting and competing elements. God, in wisdom, provided complexity and diversity in Eden and then preserved it in the fallen world. Christianity claims that in order

for the entire diversity of confluences to bring all to thrive, we need a center that holds all things together. St. Paul, in the letter to the Colossians, states of Christ, "He is before all things, and in him all things hold together" (Colossians 1:17). Christ is that center.

In the hidden nature of the postlapsarian (fallen) world, that center may remain invisible. It requires faith to trust in the invisible rather than the visible. The true church may remain invisible to the eye, or exist beyond any institutional structures. Therefore, no matter how perfect our churches may be, no institution can claim to have all the answers. This is the paradoxical nature of Christ's exclusivity; Christ is "the way and the truth and the life," but he, as a good Shepherd, may lead his sheep to the wider pastures of his own design to push us out into a world that may be hostile to our faith. These wider pastures demand a nonexclusive relativism. Christ may indeed lead us to mystery and humility that gives away power; thus this exclusivity comes with quite a price. Christ holds the center still, and yet guides us into the storms of life.

Endo pursues this complex path. He wrote his last book, *Deep River*, as an emblem of his effort to kick-start a conversation about the wider pastures of faith, the type of faith that survives trauma, persecution and pluralism. Future generations need to move beyond survival and live in generativity. We may preserve the form of faith structure in some encoded way under severe persecution, like the Kakure Christians, but faith requires that we follow Christ beyond the sheepfold if he leads us toward a different wide-pastures framework.

ENDO AND THE GOSPEL: AMBIGUITY AND THE GOSPEL

Endo's faith was neither prototypical nor well defined, despite his intense interest in Catholic history and Catholic theology. What comes through in *Silence* and his other works is that he viewed faith as a way to affirm the ambiguity of God's working through the suffering of human existence.

In an introduction to one of the English editions of *Silence*, William Johnston of Sophia University in Tokyo notes,

> In all fairness to existing Japanese Christianity, I must add that Mr. Endo's book and his thesis have been extremely controversial in this country, and one can scarcely take his voice as that of Christian Japan. Shortly after the publication of *Silence* I myself was in Nagasaki where I found some indignation among the old Christians, who felt that Mr. Endo has been less than fair to the indomitable courage of their heroic ancestors. Criticism also came from Protestant Doshisha University where Professor Yanaibara protested vigorously that these two priests had no faith from the beginning.[7]

This comment, and especially Professor Yanaibara's protest, reflect the typical response to Endo's faith. Criticism of the faith of the character Father Rodrigues is evident here, and there also is implicit criticism of Endo's faith. Yet, according to many witnesses, Endo's faith was real to him, a center point of his creative output, and he led other intellectuals to have faith in Christ.

In reading Endo's writings about faith, especially the most illuminating *A Life of Jesus*, I must admit that I do not completely align myself to Endo's theological conclusions. His dismissal of many of the miracle stories as metaphor (or at least shrouded in mystery) rather than as actual events, and his interpretation of the New Testament Gospel of John 10—a passage I have spent quite a bit of time wrestling with—seem inadequate to me, too restrictive in their theological interpretations. I see many philosophical and theological problems with his later fascination with John Hick's "pluralistic hypothesis," which assumes a relativistic base of God's incarnation, which to me is inconsistent with God's absolute character. Nevertheless, Endo's faith was real, authentic and vital, and the expression of it that lives on in his writing continues to be so. His books unveil a vital link between trauma, hiddenness and

beauty of faith in the ambiguity and relativism—two features of post-modernism and Japanese culture.

❧ ❧ ❧

Silence is valuable not because of theological precision; it is a master-piece of literature that captures with immeasurable value the Japanese ambivalence toward faith and life. It also explores, without any senti-mentality, the aesthetic counterpoint to Japanese modern culture. This ambivalence impregnates all aspects of Japanese faith—not just Christian faith or even religious faith. What I mean by "aesthetic counterpoint" is to be contrasted with the surface cosmetic beauty typically associated with the Western concept of beauty. The Japanese aesthetic is profoundly connected to the brutal, inevitable reality of death. Kawabata defined a lyrical Japanese concept of beauty linked with hidden eros, and then Endo (as well as Oe) more deeply calibrated that aesthetic past. Endo saw that the world is brutal. Their nation's history reveals that horrific reality, and with the experience of two atomic blasts still fresh in their minds, Endo wrote out of that trauma.[8]

Endo carved a path toward the world with his precise and clear lan-guage while still deeply embedded in the Japan that Kawabata and other postwar writers saw. Here, Endo connects the suffering of the Savior with the beauty of Japan. I do not know how conscious he was of this con-nection; many of his lectures and essays only indicate an indirect con-nection. He was simply determined to succeed in writing something that communicated beyond his own culture and language. He saw human trauma, evil and suffering as the universal language. He saw Jesus of Nazareth as the ultimate mediator of such trauma. Endo was moved more by Jesus the suffering servant than by Jesus the miracle worker, and he spent the rest of his life writing to explore why.

There are powerful metaphors that extend from Endo's phrase "the mud swamp of Japan." In such muddiness, there may be quicksand, and a purely

rational approach to Christianity is bound to sink in quicksand. But
Christian faith is more than a mere rational proposition. It can take root
deeply in a muddy swamp if it is designed for propagation there, like, for
instance, planting rice in rice paddies. Faith planted in this way is not
dominated by clear distinctions between doubt and belief; it constantly
sinks and rises; it fluctuates between faith and doubt, ambiguity and clarity.
Rationality and our desire to control lead us to demand clarity and to make
quick pronouncements even in the presence of ambiguity. Overdependence
on rationality can lead to reductionism, simple decision-based faith, rather
than embracing mystery and grace with the expectation of exploring and
experiencing them throughout one's life. Even though Endo falls into a
type of postmodern faith that depends on an experience of God for vali-
dation, his writings effectively reveal a new path, a path toward a world in
which faith can rejuvenate a traumatized, orphaned culture.

In reading many interviews that Endo gave after writing *Silence*, one
also senses that Endo wanted to depict a reality that tests one's imagi-
native ability to move beyond the obvious. He considered black-and-
white judgment, especially by the religious, to be antithetical to his faith.

Some of the critics of *Silence* were of the opinion that the reason
that Ferreira and Rodrigues apostatized was due to shallow faith.

To such a comment, what I'd like to say is this; how can anyone
who has never experienced the horrific tortures of the Christian
persecution era have any right to say anything about the depth or
the shallowness of the believers then? . . . If anyone criticizes the
apostate to have shallow faith, even if that person is a Christian,
I would be most angry with their assessment. First, that person
has no imagination. It shows not the shallow faith of those who
end up apostatizing, but it reveals the lack of compassion in the
ones making such a judgment. I cannot accept the faith of those
who lack compassion. I cannot actually imagine such a person to

exist today, but if he stood in front of me, he would see me staring into his face in silence.[9]

Endo's lectures often brim with irony. This statement is a good example of such a setup in communication. He states that faith without compassion is not faith to him, and he follows up in a typically cryptic fashion with the comment, "I cannot actually imagine such a person to exist today." As with anything Endo states in lectures, it is best not to take him literally here. In jest Endo is speaking of exactly the opposite condition in which Christians are seen to rush to judgment rather than compassion and to declarative statements rather than poetry. A Christian who lacks imagination strikes Endo as a terrible ambassador of faith. He makes this criticism not because he is an artist who particularly values imagination but rather because an unimaginative perspective limits one's faith in the mystery of God. Of course, Jesus never abandons the religious authorities or the Pharisees to their own judgment, but loves in spite of their legalism. But some of the harshest words coming out of Jesus' mouth were toward the religious. Reading Endo, one may come to the conclusion that the type of faith born of strict moralism will not withstand the complex challenges of faith or the circumstances of the fallen world.

I have encountered many Christians who make black-and-white judgments about others, especially in regard to failures of faith. We have a culture of judgmental reflection within the church, the we-versus-them duality, a culture in which any violation of behavioral codes is seen to be the *only* aspect of a faith journey to be examined. If I argue that faith is much deeper and that we cannot see what God sees in a person, then I am often labeled as an antinomian (against the law) and dismissed from the discussion of what to do as leaders in the church. Leadership decisions, often disguised as "protecting the sheep," at times turn out to be uncaring judgments that do not value mystery and that lack patience with the person's ability to grow and change. This inflexibility is not just a mark

of the church but of the broader culture as well. As a consequence, artists sense the disappearance of margins, cultural estuaries where they can be allowed to explore the confluence of the ambiguous and the beautiful, and where the reality of faith is always shifting.

Hemingway used the title *A Movable Feast* to describe his Parisian exploits. Christianity is a movable feast as well, transforming how we view ourselves, our marriages, our families, our communities. Christ began his ministry at a wedding in Cana, where in his first recorded miracle he turned water into wine. The Bible begins at a garden and ends in a feast. Thus, a theological map should explore these celebrations as the beginning and ending points of faith. But typically, religious communities are marked by somber legalism, and they avoid the complex nuance of extraordinary wine or art. A complex work of art that may lead to a deeper reflection on human experience and complexity, a work of art such as *Silence*, will be deemed suspect in such a setting, as its ambiguity strikes many Christians I know as something to be avoided. They might say, "I do not want to have anything to do with failures of faith," or "To doubt God is to sin." Endo exposes the flaw in this thinking. It does not express faith in God but instead a faith in clarity and, as one of my friends puts it, "our lust for certainty." Faith can be rational, but only after a deeper journey toward mystery and transcendence.

Endo connected faith with compassion, imagination and nurture. Compassion can be made available to those willing to wade into the uncertain, muddy territory of the human heart. To nurture is to have a mother's heart for those we love. Imagination guides us beyond the cruel reality of brokenness. Yet Endo was aware that Western Christianity often fails to communicate these biblical principles. God is often portrayed as an angry disciplinarian, an aloof father figure forcing his children to submit without using their imaginations. This was especially potent in postwar Japanese society, in which many were orphaned by the war, or—as in Endo's case—grew up without a father as a consequence of divorce.

He struggled with his relationship with his father until late in his father's life, at which point Endo began the effort to forgive his father for leaving his mother. But at any point in his career, Endo termed the "masculine religion of Western Christianity" as especially distant and uncaring.

ENDO AND LEVITY

Endo placed high value on levity and would have called even these comments about his faith *majime sugiru*, "too serious" (a comment that can alienate the religious even further). Growing up he failed to keep up academically, and as a young adult he never integrated into "serious" academia, though he certainly showed the intellectual acumen. When he called himself a *rakudai-bozu*, a boy who failed out of school, that expression conveyed an air of playfulness. He even wrote a humorous personal resume of himself as a rakudai-bozu and based an essay on it. He felt that faith in the mid-1900s had been hijacked by dead seriousness, imperialism and male-dominated black-and-white thinking; he advocated for more playful freedom in the church and nurturing believers to understand the "female" side of God. Later in his life he created a second identity, naming himself *Ko-ri-an*, producing theater productions, appearing on TV as a jester-like writer, and writing comedy. His ambition was always in check, and his levity was an essential value.

To Endo faith was part of his journey toward understanding and reconciling himself and his own experience to Japanese culture. It was a given to him, as a Japanese, that failure, betrayal and falling short would be a significant part of that journey of faith. *Silence* is not a levity-filled book, as his later *A Wonderful Fool* would be. Perhaps in moving into the mystery of his faith, he discovered levity: it became his way to integrate all of himself into faith and culture. Levity allowed his faith to exist side by side with his ambitious writer's goal, as a bridge between humility of his religion and his writing as a form of resistance to trauma. Levity would also allow doubt to coexist with his faith.

Endo, like T. S. Eliot and so many postwar writers, introspected over
the tensions of faith, paradox and the mystery of suffering. They desired
to move beyond what Endo termed the "two dimensional" understanding
of life into the "three dimensional." He wrote, "If life is transparent, and
predetermined from the first, I would not be interested in exploring that
(in my writings). I find value in living by giving meaning to contradictions,
mysteries and sufferings."[10] Christian culture, and Protestant culture in
particular, tends to turn away from contradictions of faith; ambivalence
is seen as lack of faith. People in such circles often quote from the New
Testament book of James: "When you ask, you must believe and not
doubt, because the one who doubts is like a wave of the sea, blown and
tossed by the wind" (James 1:6).

The typical Christian interpretation of such a verse creates a dichotomy:
faith against doubt. Dichotomy is easier to manage than regarding doubt
as an important part of our faith in God. It is true that to believe we must
commit to that foundation of faith; to waver or to doubt is to be shaken
by forces blowing against such a foundation. But James is speaking
against the resulting condition, what two verses later James calls
"double-mindedness"—vacillation between life based on faith and life
based on other principles. True faith differs from the blind faith of one
who professes faith without examining the details of the object of faith,
and true faith differs from the subjective faith of one who bases faith
only on subjective experiences. Faith and levity are both rational and
intuitive, and therefore require deeper reflection.

ᐤ ᐤ ᐤ

Endo, in an interview late in life, spoke of his son taking an exam in
which Endo's writing was used as a sample to test the student's ability to
comprehend literature. The multiple-choice test offered four possible in-
terpretations of a paragraph from one of Endo's books. "I circled all of the
interpretations," Endo noted, "and I would have failed the test."[11]

This anecdote serves well to capture Endo's personality. But it does more. Endo, in his humorous fashion, challenged the typical two-dimensional dichotomies we create: faith versus doubt, good versus evil and so on. The *interpretation* of any knowledge may have many paths. This type of flexibility is different from anything-goes ecumenism; it is a way of sharing a journey that faces human suffering head-on with multiple interpretive lenses. While Oe describes such a prismatic lens as a form of distortion or even of illness, I see Endo's prism as heightened awareness of reality. Endo is at once complex and innocent; he looks at trauma-filled reality as if through a kaleidoscope, and finds a prismatic image. It is no coincidence that he titled a series of his newspaper essays *Mangekyou* (*Kaleidoscope*).

Certainty of faith means trust, and trust means entrusting one's future to God. At the same time there is a type of doubt that presupposes a trust in God as well. Thus, rather than having faith in faith itself, as a point of certainty that relies on our volition only, true faith is a childlike trust in God, who allows his children to question him as they might question their earthly parent, and to do so in the certainty of the relational knowledge and trust of the Father. I propose this kind of doubt was Endo's experience. Endo's kaleidoscopic faith allowed for both complexity and simplicity, chaos revealing true beauty. As an alternative to a world full of dichotomies, he wished to create a third path, moving away from black and white to full resonant color.

Doubt is not the opposite of faith but only an honest admission of our true condition, wrestling against the fallen world in which God seems to be silent. Doubt and secrets, to Endo, reveal a God who works within the dark crevices of our experiences, who is constantly *hataraku Kami* (active and moving God). Indeed, when we examine the lives of the disciples of Christ, we find failures of faith, like Peter's denial of Christ or Paul's (Saul's) persecution of early Christians, people of "the Way." These failures are markers of growth toward repentance and leadership. One cannot

experience the true Easter experience of the miraculous without first spending time in the dark, struggling for faith on Good Friday and Holy Saturday, when faith is, for most, found wanting. The Easter miracle is not to be reduced to a rational, reductionistic faith.

ENDO'S COMPASSION

As I've journeyed with Endo the last few years, I have been constantly challenged by these embedded clues, but as I journey beyond them I find my faith and my art to have grown as a result. Such is the way that Endo saw his journey with those he mentored. Muneya Kato, who wrote one of the definitive biographies of Endo, recalls an evening when he was returning from a dinner party in the same car as Endo. Endo asked the driver to stop the car in front of a hospital; stepping out, he asked his companions to wait in the car. For five minutes he stood in front of the hospital, pondering the lights in the windows of the building. "I do not know what he was doing, or why he did it," Kato says, "but it's an image I never forget of him."

In understanding Endo, it is also best to say, "I do not know what he was doing, or why he did it." Perhaps that mysterious five minutes was itself a clue, a parable set up for us to ponder, a generative starting point in understanding Endo.

I imagine Endo, reflecting on his journey of illness, conjoining his own journey with those who were struggling in those rooms. Endo saw trauma as an entry point of his own journey, as T. S. Eliot did in writing his postwar masterpiece *The Wasteland*. The section of *The Wasteland* that starts with "April is the cruelest month" is subtitled "The Burial of the Dead." Endo's "burial of the dead" was not just a response to the recent trauma of the war dead and of domes and churches melted down in an atomic blast; he also was remembering the burial, finally, of the martyrs of the seventeenth century, whose ashes were cast out into the ocean, for the authorities were well aware of the power of relics of the martyrs. These

"compound ghosts" (Eliot, *Four Quartets*) will come back to haunt us—or bless us. In the Catholic imagination, saints of the past are just as alive to them as are those present in body. The magistrates of Japan realized, as the bodies of the first twenty-six martyrs were carried by believers into Macao, that the physical remains of martyrs can become a powerful witness as relics, creating more interest and fervor of faith. The magistrates succeeded in squelching the fervor by "poisoning the roots" (Inoue) of Christian faith by forcing priests and leaders to recant. For Endo "memory and desire" stirred up the weak "dull roots" of Christian faith in Japan. He found himself having particular empathy with the dull roots, those whose voices cannot be heard, and with those who continue to suffer. Consequently, Endo transcends Japanese ambiguity and the Japanese propensity to stoically surrender to fatalism.

SEEING IN BETWEEN

The Japanese word *kaimamiru* flows out of the art of garden design.[12] It means, literally, to "see between." If stalks of bamboos are set up as a fence, what is most desirable is that the fence and garden be built so that the most beautiful and intriguing experience comes from seeing in between. Oe's "opposite poles of ambiguity" may be fenceposts through which Endo peeked in writing *Silence*. Kaimamiru unites Oe, Kawabata and Endo.

Endo noted, "A novelist cannot write about what is holy. . . . He cannot depict the holy Christ, but he can write about Jesus through the eyes of the sort of people who stepped on the fumi-e, or the eyes of his disciples and others who betrayed the Christ."[13]

Such ambiguity may trouble Christians who want their faith to create clarity about how they should judge the world. Much of the criticism of Endo, O'Connor and even of Eliot has come from those who see their work as dealing with evil, suffering and the unholiness of fallen humanity. Christians often consider works of art, especially art created by those who

profess to be part of the church, to be "Christian," a label that designates a certain isolated existence. It's important to note here that professing Christian faith and having great worth as a human being does not necessarily mean that one can make great art. Often those with less than pious lives create great art—as in the case of Mozart. While Endo's faith can be debated, it is ultimately not important to how we may behold his works of art now.

Through the windows of a hospital, a novelist saw through the eyes of fallen humanity; can a novel about the failures of faith be edifying to Christians and to others? When does an artist cross the line between depicting fallenness, or even depicting evil, and actually participating in the dilution of faith? Is this ambiguity essential for religious clarity? Given the extent to which my encounter with fumi-e and my subsequent encounter with *Silence* have been fuel for my faith and my journey as an artist, I disagree with Endo's statement. I believe that all art responds to what is holy. What Endo was responding to was Christians' tendency to pretend that they are untouched by the corruption of the world, as opposed to art's and religion's true calling. Endo saw through (kaima-miru) the windows of modern struggles and stopped to ponder and empathize with those behind the windows. That was a holy act.

Poet Dana Gioia, a former chair of the National Endowment for the Arts, makes a similar point about Flannery O'Connor and other Catholic writers:

> [O'Connor] does not believe that faith alone justifies an artist. The writer needs good works—good literary ones. The goal of the serious Catholic writer is the same as that of all real writers—to create powerful, expressive, memorable works of art. As Flannery O'Connor observed, "The Catholic novelist doesn't have to be a saint; he doesn't even have to be a Catholic; he does, unfortunately, have to be a novelist."[14]

Religion can be seen to separate what is holy from what is "earthly." Endo, in this sense, may be playing with the false dichotomy created by the public perception of Christianity. When the prophet Isaiah declares "Holy, Holy, Holy, is the Lord Almighty; the whole earth is full of his glory" (Isaiah 6:3), the prophet is calling beyond the dichotomy we create of heaven versus earth; he speaks of the presence of the divine in every inch of the earth. Our failure is not that we chose earth over heaven: it is that we fail to see the divine in the earth, already active and working, pouring forth grace and spilling glory into our lives.

Artists, whether they are professed believers or not, tap into this grace and glory. There is a "terrible beauty" operating throughout creation. If Christ announced his postresurrection reality into the darkness, even into hell, as the Bible and Christian catechism suggest, then, as theologian Abraham Kuyper put it, there is not one inch of earth that Christ does not call "Mine!"

ENDO'S REQUIEM

Endo quotes Isaiah frequently in his memoirs and writings. The book of Isaiah was written in the eighth century BC, during the exile of the nation of Israel in Babylon. It speaks of confusion, loss of identity, the trauma of captivity. And yet Isaiah is the Old Testament book that Jesus of Nazareth quoted the most and actually started his ministry with as he introduced himself in a synagogue by reading from a scroll from Isaiah 61:1-2. (Jesus was an observant Jew, and followed the customs of his religious heritage.)

The Spirit of the Lord God is upon me,
Because the Lord has anointed me
To bring good news to the afflicted;
He has sent me to bind up the brokenhearted,
To proclaim liberty to captives
And freedom to prisoners;
To proclaim the favorable year of the Lord. (NASB)

This Isaiah text connects the Spirit with the work of bringing the good news to the afflicted and brokenhearted, and the work of providing liberty for captives and freedom to prisoners. There is a banquet promised to "all peoples." Christ spoke of these verses and stated that he himself is the fulfillment of these words spoken by the prophet (see Luke 4:17-21). The authorities of the time considered his claims to be blasphemy, and Christ's journey into the heart of the conflict began. To Endo this suffering Servant who brings hope into the darkness and conflict was the true deliverer. The gospel of Jesus can liberate the Japanese to find their own voice and culture, to be healed from their wounds. After all, Christ's suffering and his sacrifice are directed at what Oe called a "polarization imprinted on me like a deep scar." Endo's brilliance was to identify such a scar on a smooth, worn-out fumi-e plate, thereby bridging these "opposite poles of ambiguity."

The worn smooth surface of fumi-e also doubles, for Endo, as a type of requiem. Don E. Saliers, in an essay titled "Beauty and Terror," writes of Benjamin Britten's *War Requiem*:

> In Britten's art, texts of terror are musically articulated in ways that go beyond what language itself can hold. The silence acknowledges the unspeakable, both denying and permitting access to certain elemental facts of human experience of war. Yet I am drawn to hear this musical work again.[15]

Endo's work may be the literary equivalent of a musical requiem. In his writing, "the silence acknowledges the unspeakable" and merges with the terrors of our times.

- 4 -

GROUND ZERO

I woke up on September 11, 2001, in my loft only three blocks from where the World Trade Center towers stood. That fateful morning I began the journey of the unexpected, a journey that resulted in spending the next decade as a Ground Zero resident, and my children growing up as Ground Zero children. After hearing of the "accident" at the Twin Towers at an artists' prayer meeting on the Upper West Side, I rode the subway home. When the train stopped at Chambers Station, I later surmised, was when the first tower collapsed, sending that incendiary ash and smoke right up Chamber Street, exploding cars. One of the engines fell on Murray Street, where we lived, almost killing a pedestrian. My train backtracked for forty-five minutes to 14th Street Station, and by the time I got out, the towers were gone. I had no idea what happened—all I could see was smoke, and I knew that my wife was at home, and my children were attending public schools surrounding the towers. It was only when I arrived at my studio below Canal Street, ten blocks north of the towers' remains, that I heard my wife's message on the phone that she had evacuated and the children were okay. I have written elsewhere

about the details of that 9/11 experience (and it is painful, still, for me to discuss it), but the ensuing ten years were years of recovery from the trauma of that day.

I have come to call this posttraumatic experience "Ground Zero reality." My art turned to lament for a decade afterwards as I wrestled with that day's images of flames and destruction. *Silence* is an artistic expression that moves us into the darkness of our Ground Zero conditions, as much as the *Four Quartets* of T. S. Eliot or the musical *Quartets for the End of Time* by Olivier Messiaen. Human depravity and evil haunt us, universally, and Ground Zero conditions expand every day. Life has become a journey of peering through the darkness, chaos and confusion of our time. But with faith it also is a journey that looks toward the future and a journey of grace.

I have struggled with the term *Ground Zero*. As a Japanese American I am hyperconscious that the devastation that took place on 9/11 was not even close to the meltdown at the true Ground Zero of Hiroshima and Nagasaki. In the months that followed the World Trade Center catastrophe I visited Hiroshima with my thirteen-year-old eldest son, and visited Nagasaki with friends. As a resident of New York's Ground Zero I wanted to pay tribute to these sites and to try to comprehend my role as we tried to recover our emotional equilibrium. It occurred to me during these trips that Ground Zero can be a starting point, as much as it is the designation of devastation. Ground Zero conditions can arise from a unique conflation, a complex matrix, of ethnic, religious and ideological tensions, triggering massive upheaval and a shift in public consciousness. Ground Zero may be defined as a symbolic center of a shift in awareness, not limited to nuclear devastation.

Looking back, that trip I made with my son may seem like the worst thing for a parent to do in the wake of trauma. Why would one want to see a greater trauma after you have experienced one? Endo's *Silence* and other novels echo this approach. What I experienced with my son was an unforgettable searing of our minds and hearts with a greater trauma than

what we were going through. I thought about my grandfather on my mother's side, who worked for the education department of the Japanese government and was one of the few sent to observe the postatomic Hiroshima only a week after the devastation. According to my mother, he could never speak of the experience.

I visited Nagasaki, another Ground Zero, with friends later in 2002. Moving so quickly between the Ground Zero of lower Manhattan and the Ground Zero of Nagasaki gave me a keen sense of the difference in the feel of these two true Ground Zeros. Ultimately I explored this in a series of paintings. The overlap between the Ground Zero reality and the history of persecution of Christians must have became part of Endo's encounter with fumi-e, merging together in his intuition. I also speculate that he had a more than casual reason for depicting Nagasaki as the backdrop to his drama. To Endo the journey of recovery from trauma—whether that of the Great Wars, the experience of being bullied by his own countrymen, the experience of being discriminated against abroad or even his own failures (which he describes as "stepping on his own fumi-e")—is best accomplished by identifying a greater trauma and entering into that darkness, while also being bathed in prayer and forgiveness.

There are visible and invisible Ground Zero conditions. There are private Ground Zeros. The systematic, slow, cruel death of tortured Christians that Endo describes in *Silence* may leave less visible scars in the psyches of culture than the well-known cataclysmic Ground Zeros. But one thing is certain: Ground Zeros as personal and public realities are now expanding all over the world. Japan has always faced natural disasters such as earthquakes and tsunamis, but the earthquake, tsunami and Fukushima Daichi nuclear disaster of March 11, 2011, drove the nation into a new reality of despair and fear. It is telling that the Japanese refer to this event as 3/11. The disaster introduced a new reality: contamination of the entire island. How will the Japanese face the prolonged suffering and

torture of their own land, the ubiquity of the Ground Zero of Fukushima and, in particular, the irreversible damage to nuclear plants in Fukushima allowed by their own hands? How do our own betrayal and violation of the ethics and aesthetics of our own culture result in such prolonged psychological darkness?

THE SILENCE OF GOD

I came home in November 2001 to my loft on Murray Street. It was the first time my children entered our home since we fled on 9/11. My family made it our goal to return to our loft by Thanksgiving. At the nearby site of the collapsed Twin Towers smoke still rose like incense, and workers were still discovering body parts. Part of Tower One, fragmented and tilted, still glistened in the morning sun and stood as a monolith, a reminder of the one of the darkest chapters in New York history.

I thought of the silence of God.

The vacant space where the towers used to stand felt like a gash, a wound in an open blue sky. American flags were waving all about. I allowed my heart to ask the question, *Where is God?*

On the one hand, my answer to my own question is that God is everywhere. I might remind myself: Remember that God spared your family, many of your friends, the parents of our children's friends. God is here now, in the thousands of volunteers coming in to help and in the many loved ones and friends calling to encourage and to pray. But facing Ground Zero it was as if doubt had captured all the faith that was left in my heart and punctured it. Of course, with the marathon that my wife and I and friends and colleagues had been running—to recover, to protect our children, to make their lives as normal as possible, to figure out how to provide for them—what adrenaline I had post-9/11 had begun to wane. It may seem odd that two months passed before I could ask the question, but this is not unusual. People experiencing trauma often do not dare to ask, because we know no answer will come back, only silence.

Where is and where was God?

Philosopher and theologian David Bentley Hart wrote after the devastating Indian Ocean tsunami that devastated Indonesia and other nations in 2004,

> I do not believe we Christians are obliged "or even allowed" to look upon the devastation visited upon the coasts of the Indian Ocean and to console ourselves with vacuous cant about the mysterious course taken by God's goodness in this world, or to assure others that some ultimate meaning or purpose resides in so much misery. Ours is, after all, a religion of salvation; our faith is in a God who has come to rescue His creation from the absurdity of sin and the emptiness of death, and so we are permitted to hate these things with a perfect hatred. For while Christ takes the suffering of his creatures up into his own, it is not because he or they had need of suffering, but because he would not abandon his creatures to the grave. And while we know that the victory over evil and death has been won, we know also that it is a victory yet to come, and that creation therefore, as Paul says, groans in expectation of the glory that will one day be revealed. Until then, the world remains a place of struggle between light and darkness, truth and falsehood, life and death; and, in such a world, our portion is charity.[1]

Some have said that these calamities are a judgment of God. We have not done enough to appease *our god* to contain the devastation; we need to bring offerings to prevent another such disaster. Christian leaders spoke of the judgment of God after the AIDS crisis broke out in San Francisco. After 9/11 some Christian leaders spoke of "lessons that God is trying to teach us" through tragedies.

It is tempting to create a cause-and-effect analysis, playing the role of diviner to "understand" calamity. However, as Hart notes, any simple view of the complex reality of an upheaval is bound to be reductionistic and

unhelpful. To try to diagnose an individual's deep suffering and give advice, even if such advice may be theologically or sociologically sound, is in itself an attempt to explain away the suffering as unnecessary. During the great suffering of the American Civil War, Abraham Lincoln often quoted the book of Job. In that Old Testament book Job suffers, and his good friends try to help him with sage advice about why he is suffering. They want to explain away the suffering so that they will not experience the same fate. God reprimands them. During the months after 9/11 all efforts, psychological and physical, were focused on rebuilding. What if Ground Zero cannot be solved? What if some Ground Zeros are permanently broken and irreducible?

My grandfather, Junichi Sugai, was a Protestant Christian involved in the *mukyokai* (literally, "no church") movement established by Kanzo Uchimura composed of small groups of Bible studies. But my grandfather struggled in his faith after what he saw at Hiroshima. He could never talk about it. He kept that trauma behind his gentle countenance; it was not to be exposed in the life he wanted to give to his children and his grandchildren. He must have stood in the same juncture facing his Ground Zero as I have since 2001. It occurs to me that such an experience may be universal. We live in a world full of trauma, a world full of Ground Zeros.

The wrestling with God that is depicted in *Silence* overlaps with the question of suffering (what theologians call theodicy), whether we are standing on the ashes of Ground Zero in Hiroshima or in New York City, or reading of the lives of tortured Portuguese missionaries in seventeenth-century Japan.

My grandfather gave my mother a *shiki-shi* (a square mounted paper) with calligraphy before her journey to the United States (from which she would not return until after his death). This biblical verse was written on the shiki-shi: "I consider our present sufferings are not worth comparing with the glory that will be revealed in us" (Romans 8:18).

Romans 7–8 became for me, as for my grandfather, a refuge, a safe harbor to which the wind blew our faith vessels. Romans 7 speaks of our "wretchedness," as Paul confesses he has failed to keep up with his own expectations of goodness, let alone God's expectations. He states, "What I want to do I do not do, but what I hate I do" (Romans 7:15). In our fallen condition, even if we meditate on the good laws of God—for instance to not covet—we develop covetous desires. Thus, what the Bible terms *sin* is not just ignoring God's laws but desiring to do the opposite. (The Greek word we translate as sin means, literally, "being off the mark.") Paul exclaims in Romans 7:24: "What a wretched man I am! Who will rescue me from this body that is subject to death?"

Who will rescue me from this body of death? This genuine cry expresses our Ground Zero realities. It is a cry not made against terrorists or magistrates, but *toward* a realization of the inner darkness operating in us. Such is the cry of Father Rodrigues at the end of *Silence*. We will come back to this theme, and these particular Bible verses, as we consider the good news, the antidote to our Ground Zero conditions.

<p style="text-align:center">❧ ❧ ❧</p>

After I wrote my post-9/11 book, *Refractions: A Journey of Faith, Art and Culture*, a reader wrote that he used to struggle with the metaphor of Christians as a mirror of God's light, able to cast God's light into the world. "What if my mirror is broken, shattered to pieces?" he asked. But having read the book, he continued, "I now understand that God can still use the shattered, broken mirror; now I can refract God's light."

Japan, in that sense, is the broken, shattered remains of a mirror. In the Shinto religion the mirror serves as one of the physical objects of contemplation, one of the three sacred objects. Therefore, the mirror cannot be broken or rendered useless. Endo reveals that Japan is a broken mirror. Paradoxically, it is the *broken* body of Christ that turns the useless into the permanent, transforming the broken into the enduring new reality.

Christ's resurrected body still holds the wounds of the suffering at Calvary. Japan can be one of the keys to unlock this mystery of the wound, of the shattered mirror. Just like the surface of my paintings, Japanese culture can become the avenue that leads to greater insight about how we may live beyond our Ground Zero conditions.

WRESTLING WITH BEAUTY

I knew from very early on that I was called to be an artist. When I drew something or worked to make a work of art or a creative endeavor of any kind, I felt something flow through me; this *something* was not my own. Even before I came to have personal faith in Christ, I used the word *calling* to describe my artistic inclinations. Art was a gift given to me by *someone*. I was resigned to admit, though, that this something could be known or named.

Judy and I got married at a small Catholic church in South Jersey in 1983. Having no faith background to speak of, I simply wanted to honor her wishes in getting married in the church; she grew up in the church, and her uncle was a priest. I found Catholicism to be valuable as the dogma of faith, a code of behavior and moral identity. I did not fully agree with many of the tenets but felt such a path was worthy of consideration nevertheless.

After attending middle school and high school in New Jersey, I attended Bucknell University, where Judy and I met. At Bucknell I explored literature, animal behavior studies (their monkey lab was next to the art barn studios), and evolutionary biology and ecology. It was then that I found myself fascinated by William Blake, the poet and an innovative engraver of the nineteenth century, who painted, designed and printed his own illuminated books. The professor who taught classes on William Blake was also a renowned lecturer in Shakespeare and also taught a class called "The Bible and Literature." I took (or audited) every class he offered.

In *Jerusalem*, the last epic poem Blake wrote, he synthesized his

faith inquiries. I consider the last few chapters of *Jerusalem* to be one of the greatest literary summaries of the gospel of Jesus Christ. I describe my journey in my first book, *River Grace*, and here's a brief excerpt from the book that recounts my journey of faith that began at Bucknell but was clarified in Japan during my years as a graduate student studying nihonga tradition:

> How do you love your spouse, if your most important priority is Art? Is your partner in life an impediment to your goals and career? My wife began to answer these questions on her own and started to attend church in Tokyo. I reluctantly accompanied her at first. Being highly suspicious of any institution, I saw the church as irrelevant at best. I remember, growing up in New Jersey, passing by a nearby church one Sunday morning. I noticed two drivers, driving out of the church parking lot yelling at each other. This was the supreme hypocrisy; one moment pious, the next just as worldly as anyone else. This was the church to me. But missionaries that I befriended at my wife's church intrigued me.
>
> They had similar backgrounds to my own, had graduated from well-known universities, and could have had successful careers in their fields, but they opted to be missionaries instead. I could read into their eyes the commitment and zeal they possessed; they were convinced of the reality of Christ. They were serious but enjoyed life at the same time. I thought being an artist gave me an internal discipline I sought, but my art could not make me a loving husband. The more internal discipline I sought, the less I could possess an outward love. But my missionary friends had both internal discipline and love. They also possessed refreshing candor about their failures. They found enjoyment in life through the freedom of their relationship with Christ. Their engagement to the person of Jesus Christ gave them fullness in their being.

But coming home from church, to Futako-Tamagawaen (Twin-Rivers) station, I told my wife that I could not possibly become a Christian. Though the experience of going to the church had intrigued me, I told her, there were too many issues on which I strongly disagreed with the Bible. Of course, the idea of judgment incensed me. I refuse to believe in a God, I said to her, who willingly put people in hell. Two weeks later, on a cold February day, in a small apartment in Futako-Tamagawaen, I read through the last epic poem of William Blake. Looking back, I was, in my own way, searching to see what this Christ of history was all about. By the end of the 120-page poem I found myself responding to Christ and his message. My allegiance shifted from Art to Christ. It took me a year to realize that what had happened that day was a conversion experience. Albion, one of Blake's Emanations, is a symbol of all searching humanity. *"Our brother Albion is sick to death . . . he hath studied the arts of unbelief"* (Chapter 2:14), stated the Valley, Hill and River. I was prone to exercise the "arts of unbelief" against my wife and my Christian friends. They always responded patiently to my criticism of the hypocrisy of the church. I had considered the Bible to be a creation of human ideals. I did not see that it was still relevant in this atomic age. *"Have you looked, really looked at Christ? Do you know what he said?"* my friends at church asked. So I journeyed with Albion to the end of the epic poem, where at the foot of Christ on the cross of Calvary, with his arms outstretched to reflect Christ's, Albion heard Jesus say:

Wouldest thou love one who never died
For thee, or ever die for one who had not died for thee?
And if God dieth not for Man & giveth not himself
Eternally for Man, Man could not exist; for Man is Love
As God is Love; every kindness to another is a little Death

In the Divine Image, nor can Man exist but by Brotherhood.
(*Jerusalem*, Chapter 4, plate 96:23–29)

These words caught me off guard. An eighteenth century Romantic
poet and artist captured with eloquence and clarity, exactly the
same message the twentieth century missionaries proclaimed at
my church. Christ is the bridge, a gift, spanning the chasm created
by our prideful hearts. We can only love if we are shown love; we
can only die for another if another has died for us. To love is to die.
And Christ's death on the cross demands the definition of love to
be nothing less than this. This connection, an agreement of pro-
found significance that spanned the centuries, penetrated my heart.
In order to love my wife, I had to be willing to die. But even more,
I had been dying for the wrong reasons. I knew Art had been my
treasure, the center of my life and my identity. I thought Art to be
my bridge to others and God. But this bridge, if not given the right
perspective, could result in a distorted view of ourselves and God.[2]

When I wrote these words in the early 1990s, I could not envision that
my faith journey would thrust me into what is now a substantial faith-
and-art movement in America. Like Endo struggling to find his faith
consistent with his Japanese culture, I struggled to find a proper way to
understand and articulate my faith in the art world of New York City as
a Japanese American. As I look back, though, my journey has always been
centrally about the nature of Japanese beauty. Creating from that source
is central to my being today, and even as a writer I find my core in the
studio, working with nihonga materials.

As a graduate student I wrestled with my identity and faith, and
with the visceral beauty that I was creating. An assistant professor
walked into my studio one day unannounced. He stared at the surface
of a landscape I just painted and said, "that surface is so beautiful, it is
terrifying." And left.

I then deeply wrestled with what he had said. I did not mean to create "beauty," even this "terrifying beauty," but my hands were creating it. At the time, I did not know what to do with beauty and did not have a shelf in my own heart to place that beauty on.

So, after my professor left, I washed the painting down. I destroyed this beauty because I simply did not have a framework in my aesthetics to welcome it into my art, or my life. In small but significant ways, I began to feel my personal Ground Zero zone expanding in my heart.

I was simply being honest with myself. At that time, in the late 1980s, beauty was suspect in the art world; it was seen as a remnant of the imperialistic past and associated with cosmetic, superficial images in Madison Avenue advertisements. Artists preferred darkness, cynicism and satire. But the pulverized mineral pigments were drawing me into another realm—of beauty that is indeed terrifying. One of the reasons why Endo (and O'Connor) described the world in a series of stark, violent imageries is this suspicion toward beauty prevalent in modern times. But, at the same time, Endo moves beyond them into the beauty of hiddenness.

The "greater sacrifice" that the philosopher Tomonobu ponders is linked to beauty too. Endo would add that this "greater sacrifice" is hidden in Japanese culture. When I saw Christ's work on the cross through William Blake's poem, I saw this greater sacrifice of love lifted up. This 美, the "greater sacrifice," is the antidote for the culture of Japan, which after 250 years of persecution has become a fumi-e culture.

FUMI-E CULTURE

If the word has the potency to revive and make us free,
it has also the power to blind, imprison, and destroy.

Ralph Ellison

The smooth worn surface of fumi-e is a mirror reflecting the Japanese soul and culture, and at the same time the trauma of Japan's past. Years of stamping out faith has left inevitable imprints, albeit mostly invisible ones. Endo saw fumi-e as emblems of a greater, universal impact. When in lectures he spoke of "having a personal fumi-e," he was not speaking of a literal religious icon but was acknowledging that each of us steps on and betrays the "face of ones that [we] love, even the ideals [we] cherish."[1] To step on one's own fumi-e, in that sense, is to betray oneself out of desperation due to public or cultural pressure. In *The Golden Country*, the play that Endo wrote as a companion piece to *Silence*, there is a scene in which a female Christian protagonist tells her lover to step on *her*, rather than on the fumi-e, to show his devotion to the imperial authorities. Endo found

in fumi-e a metaphor for our betrayal of the people we love. He observed the ways dictatorial coercion continued to manifest itself in postwar Japan and abroad, but he was keen to point out as well his own failures to those close to him. These allusive confessions reveal a man who felt deeply his own fumi-e, who was troubled to realize in retrospect that he had stepped on his own mother, on his Parisian first girlfriend Françoise, on his friends. Fumi-e, then, constitute a portal through which Endo saw the wretchedness of the human condition; through *Silence*, his personal reality became a universal phenomenon.

The muddy swamp of Japan gave birth to fumi-e culture, a culture that forces individuals to suppress their most treasured identity. Fumi-e culture, as a unique, attenuated crucible of trauma, slowly seeped deep beneath the surface of society over 250 years. Tokugawa magistrates created local accountability groups to enforce the edict that banned Christianity, assigning five neighbors at a time to watch others in their neighborhood to find out whether any were practicing Christianity. These local reporting units were called *gonin-gumi* (band of five), and their vigilant monitoring was used by the dictatorial powers to insure that the Christian faith did not spread. Gonin-gumi were designed to ferret out hidden sects of crypto-Christians, but ironically, their activities eventually led to the phenomenon of Kakure Kirishitan, which served as their own hidden unit.

Imagine a culture in which your neighbors are by law forced to spy on your personal life. Surely, there are other cultures in history in which this type of oppression has occurred, but in Japan this type of coercion remains strong a century after the ban has been lifted. Group solidarity and harmony have long been central values in Japanese culture, and strategies to protect that harmony are woven into the fabric of society. For hundreds of years the Japanese have internalized a cultural reality called *mura-hachibu* (literally, "village of 80 percent"), which means that a person or a family can be ostracized by the community for disturbing its

wa, its harmony—but that exclusion is only 80 percent, meaning that the ostracized person or family will be accepted as part of the community when the village comes together for events beyond day-to-day life, such as a funeral or a fire. The Japanese emphasis on group solidarity allowed government-imposed monitoring to be profoundly effective.

The Japanese long ago developed a refined cultural language and a polite and honorific code of conduct. On the other hand, any sort of individual voice that may disrupt group solidarity will be banished from public conversation; as a Japanese adage puts it, "the nail that sticks out will be hammered down." There is intense social pressure to conform, regardless of one's faith or philosophical perspective. Remaining silent, being stoic and being good at hiding one's true feelings and thoughts have become the accepted ways to deal with trauma and fear. Therefore, when Endo writes about fumi-e he is not just pointing to the historical reality of Christian persecution in Japan; he also is revealing a deeper issue of Japanese culture having become what I deem to be a fumi-e culture, a culture of groupthink, a culture that bullies those who do not fit in. Instead of religious faith, such a culture insists that group adherence is of highest value, and it builds a code of ethics on that premise. Fumi-e culture rejects not only Christianity but individual thinking as well.

Endo describes, through his characters, the psychological trauma of what all Japanese faced in varying degrees during the Tokugawa era. In *Silence* the magistrate and the translator argue that stepping on a fumi-e is just a "formality." Yet, that very statement in itself coerces the individual to abandon his or her most important values. It is an invitation to live a two-faced life, keeping what is true on the inside, but acting in the opposite way to accommodate to the culture. It creates a culture of vacillation, which Oe identifies so well in his writings as a critical core of the Japanese culture of ambiguity.

The Tokugawa persecution not only removed Christians from Japanese society; it shackled free thinking in general in Japan. The Japanese,

perhaps uniquely among oppressed cultures, developed a type of dependency on dictatorial power and accepted the narrative of homogeneity of culture. In wiping out Christianity and persecuting free thinkers like Sen no Rikyu, Japan lost its prophetic voices and the possibility of future change. The isolationist era bred passive acceptance of institutionalized authority. At the same time, Japanese culture refined its deep expression of beauty and ambiguity. This unique combination is what I deem to be fumi-e culture: on the one hand, dependency expressed as stoic resignation, but at the same time the birthing of a highly refined visual communication code that moves deep beneath the surface of social reality.

Over time, this duality of Japan's cultural character infused the Japanese language with ambiguity and further cultivated its lyricism. That the Japanese language is notoriously difficult to translate can be attributed in part to a literary tradition that is intentionally vague. When dictatorial forces in Japan expunged Christianity, this orphaned the hearts of individual freedom and gave birth to a culture of hiddenness; Japanese groupism reinforced such dependency. Fumi-e culture is an orphaned culture full of hidden truths, ambiguity and, at the same time, lyricism.

THE ANATOMY OF DEPENDENCE

Psychiatrist Takeo Doi has offered a helpful analysis of the Japanese psyche that explores various dimensions of the concept of *amae* (dependence) as a key element. Amae can be understood as a form of childlike dependency, and Doi uses it in this sense to describes Japan's culture of a group mindset. Amae also can be understood to refer to a nurturing female presence, such as a mother, counterbalancing stoic male resignation to authority. Dependence on filial and communal existence—and especially deep ties to one's mother—resulted from the Japanese history of persecution and coerced harmony. Amae is a footprint in the sands of the Japanese psyche, helpful in understanding why the 250 years of persecution left an indelible imprint still recognizable today. Doi

connects this amae to a clear distinction of the Japanese psyche between the inner and the outer.

> Not only has Japan failed to establish the freedom of the individual as distinct from the group, but there is, it seems, a serious dearth of the type of public spirit that transcends both individual and group. This, too, would seem to have its origins in the fact that the Japanese divide their lives into inner and outer sectors each with its own, different, standards of behavior, no one feeling the slightest oddity in this discrepancy.[2]

Doi makes the case that this pronounced separation of the inner and the outer selves and the custom of *enryo*, constantly deferring to the other's wishes, has its roots in the forced national identity of the Meiji era that followed the Tokugawa persecution.

> The almost religious character that the Meiji Constitution came to acquire seems, incidentally, to have been influenced by the fact that Ito Hirobumi, its drafter, perceived that religion lay at the foundation of constitutional government in Europe. Ito himself, during debate in the Privy Council on the draft of the Imperial Constitution, referred to this fact, and declared that apart from the Imperial family there was little to serve as a spiritual focus for constitutional government in Japan.[3]

While the Meiji era put an end to dictatorial feudal powers, it did not nurture individual opinions and freedoms but simply transferred dictatorial powers to the emperor. Making the emperor the central pillar of authority intensified the culture of dependency. Doi continues,

> In short, he treated the Imperial family as a kind of spiritual substitute for Christianity. Whatever the rights or wrongs of the matter, his view that the traditional religions were useless for his purpose, and that the only thing that could help in binding the

nation spiritually was the ancient concept of the nation as a
family, with the Imperial family as its main branch, was un-
doubtedly wise in its way. . . . The Japanese, in short, idealized
amae as a truly human world; and the emperor system might be
seen as an institutionalization of this idea.[4]

In effect, the Meiji era brought a fresh influence of the West, but in-
ternally not much changed in terms of the group-oriented inner mech-
anism of Japanese society. The Tokugawa era had successfully stamped out
any psychological desire to be unique or to challenge the authoritarian
structure. What Endo describes in *Silence* of the magistrate Inoue's re-
peated torture of both of the priests in order to control their minds rep-
resents well how a mindset of fear infiltrated the land. Thus, fumi-e
culture continued after the end of the Tokugawa era, but in the guise of
the "open policies" of the Meiji era. Amae exists as the residue of the
Japanese past; it is a particularly acute symptom of the Tokugawa era and
a psychological state that still operates today.[5]

Such cultural dependence affected the generations after Hiroshima
and Nagasaki as the atomic destruction made Japan the subservient
"stepping block" of modern culture, creating, as the writer Oe (see ap-
pendix two on Oe) stated, an ambiguous culture unable to find its true
voice in the international arenas. Emperor Hirohito, after the war, an-
nounced that he was less than divine and instituted pacifism as a way
forward. But psychologically, amae dependency continued, this time fo-
cused on complete dependence on the American military and American
capitalism, as Oe amplifies in many of his novels.

Japanese culture was defined through trauma and isolation that began
in the sixteenth century and continued for 250 years. Wounds still remain;
they are evident in both the beauty and the despair of the Japanese psyche.
This may explain why, to this day, Japan remains one of the most difficult
terrains for missionaries. The psychological malaise of the Japanese in

their post-Hiroshima journey, compounded by the more recent trauma of the tsunami and earthquake of 3/11, follows the pattern of stoic despair that reflects a culture of honor—symbolized by the sword. At the same time, quite paradoxically, Japanese beauty—the chrysanthemum—flowered in that isolation, refining the influences that had previously filtered into Japanese culture from outside and assimilating them into Japanese experience. Thus, the flowering of Japanese culture leaves clues to the true despair beneath the surface. In order for us to resolve the mystery of the trauma of Japanese soul, we must find clues in the Japanese concept of beauty that began to define the nation during the late sixteenth to early seventeenth century, the century of the martyrs.

Fumi-e capture both the Japanese aesthetic experience and the reality of Christ. The Japanese concept that there is beauty in wabi (things worn) and sabi (things rusted) overlaps with the surface and the color of fumi-e. For a Japanese to behold a fumi-e reminds that person of the beautiful, and at the same time casts light on its most improbable source—Christian persecution and, ultimately, the person of Jesus. Curiously, Japanese persecution produced a hidden culture of the beautiful while accentuating the unique presence of Christ and the exclusive claims of the Christian message. Japanese aesthetics is therefore linked deeply with the unique imprint of Christ, but this deeply embedded reality is never acknowledged. Japanese culture constantly navigates between objective reality and the mystery of Japanese ontological existence, the mystery of a culture that hides the *hon-ne* (true voice) while accentuating the *tate-mae* (public face to please the group). Japanese social experience vacillates constantly between what is considered to be inside and outside. Theologically, these Japanese principles can accentuate a certain aspect of biblical reality. Christ was born as the son of a carpenter in the small town of Nazareth, which made him an insider, but he also was an outsider, born with a messianic, divine mission sent by God to earth. Christ hid his true calling until the time was right. It was not the religious authorities who first

recognized the birth of Christ but the magi (pagan astronomers) and shepherds (marginal servants); what an improbable beginning. He was birthed at a manger, a wabi birth.

Misunderstood even by his own disciples, Christ made many startling statements that reveal a unique presence in history, one that challenged normative human behaviors programmed for self-preservation and survival. Instead of seeking revenge in an unjust world, he taught his followers to love their enemies. Instead of upending the world order as the professed "King of the Jews" and rallying forceful resistance to the oppression of Roman rule, this powerful Messiah came to lose his life as a "ransom for many." He submitted to arrest when he had done no wrong; he suffered unjustly; taunted, he remained silent and refused to defend himself. He endured the punishing path toward Calvary, carrying his own cross toward his own demise, even though he had the power to stop the inevitable. Even as he was executed on the hill of Calvary, he displayed love; he forgave a thief dying next to him and promised him paradise. Then he asked God to forgive those who mistreated him, saying "Father, forgive them; for they know not what they do" (Luke 23:34 KJV) before crying out "*Eloi, Eloi, lama sabachthani*"—"My God, my God, why have you forsaken me?" (Mark 15:34). Instead of changing the world through a mere display of power and wealth, even though he *was* a powerful and influential leader, he died as a poor criminal, prosecuted unfairly by a corrupt system. But precisely because Jesus lived counterculturally, speaking with audacious authority and a voice full of love without any guile, his voice became the most powerful force of change, change that catalyzed Western civilization as we know it and provided a foundation of knowledge and certainty in creation's order that led to the development of occidental sciences and entrepreneurial democracy. This counterintuitive reality—Jesus' paradoxical power through weakness, beauty through brokenness—is expressed perfectly in the surface of fumi-e. The magistrates designed fumi-e to break the will of the believers,

but Christ spoke through them powerfully from within Japanese culture, even through the accursed object.

Endo entered into the dark corridors of the Japanese past after his experience encountering a fumi-e display in Nagasaki. His objective reality and the mystery of existence were merged in his faith as a Catholic. He created in Father Rodrigues a character truly ostracized both by his own people and by the Japanese. *Silence* is not a triumphant pilgrimage with clear outcomes, but a meandering pilgrimage of one wounded by life and confounded by faith, whose experience of faith has been punctuated by betrayals, his own and those of others. Endo notes repeatedly in his memoirs and through his characters that through his own struggles of faith God never let him go. Endo himself is like the fumi-e, a historical marker birthed of a traumatic time, finally worn smooth through many disappointments, failures and betrayals, but whose surface reveals the indelible visage of a Savior.

JAPAN, THE VISUAL CULTURE

Japanese culture is highly visual; from presentation of cuisine (helpfully exhibited to foreign visitors as wax models in the windows of restaurants) to flower arrangements, from industrial design to graphic design, Japanese visual expression is highly valued. Japanese *kanji*, ideograms imported from China, are visual forms, often derived from pictograms that visually encapsulate an object or idea. Therefore, for a Japanese to learn to read is to learn to identify visual cues and apply the corresponding meaning to them. To go to grade school in Japan is to be trained in visual thinking.

Added to this unique feature are the uniquely Japanese phonetic alphabets called *hiragana* and *katakana*. Since the Meiji restoration, and to some extent prior to that time, these phonetic alphabets have been the first written language that children learn in school. These are derived from phonetic readings of kanji, and in the calligraphic tradition of Japan, hiragana

and katakana are just as important, and visual, as kanji. Both phonetic alphabets flowed out of the linguistic device of capturing poetic and lyrical elements of early courtesan life, as captured in the eleventh-century *Tale of Genji* and other narratives. (The *Tale of Genji* is often called the world's first novel, and it could also be characterized as the world's first soap opera; it was written by a woman in an early form of hiragana that was used among women in the imperial court to gossip with each other.) While the Japanese phonetic alphabets deviate from the Chinese ideograms, they nevertheless are visual; readers must rely on subtle visual cues in handwriting to decipher the meaning. Shikibu, the author of the *Tale of Genji*, created a language of hidden seduction and whispered universal secrets that lie within every heart. Yasunari Kawabata took this lyrical language and spoke into the trauma of the twentieth century.

For Endo's analysis of Japanese culture and the world of faith, linguistic development of this sort was critical. He saw that the Japanese culture retained a visual way of depicting meaning, but also developed a feminine form of communication. The significance of the feminine in Japanese culture and beauty, amplified by Kawabata, is significant for the development of Endo's characters.[6]

ENDO AS A VISUAL ARTIST

When Endo traveled to do research for his books, he carried a sketchbook; he describes these trips as "nature sketching" and the process of writing as looking "through the eye of a camera." He particularly focused on the landscape, atmosphere, aroma and light:

> The purpose of the research trip is not to gather facts: facts I have already researched extensively and are in my head. What I seek from the particular place is what my characters breathed in as they walked about, what they heard through the wind, what they saw in the sun rays. That is my landscape.[7]

Endo frequented art museums, and like many Japanese intellectuals he delighted in works of Georges Rouault; he even owned a Rouault portrait of Christ, which hung in his home. This description of his first encounter with a fumi-e reads much like an observation that might be made by a visual artist: "I noticed that on the wooden frame surrounding the bronze plate, were what seemed to be imprints of toe prints. I stood for a long time, staring at the darkened imprints."[8]

As a visual artist myself, I respond to these descriptive elements. These observations are not just of visual input but of a comprehensive sensory experience. They are generative, expansive descriptors of the world that is being described. A good artist depicts more than visual details; good writers paint with their words. Therefore, a visual writer uses words to invoke the visual rather than merely to explain the scene visually. Father Rodrigues's observation of Nagasaki is just as visual and sensory, a perfect example of a scene evoked through visual cues:

> Once outside the village his eyes were suddenly dazzled by the glare of the sun. He felt overcome with giddiness. The fellow behind, constantly muttering something, kept pushing him on. Forcing a smile the priest asked if he might be permitted to rest for a moment, but the other, hard-faced and grim, shook his head in refusal. The fields beneath the glaring sun were heavy with the smell of manure; the sky-larks chattered with pleasure in the sky; great trees, the names of which he did not know, cast a pleasant shadow on the road; and the leaves gave forth a fresh sound as they rustled in the breeze. The road through the fields gradually narrowed, and when they reached the far side they found a hollow stretching into the mountain. Here there was a tiny hut made of twigs. Its black shadow fell on the slimy earth. Here four or five men and women clad in peasant clothing, their hands bound, were sitting together on the grass.[9]

The "glare of the sun," the nameless "great trees," even the leaves that give forth "a fresh sound as they rustled in the breeze" evoke imagery. Endo is painting here, through Father Rodrigues, what Japan is like, especially as seen by an outsider. This empathetic visual journey is critical in understanding Father Rodrigues's reaction to the fumi-e.

The whole premise of *Silence* is to highlight the importance of fumi-e as visual icons. Fumi-e culture is a visual culture that places an unusual emphasis on the power of visual imagery. American Protestants, by contrast, very rarely find spiritual meaning in icons. Some of my Protestant friends who read *Silence* have remarked that they would have had no trouble stepping on fumi-e. "It's just an image," they say.

But to a Japanese, a fumi-e is not just an image. The genius of the historical character of the apostate priest Ferreira, in *Silence*, coming up with the creation of fumi-e, is that he understood how important visual images are to a Japanese. We can also deduce that both of the priests, Father Ferreira and Father Rodrigues, themselves internalized the *Japanese view* of visual imagery by the time they encountered fumi-es of their demise. The intentionality of having such an image made—the care with which, one might say, a torture is planned—communicates to a Japanese. A fumi-e is an image made to be stepped on. Simply facing such an image already crosses a threshold, a demand for the individual to submit to the group; the image symbolizes a psychological state of fear toward a suffering person hanging on a cross. Perhaps many Japanese thought that by stepping on it they were rejecting the suffering of a Western individual, thus rejecting an outsider. But to a Christian who has internalized the image of Christ as their Savior, a fumi-e uniquely portrays their own experience of choosing between being a Christian and being a Japanese. Creation of this dichotomy, as false as it is, is the brilliance of fumi-e as a torture weapon.

But unlike any other torture weapon, a unique feature of fumi-e is that the actual object poses no physical threat to the viewer. This fact

amplifies the intent. Even if the image were not of Christ but of the Buddha, Muhammad or even an American flag, one would hesitate to obey the order to step on it, to resist the intentionality and the forced demand of one's oppressors. What is powerfully resonant to me is that if any of these other images were used, there would be violent outrage and the object would be scorned and quickly destroyed or put away. But a fumi-e, because it is an image of Christ, is kept as a venerable object for contemplation by the Japanese for all of us. In the violent reaction of the Muslim community to satirical cartoons made in Paris in 2015, the Muslim community instantaneously coalesced to demand these offensive images be removed. For a Buddhist, suffering is part of the universe, and one would not think to torture a faithful Buddhist by forcing her or him to step on the mandala, because Buddhistic faith is internalized and not attached to a physical object. If an American flag were burned, it is very unlikely that all Americans would see the charred remains as something beautiful. But uniquely, an image of Christ, a fumi-e, remains as an object of contemplation. It is no surprise then that behind such a unique creation is a unique story of fumi-e's maker.

Endo knew of an obscure novel called *The Bronze Christ* written by Yoshiro Nagayo in 1927. The author weaves a historically based story of the metalsmith Yusa Hagiwara, who is recruited by Chuan (the Japanese name of the apostate Father Ferreira) to create fumi-es. There are twenty of the original fumi-es in existence; nineteen of them are in the Tokyo National Museum display that I saw on that fateful day.

The Bronze Christ tells the story of Hagiwara reluctantly taking on this commission. He is a fine artisan, the only one in Nagasaki who could take on Chuan's desire for a well-made image, but done quickly. Hagiwara is not a Christian, but during the conception of the image of creating fumi-e, he has a dream about heaven, which is associated with a Christian girl he befriended who spoke of this Christ figure.

After he casts the images in bronze, being faithful to the dream, and brings them to the magistrates, he is arrested. The magistrates consider the images to be "too well done, a masterpiece," and despite Hagiwara's offer to step on the images, they interrogate him about how he knew so well how to create images that were such powerful likenesses of this foreign religion. They suspect he is a sympathizer, and Hagiwara ends up being "martyred" with the Christians whose faith was identified by their refusal to step on the fumi-e Hagiwara created.

> "We do acknowledge that what you created were masterpieces." The magistrate spoke in a soft voice. "We will take good care of these masterpieces. In order to move and test the believer's hearts, we must have such quality for them to be useful . . . but the object you created reveals your faith—a kind of deeper faith than a typical believer; more powerful and filled with awe. We admit we see that in the works, too."[10]

A conversation like this, a situation so absurd, could only be possible in Japanese visual culture; the fact that this novel is based on historical events can only add to the intrigue and tragedy. Nagayo wrote *The Bronze Christ* during the expansion of Japanese nationalism and military growth after World War I. Endo recounts that the era between the Great Wars was a time of great testing of Christians, who were considered to be part of the conspiracy against the country because they, or their spiritual forebears in the Japanese Christian churches, associated with "foreign enemies." "There were many times that I stepped on my own fumi-e," he notes in one of his lectures, "and we all did." To many Japanese, to harbor thoughts of Christ was to be unfaithful to their own country. But Endo moves beyond his own experience as a Catholic in telling this story of fumi-e; to him *everyone* has their own fumi-e, defined by what each individual values the most in life, whether that be loved ones or objects of beauty. Fumi-e is that beauty betrayed by us through coercion or circumstances.[11]

❧ ❧ ❧

To a Japanese person images may be more important than a rational, propositional argument, and Chuan tapped into that uniquely Japanese trait. Of course, the character of Father Rodrigues, as a non-Japanese, is also invited to accept such stoic resignation. It is significant to the Japanese that the expression used in convincing the priests to step on the fumi-e, when Chuan states "it is just a formality," echoes Inoue's voice when Chuan himself was tortured. In Japanese "formality" is *katachi* or "form." This word means the outward appearance of an object, and moreover, just a tracing or an outline of it. When a formality is used to keep individuals in check, the Japanese mindset connects this choice to the power of images. But such formality is also an entrapment: it delimits one's choice to predetermined options, creating a false dichotomy. If you step on the fumi-e, it supposedly will maintain the katachi of the society's order; if you do not, it will lead to alienation and persecution. By depicting this struggle visually, and not just rationally, Endo crafts a unique description of persecution in Japan, but at the same time this unique path leads to the deeper journey of faith that Father Rodrigues begins to walk at the end of *Silence*.

The Japanese recognize the iconic power of objects and images. They trust images to convey truth, and the power of fumi-e is bound up in that belief. Fumi-e as icons of the Japanese art of persecution gained notoriety and hovered in the imaginative arena of faith for the Japanese and missionaries alike. It could be that the artisans who created fumi-e wholeheartedly agreed with the authorities that Christianity should be outlawed, but the reverse is also likely. Artisans who knew Christ, or at least valued Christ, would be more likely to create convincing imagery of Christ, as in the case of Hagiwara. If the purpose of creating an image is to place it before Christians and demand that they deny it, it follows that one must make a convincing image and set the image as something venerable and valued.

By creating images for the purpose of denying Christ, Hagiwara created an object to behold, an exceptional piece of art. Such is the paradox of fumi-e: A venerable image created by Hagiwara was made smooth by thousands of betrayers. Its worn-smooth surface may now capture Christ's true visage more than any paintings of Christ done in the West.

KATACHI AND THE PORTRAIT OF CHRIST

Japanese acknowledgement of the power of the katachi (form) also indicates that there are, to a Japanese mind, differences between the form and the essence of an object. I call the process of finding the essence "essentiation" (which is quite different from "abstraction"). When I was an undergraduate, my drawing teachers noticed that I have a tendency to depict an essence, rather than the outward appearance, of an object or a person that I am depicting. I did not realize then that this distinction would later lead me to view the seventeenth-century Japanese screen paintings in Boston, which would then persuade me to go to Japan to study nihonga. I realize now that the time I spent in Kamakura as a child had much to do with the way I view an object. Zen paintings and sumi-ink works present the world in a manner quite distinct from a Western view; it took time for me to realize that abstract expressionists like Jackson Pollock or modernist artists like Mark Rothko were also "essentiating" their sense of reality in traumatic times. Their art affected me deeply as their vision overlapped with a Japanese sense of reality. Thus, these abstract masters were not operating out of Western practice (as in the typical dichotomy of abstraction versus realism) but creating a new overlap.

Throughout my journey as an artist, I have heard the whisper of Christ through my work, though I did not identify that voice until I reached the age of twenty-seven. What Father Rodrigues experiences in hearing the voice of Christ at the end of *Silence* is also, in a much more severe way, a move from the *form* of religion to the *essence*. Father Rodrigues hears the voice of Christ through the essence of fumi-e, the

invisible substance of things unseen, rather than through a mere appearance of the katachi, the outward shape. Only through the defaced, what one might call abstract, reality of a Savior is Christ's true visage revealed, and it proves to be a face of forgiveness and liberation. As he steps on the fumi-e, Father Rodrigues steps into an *essentiated* reality of Japanese aesthetics, beyond silence—and the terrible beauty opens up to him.

When I was lecturing in Hiroshima, a graduate student told me that she remembered seeing and learning about fumi-e in her high school textbook. "I paid close attention only because the teacher told me it would be on the test," she confided. She and her fellow students knew of fumi-e, but most of them felt no personal connection to it at all. If a fumi-e becomes only a tool for education, an item on a checklist of things to know about Japanese history, a mere formality, then it can lose its power as well.

It may be a sign of the impact of Endo's writings in Japanese culture that fumi-e are even mentioned in Japanese textbooks. Certainly, fumi-e are an icon of the Japanese past, an icon that in the psyches of the Japanese symbolizes something significant about their own culture. People all over the world knew about fumi-e, even in the seventeenth century; Jonathan Swift, in *Gulliver's Travels*, mentions them, as does Voltaire in *Candide*. Even if the image was ubiquitous in Endo's time—though his recounting of the images indicates that not many were aware of fumi-e at the time—it seems clear that Endo wanted to reframe the meaning of what exactly fumi-e conveys.

During the same trip, at Hiroshima City University, hosted by a Professor Atsushi Suwa, one of the greatest portrait and figurative realists in Japan, I spoke on "Silence and Beauty," and after my lecture he interviewed me on the stage. A student had a question about fumi-e, so we began to discuss the history of fumi-e. As we started, Professor Suwa made a comment that has remained with me to this day. He said, "Fumi-e *is the best portrait of Christ I've ever seen.*"

From an outsider's perspective, a Japanese portrait realist saw perhaps what Christians may miss because we wrestle with our own struggles of our history of betraying the One we love. Hagiwara's creation, the one that caused his own demise, paradoxically captures, through years of persecution, the worn-smooth face of Christ as the best portrait of Christ in the world. Only in the visual culture of Japan is this fumi-e phenomenon possible. Chuan, or the apostate Father Ferreira, could not in his wildest imagination have predicted that his own creation of persecution would become, in due time, the most powerful human image of Christ.

Christ's face is stepped on by his enemies and his friends alike. He is singularly the most unique presence in the history of humanity in that he led by giving his power away. Even in the violation of the image of Christ, and even though it was his own followers who violated that image, his true, enduring portrait emerged. What Chuan devised as a way to deny his own Lord and Savior as a cruel and wicked weapon turned out to be the most beloved image, the most enduring image, of the very Savior he tried to deny.

This paradox of Christ's true visage is what Endo depicts in *Silence*. In that sense, we might note that Endo too depicted through *Silence* the most profound visage and portrait of Christ in literature, and by doing so he revealed Japan's true beauty of sacrifice.

ISIS AND THE BREAD SHOPS IN KYOTO

On a day I spent in Kyoto to do research for this book, the front-page news was a picture of two Japanese journalists who were being held hostage. Japanese journalist Kenji Goto was captured by the terror organization Islamic State while trying to find information on his friend Haruna Yukawa, who had disappeared some months before. In a story eerily reminiscent of the journey of Father Rodrigues trying to find information about Father Ferreira, Kenji Goto risked his own life to try to negotiate his friend's release. He was captured because of a betrayal by a trusted source, and to the outrage of many both men were decapitated after negotiations failed.

That day on the front page of the Japanese newspaper in the *ryokan* (a traditional Japanese bed-and-breakfast inn) in Kyoto there were photos of the orange-clad journalists, bound, on their knees, with a jihadist behind them with a sword. The picture was intended to bring fear and inject terror into our psyche, and broadcast the message of ISIS. On that very day I had visited the site where the twenty-six martyrs were paraded through the city of Kyoto in 1597. The plaque noted that among the martyrs were Franciscan and Jesuit priests, both Japanese and missionaries, and three children. The authorities cut the ears off some and the noses off others, and had them walk from Kyoto to Nagasaki, where they would meet their martyrdom.

I could not help but notice that the photo in the newspaper was manipulated; it looked photoshopped; it appeared to be a collage of images. The headline and article identified facts of the incident that seemed to support this. ISIS communicates through such hastily collaged elements, creating an image of a jihadist standing tall in the wind-blown desert, with a menacing gaze through the mask. Tokugawa magistrates also designed the parading of twenty-six martyrs to strike fear into the hearts of those who saw them pass. Fumi-es were created as a visual symbol of such fear and terror. Images can indeed be powerful tools for manipulating public perception.

Kenji Goto, I found out later, was a Christian who sought to report on the lives of children and orphans caught in a war zone or in situations of poverty. In Syria, in Chechnya during the crisis there, in northern Japan after it was stricken by the 3/11 earthquakes, his way of journalism was a fulfillment of his calling. When he went to orphanages, he began by embracing children. He said, "By embracing them, I can talk with the people. I can hear their views—their pain and their hopes."[12]

The photoshopped image of Goto-san about to be beheaded successfully carried terror into our hearts. But I noticed that even in this photo, Kenji Goto's face is filled with quiet resilience. Even a manipulated photo

could not take away the calling of a courageous journalist whose faith seemed full of confidence and peace.

It is ironic that in Japan the beginning of fumi-e culture was, in fact, a courageous and quiet defiance of terror, similar to what Kenji Goto displayed. In sixteenth-century Japan, arresting and even killing Christians led to the growth of the church. Magistrate Inoue devised ways to counter the growth of the church with one of the most cruel forms of torture for the priests. They not only wanted to eradicate the Christian faith; they also wanted to broadcast publicly the Christians' forced conversion to Buddhism. They used Christian love, love toward our neighbor, against the priests to apostatize. Whether or not one is a Christian, it is clear that this tactic was a type of mind control, the type of coercion that terrorist organizations continue to exercise. Carry that further with consistency and duration, and a traumatized fumi-e culture will be birthed.

<p style="text-align:center">◉ ◉ ◉</p>

"There are many small bread shops in Kyoto," the kimono-clad *nakai-san* (attendant) at the ryokan in Kyoto told me. "I was told by a friend that it's because there were so many Kakure Kirishitan in Kyoto."

There is no way to prove definitively what nakai-san stated about the bread shops, but she noted, "Why else would Kyoto, a place that gave rise to Japanese culture, have so many little bread shops? It makes sense to me." Christians, forced to hide their faith, kept some links to elements of Western culture. Bread is a symbol connected with the Eucharist. I nodded in agreement. Perhaps Hidden Christians went to bread shops to receive Communion.

Japanese have hidden their deepest longings and have assimilated hidden Christianity deep into their culture. These little shops serve some of the most delectable bread, a highly refined and typical Japanese translation of a Western product. They are beautiful little breads.

Beauty is a refinement of fumi-e culture, a Christ-haunted culture that cannot disappear.

Fumi-e could be also interpreted as a condition in our lives that leads us to believe there are only limited options and limited resources. Fumi-e represents a road to persecution, entrapment and torture. Japanese often use the expression *shikata-ga-nai* (there is nothing you can do) as a fatalistic response to a given circumstance. They assume that circumstance is all there is; they face that shikata-ga-nai with stoic resignation. But the Christian God offers a reality far greater, a possibility of the infinite breaking through, even though the fallen world is cursed and operates within the limitations of a natural, closed mechanism. Our Darwinian struggles in this closed, limited-resource world are at the root of despair in our hearts, because we know that death is the end game of such a system. But our deep convictions are not based purely on observation of how our world and universe operate; they are based also on a certain belief system. I will develop this idea theologically at the end of this book.

Although it has been centuries since the Japanese had a culture of dependence forced on them by dictatorial authorities during the two hundred years of isolation, the wounds remain fresh. The fear of independence, the difficulty of differentiating oneself from society, carry shame. Japan's fumi-e culture is quite debilitating. It is a culture that values strong allegiance to the power of the age, whether it be nationalism leading to Pearl Harbor or the pragmatism that led Japan to build and develop utter dependence on over seventy General Electric nuclear power plants—an amazing number when one considers that all the islands of Japan combined are roughly equivalent to the land mass of California. Forced allegiance and insistence on consensus produce a stoic, blind march that is ultimately dehumanizing. Today, after a century of rebuilding, the Japanese find themselves trapped in the wounds of such a fumi-e culture—and, just like the priests in *Silence*, unable to recover hope.

KATAKANA EXISTENCE OF KICHIJIRO

My Japanese name is written in katakana. In a fumi-e culture it is important to have a way to designate insiders from outsiders. Of Japan's two phonetic alphabets, katakana was created to identify foreign objects and people—foreign objects, particularly, such as a piano or a television. Words like this always are written in katakana rather than in kanji, the traditional Chinese ideograms adopted by the Japanese language, or hiragana, the other phonetic alphabet form used to write in the Japanese language. Even in their language forms the Japanese identify what belongs outside and what belongs inside. I was born in Boston and am an American citizen; therefore my name has to be in katakana. I am a Japanese American, not fully Japanese. My parents assigned ideograms to express my name, but the last time I used them I was in grade school.

The Japanese word for Christianity today is *Kirisuto-kyo*. It is always written in katakana. Every time a Japanese reads or writes this word, it reemphasizes that Christianity is an outside and foreign teaching.

Endo often used the katakana name of Kichijiro, the character in *Silence* he identified with the most. The name can be expressed in kanji, but to Endo it seemed more fitting to use the form of language that shined light on Kichijiro's identity as an outsider. He is a character whose weak faith vacillates between acceptance and rejection, and so he is regarded as an outcast by non-Christians and by his fellow Christians. When Endo describes his early struggle with his Catholic faith as "like wearing western clothes," he is describing the mismatch that katakana religion created in his life. In many ways, *Silence* is a depiction of katakana culture, the male-dominated culture that demands precise delineation of rational decisions. Yet Endo spent much of his time reflecting the hiragana feminine culture and theology. Endo did so *via negativa*, by defining the opposite, in this novel that is so much about being an outsider.

With my katakana name I too cannot be an insider to the Japanese culture. As an artist this outsider perspective has helped to form my career. (*Katakana* stands out in, let's say, a group exhibit in which all the other artists' names are in kanji!) It was an enormous privilege to be the first outsider invited to study in the Tokyo University of Arts nihonga doctoral program—to be the one katakana artist injected into the long lineage of Japanese painting. But I also know, and respect, the fact that I can never become an ultimate insider, and it would be unprofitable for me to try. If I did, I would be imprisoned in the hierarchical Japanese system and would suffer the same fate as Father Rodrigues: unable to express my views, and therefore, not free to be a true artist.

<p align="center">෧ ෧ ෧</p>

In the Japanese language there are several words that refer to bullying. *Ijime*, the basic Japanese word for bullying, conveys the identification of something about an individual that marks him or her as an outsider. *Nakama hazure* describes what happens next: ostracizing the person, or literally translated, to "exclude one from a group" or brand the person as a misfit.

Logic in Japan dictates that if you excel in anything—schooling, sports or the arts—you are indeed becoming a misfit and a "nail that sticks out." Therefore, for a Japanese individual to admit to superiority or success is paramount to disowning their Japanese self. Imagine that you are Masahiro Tanaka, the young baseball player who in 2014 left his meteoric career in Japan to pitch for the New York Yankees. You are trained to speak only of your imperfection rather than your accomplishments. Tanaka—just like his New York Yankees predecessor Hideki Matsui, the best slugger ever to come out of Japan—apologized to the team and its fans for getting injured and having to go on the disabled list to recover. Even after he put in his best performance and won a significant game, the first things out of his mouth at the postgame interview were about what

he failed to do: how he missed slightly on a pitch in the first inning, giving up a run. To the individualist ears of Americans, this act of contrition sounds outrageously odd. But in Japan this is the only way one can fit in.

The survivors are those who hold their individual convictions close to their chests, never revealing them at all—or who never develop any convictions in the first place. Therefore, by the time a typical Japanese reaches middle school she or he will be well trained to suppress individual thought. This child will even suppress calling abuses as abuses. Her or his stoicism will be honored. Any creative gesture will be seen as a threat to the whole. (See appendix two on Kenzaburo Oe's writings exposing this Japanese trait.)

This cycle of codependency and abuse is what Endo describes well in *Silence*. It is not merely a novel about persecution of a religious minority in seventeenth-century Japan: *Silence* is ultimately about the cycle of communal entrapment repeated over and over in Japanese history, which reverberates throughout Japan still, from the business culture to schoolyards. Kichijiro is the katakana incarnation of Endo himself, often failing and ostracized from his own community as well as from the establishment.

Jesus, in this sense to Endo and to me, has become a misfit, a *nakama hazure* (exiled from a friendship group), bearing that true identity as an outsider for our sakes. Jesus is the ultimate misfit, an outsider whose birthright was to be a true insider.

☙ ☙ ☙

Japanese culture has developed two faces toward the world: *omote* (front) and *ura* (back or hidden). Omote will be kind to outsiders, but ura will expect complete submission to the group. There is a Japanese word, *omote-nashi*, that means to be hospitable to strangers, but the very existence of such a word recognizes that ura is the norm. A business article focused on this dynamic calls the Japanese the "kindest, cruelest" people in the world. "The face presented," the authors note, "depends entirely on whether you are seen to be part of a group or outside it."[13]

When I was a graduate student in Japan, my wife and I took the train to see Kyoto. My wife is of Irish-English descent; she is obviously an outsider. I look fully Japanese. She went ahead of me and found that when we used a machine to buy our tickets as we began the trip, we applied less money to the tickets than the trip required. As she left the train at the exit, the officer at the counter kindly explained in his broken English that she needed to pay an additional amount of yen because the ticket was not paid in full. But as I exited through another counter only seconds later, I was given a full, stern lecture on why it is so prudent to pay the exact amount when you buy the ticket, and how this act of falling short was causing problems to other customers! I appeared to be an insider who made a mistake, and for an insider to err—even in so mundane a matter as getting a ticket price wrong—is a major violation of the code of unity.

This dual personality of Japan became acute after the period of isolation that Endo's book *Silence* describes. In describing the years of Japan's persecution of Christians, he also describes this tension between the old and the new, insiders and outsiders, and the Japanese culture's insistence on taking outside ideas and refining them.

It's one thing to be reprimanded by a train-ticket master; it's another to be persecuted for having faith. If you consider the railway employee's reaction to our misstep in getting tickets to be a small reminder of what can happen in a country that prizes homogeneity, then one will start to see the whole picture of persecution of Christians. What happens sociologically today has much to do with the 250 years of consistent, forced correctives that the Japanese culture has experienced.

A groupthink mentality depends on the assumption of homogeneity. Japan has been assumed, by the Japanese and by outsiders, to be a homogeneous culture. Yet even a quick examination of the historical and sociological reality of Japan makes it clear these assumptions are not historically accurate. Japan is the endpoint of the Silk Road, and

therefore many cultures and religions, including Christianity (in the form of Nestorian practice, exiled from the main body of Christianity), entered Japan very early on. As the destination of merchants and travelers Japan must have had one of the most diverse populations, including people from the Middle East, Mongolia and India. To that complexity add the native Japanese, the Ainu tribe, whose history parallels the plight of Native Americans being pushed aside by the invaders of the land.

Any culture that is birthed out of dictatorial control will have similar psychological traits. The African American experience of enslavement, Nazi Germany's relentless dehumanization and then wanton killing of the Jews, or any dictatorial forces that rule today—all of these spur conformity and create a two-faced way of dealing with oppressors. The myth that homogeneous consensus can be built within a culture requires bold and courageous leaders, like the Reverend Martin Luther King Jr., to counter. Even the most cynical must admit, however, that the true seeds of Christ's love did embed deeply in the Japanese soil. These seeds remained in the ura culture, deeply hidden but stubbornly alive through Japanese beauty, an aesthetic in which the highest order of communication is through silence and quiet beauty.

Christianity, from its onset, has valued individual voices, as each person is made in the image of God. Jesus' welcoming of outsiders— even those commonly not considered worthy of attention, or those like the lepers who posed a health risk to communities—shows that Jesus came for the exiled, the marginal and the persecuted as much as for anyone else. Endo developed empathy for those without a voice, and those whose voices have been erased from historical records.

For Endo, as well as for me, fumi-e is a mystery, a question mark embodied. It is different from Western theism that seeks to provide clear answers. Fumi-e turns the normative assumptions of Japanese culture and our Western cultural assumptions quite upside down.

FUMI-E: CHRIST
ON THE CROSS

MOZUYA GURO
(BLACK RAKU
TEA BOWL)
BY CHOJIRO

SHORINZU BYOBU BY TOHAKU HASEGAWA

A NEW MOON BY MATAZO KAYAMA

JERUSALEM: THE EMANATION
OF THE GIANT ALBION
BY WILLIAM BLAKE

PORTRAIT OF RIKYU KOJI BY TOHAKU HASEGAWA

RYUKYO SUISHAZU BYOBU BY TOHAKU HASEGAWA

SILENCE - AROMA
7'×11', MINERAL PIGMENTS, GOLD
ON CANVAS, 2015
BY MAKOTO FUJIMURA

WHAT IS JAPAN?

In *What Is "Japan"?* historian Yoshihiko Amino includes a map of Japan in the introductory chapters. It turns Japan upside down from the conventional map the Japanese, and all of us, are used to seeing. In this version the island is the same typical seahorse shape seen in Japanese textbooks, but the seahorse is upside down; it appears as an archipelago with its northern end connected with Russia to the north and with Korea in the south. The Sea of Japan looks like a lake in between Japan and Russia, North and South Korea. In a chapter titled "The False Image of 'Japan as an Isolated Island,'" Amino states rather emphatically, "Truly, this map shows how the sea [of Japan] cannot be seen as a separation between countries. The ocean spacing in between the islands serves both to separate, but also to bring together people of different cultures, and the sea is connected to the wider ocean."[14]

Trading along the Silk Road dates back to the time of the Old Testament, and century upon century of contact with merchants from abroad created in Japan a cultural estuary. All sorts of religions, customs and cultures mixed in the first city of Nara. Endo, then, is turning the map upside down by describing the Japanese psyche in trauma and challenging the conventional view of Japan as a homogenous, harmonious island. But Endo depicts another map, actually on the first edition of *Silence* as a cover, quite another way to lift the Japanese psyche out of this "myth of isolated island." Endo, like Kawabata, desires to see Japan move beyond the persecution and asks, "What is Japan?" But Endo knows that the only way to get to that trauma is to walk right into the darkness.

A heterogeneous estuary creates cultural influx, tension and competition that lead beyond sustainability to generativity. Cultural sustainability is limited to preserving the past. Generativity, on the other hand, builds on tradition; it employs it as a soil from which to grow. Into a cultural estuary flows an abundance of new ideas, new cultural forms and

new art, and the fantastic influx meets an already-formed base of culture. Endo's work is one sign of such a meeting between in-flowing cultures and tradition. It is to Endo's credit that he, more than any other Japanese writer, fixed his gaze upon the conflict that such an influx introduces to culture, and that he described the tension and faithfully captured the process by which this takes place. His ability to see beyond the culture is akin to the historian Amino turning the Japanese map upside down. Endo, too, turned the map of Japan upside down, presenting fumi-e as a visual object to ponder, to look at objectively from a global perspective. By doing so, he created a new path for Japan to look at itself not as a homogeneous culture but as a country that can celebrate its diverse heritages.

The Meiji restoration of the nineteenth century was a fantastic current of cultures and ideas that was formative in many intellectual developments of the twentieth century. Coming on the heels of 250 years of isolation, the Meiji era held a promise of liberation. It was, ironically, the preceding Tokugawa era of isolation and persecution (accompanied by Christian persecution) that set the tone for the influx of Western ideas. Yet it was not Christian faith that brokered the shift and opened the gates to merchants and Black Ships; what led to Japan's cultural reengagement was Western cultural and scientific advancement, an heir of Christianity, and also an heir of the Enlightenment. Endo's generation, my father's generation, was asked to venture toward the new horizon of opportunity that required rapprochement with the West; culture and sciences promised to pave the way for restoration of postwar Japan. But in both arenas the Japanese found themselves at the margins, not in the mainstream. My father had to leave Japan to pursue the type of research he needed to do, abandoning his tenured position at Tokyo University to the consternation of his alma mater—no one up to that point had dared to step away from that prestigious institution. For Endo, being in the mud swamp and describing the entrapment was part of his faith, but also was an essential part of this post-Meiji-era journey.

It is a paradoxical twist of history that katakana is the earliest form of Japanese phonetic script or syllabary.[15] Buddhist monks created it in the ninth century in order to communicate monosyllabic Chinese in the polysyllabic Japanese language. What is now considered a way to identify what is foreign used to be the main way to identify Japan's unique language and culture. As I've noted, katakana was considered the men's form of writing, as opposed to the more feminine, lyrical hiragana. Japanese have always seen themselves as outsiders to Chinese culture, and therefore Japanese culture is, in itself, an outsider culture. What is truly Japanese may be the quality of refining, as an outsider, what is imported. As early as the tenth century, long before sakoku, Japan began to isolate itself culturally from other cultures. Looking at Amino's upside-down map of Japan, I wonder whether the same shift can take place in twenty-first-century Japan: can what is supposed to be foreign and outsider become a normative reality? Might Japanese culture be able to internalize this possibility? What if there are seeds of such radical permission germinating within Japanese culture? Reading Endo's *Silence* leads naturally to these questions, which the next few chapters will explore. This path of permission germinating leads to the Christian gospel. The life and demise of the tea master Sen no Rikyu holds the key to the birth of fumi-e culture and the missional possibilities that exist for the future. For those interested in journeying into Japanese past through Endo's *Silence*, Rikyu provides a critical backdrop to the story.

HIDDEN FAITH REVEALED

Sen no Rikyu (1522–1591) was one of the greatest innovators to come out of Japanese soil. Rikyu lived in the era leading up to Christian persecution. He was born to a merchant in Osaka (Sakai) in the early sixteenth century. His given name was Yoshiro Tanaka; he later was named Sen no Rikyu in a Buddhist rite. He studied the traditional form of tea under several masters in Sakai, then at Daitoku-ji Temple in Kyoto. He had a close relationship with the warlord Hideyoshi (who eventually ordered Rikyu's seppuku demise and ordered the official persecution of Christians to begin) and with Christian missionaries at the same time. His wife Oriki (one of two wives), who was present when he was forced to end his life at the age of seventy-one, was one of the early converts to Christianity when the capital of Kyoto took hold of the Christian message.[1] Those who professed to be Christians grew to over 300,000 in Japan in the mid-sixteenth century, and among them were many *daimyo* (warlords) and significant cultural figures, including many of Rikyu's disciples. Oribe (the best-known disciple of Rikyu) and five of his seven disciples were known to be either Christians or advocates of faith. This

historical reality is important for those interested in the background of *Silence*, defining the Christ-hidden culture of Japan and the future of how Japan may be liberated.

Rikyu gave an architectural structure to this refinement of hiddenness in his design of tea rooms. Through Rikyu's architecture of tea the missionaries of the sixteenth century learned of tea. His were much smaller in size than most; traditionally, tea was part of a banquet culture in China, and consequently many tea rooms were quite large. The smaller size of Rikyu's tea rooms allowed particular focus on the minute particulars of the movement of hands, subtle gestures of the placement of flowers, and often hidden messages behind the choice of utensils or paintings in the room. Rikyu was first linked with an ostentatiously ornate golden room in Osaka that Hideyoshi desired, but he began to move toward wabi simplicity as he matured in his aesthetics. His most distinct contribution is in the creation of *nijiri-guchi*, a small square entry port designed for the guest to enter the tea house. Rikyu's nijiri-guchi were so small that they forced everyone to bow and remove their swords in order to enter the tea room. Rikyu created a space dedicated to repose, communication and peace.

Deep communication can only take place through a path of vulnerability. In other words, the only way to escape the violent cycle of the age of feudal struggles is to remove one's sword; then, in safety, one can communicate truly. Beauty, one might add, is a gift given through this vulnerability. Beauty that integrates virtue, nature and religion can guide us into wisdom. This is exactly what Sen no Rikyu mastered, a phenomenon that overlapped, curiously, with the influx of Christians and the subsequent persecution of them. In considering the future of Japan, it is helpful to look to the past and to Rikyu, who holds the key to a cultural liberation of Japan—one who lived and died in the realm beyond the persecution years, one who created a distinct Japanese view of aesthetics. Rikyu's language of communication and his unique

individualism are primary examples of a Japan liberated from fumi-e culture. He lived toward that independence, a solitary figure in tumultuous times. He wrote:

I look beyond;
Flowers are not,
Nor tinted leaves.
On the sea beach
A solitary cottage stands[2]

Among the many masters of tea at that time, what stood out was Rikyu's impeccable discernment of refined beauty, which he often found in surprising ordinary objects, or in innovative placement of traditional motifs.

Rikyu did not explicitly identify himself as a follower of Christ, but it is evident from historical records that he held Christianity in highest regard.[3] He borrowed from the Bible its view of the equality of all people and translated it into his tea ceremony, or at least found overlaps. At the same time he took the derivative form of art flowing out of China and Korea, and created a distinct form of Japanese aesthetic.

The most significant portrait of Rikyu, the image that we rely on to know Rikyu's personality and charisma, was painted by Tohaku Hasegawa after Rikyu had died.

The story is told that Rikyu surprised Hideyoshi, the warlord responsible for ordering the edict to expel and persecute Christians, with the gift of a black bowl to serve tea. It was an unusual move, as the highly esteemed bowls of the time had a raku finish of a light color. Artists were quite aware that Hideyoshi did not like the color black, and Rikyu was seen as presenting a subtle challenge to Hideyoshi's power. Scholars dispute the details of this account, but we can be sure of one thing: Rikyu himself did use a black lacquered bowl. He did so to transgress against the customs of the day. Black, it seemed, was his color. Even in stories from the past that are contested, certain realities are hard to dismiss.

Rikyu's black bowl is emblematic of the beauty of sacrifice, and this beauty, bordering on protest against power, is also etched in Endo's works. Just as Rikyu offered the shogun a black tea bowl, Endo offers us a sinister story of the torturous past. Both Rikyu and Endo focused on the hiddenness of true communication. It is remarkable that someone such as Rikyu, an ambassador of peace, reached the pinnacle of influence in the midst of the feudal struggle to survive. It is a testament to Japanese culture that even—or perhaps especially—in a time of such struggle, the Japanese highly valued beauty, especially in the visual form.

Endo confessed in several of his lectures, "I do not know much about tea," which, I am learning, is a clue that Endo was actually interested in the subject and was invested in understanding the mystery of what he pretended not to know. Though Rikyu is not mentioned in *Silence*, his presence is felt throughout. The most important hidden truth of Father Rodrigues's journey in *Silence*, as I've noted, is in the book's appendix.

Tenshin Okakura wrote his introduction to tea in *The Book of Tea*, the most influential book on the subject of tea ceremony in the West. Tenshin's sentiment echoes in my mind as I read about Endo and an artist's role in a traumatic era:

> In the sixteenth century the tea-room afforded a welcome respite from labour to the fierce warriors and statesmen engaged in the unification and reconstruction of Japan. In the seventeenth century, after the strict formalism of Tokugawa rule had been developed, it offered the only opportunity possible for the free communion of artistic spirits.[4]

How did artists communicate in the persecution, the dictatorial Tokugawa era? Endo's work describing the trauma of Christian persecution overlaps with Rikyu not only in the chronology of Japanese history, but also because Endo accomplished what Rikyu also sought: the communication of deep values.[5]

Rikyu's power increased with Hideyoshi's consolidation of Japan and expansion of that power. Endo's *Silence* is the twentieth-century version of Rikyu's silence experienced in the tea house, in which bloodshed, trauma and betrayals are mediated by a deeper communication. As Hideyoshi eventually ordered Rikyu to kill himself in Rikyu's own place of refuge, the tea room in his Kyoto residence, the blood that soaked the tatami mats of Rikyu's teahouse and the blood of the martyrs paraded through the streets of Kyoto only a decade later are connected; the suppression of individual freedom, what I now call fumi-e culture, began with Rikyu's seppuku suicide ritual.

<div align="center">● ● ●</div>

Tenshin writes of Rikyu's suicide: "He only who has lived with the beautiful can die beautifully . . . the friendship of a despot is ever a dangerous honour."[6]

Scholars attribute Rikyu's demise to several factors. One, most significantly, is the wooden statue erected in Rikyu's honor in Daitoku-ji Temple; its placement above the entry gate forced even the warlord to enter under it. This drew Hideyoshi's ire, and he threatened to burn Daitoku-ji down. But persuaded by his advisers not to, he instead had the statue of Rikyu placed on a crucifix (an interesting overlap with Christian imagery). Second, Rikyu vigorously opposed Hideyoshi's invasion of Korea and China. Rikyu was heavily influenced by Korean culture and valued it as influential on his own aesthetic. Third, Hideyoshi reportedly asked that one of Rikyu's daughters be his concubine, but Rikyu refused. The fourth factor—and the most curious to me—is that Hideyoshi desired to be given Rikyu's favorite stone lantern (objects that are linked with Christianity); Rikyu refused, earning the further indignation of Hideyoshi. But the most significant detail about Rikyu's life and death anticipates the persecution of Christians that was to come.

In January 1591 Rikyu served what turned out to be his last tea ceremony for Hideyoshi. On that day, according to witnesses, Rikyu intentionally served a black tea bowl, made by Raku master Chojiro, as his last attempt to communicate his opposition to Hideyoshi, particularly of his invasion of Korea. Rikyu was soon after served notice to commit seppuku. On February 28, 1591 (by the Japanese calendar; by the Western calendar it was April), Kyoto experienced a freak weather pattern of "thunder and heavy rain, with thunder claps, and then heavy hail."[7] The seppuku ritual requires a witness and accompaniment by one samurai whose duty is to sever the neck after the ritual is done. Rikyu had one of his closest disciples, Awajinokami Makita, accompany him into the room to do that task. His Christian wife, Oriki, then entered the room and covered Rikyu's body with a white cloth.[8]

His decapitated head was delivered to Hideyoshi. It is reported that Hideyoshi did not look at the head but ordered that it be wrapped in a chain and placed under the feet of the wooden statue of Rikyu. This created a public spectacle in Modoribashi in Kyoto, where the martyrs would be paraded through six years later. There was no question in the minds of witnesses of the connection between Christianity and Rikyu. This gruesome symbolism of his beheading reverberated throughout Kyoto and then Japan, and soon after the nation entered the 250 years of perse- cution of Christians. Hideyoshi considered his enemies to be "underfoot" and trampled, and he created a spectacle at Modoribashi that put that concept on visual display. To him, the fates of Rikyu and the Christians were the same. The trampling of the master's head leads to fumi-e, and to fumi-e culture, a culture of hidden Christianity.

A BROKEN STONE LANTERN

On a fresh January morning I visited Daitoku-ji Temple. What I know of Daitoku-ji, I learned from my friend Hiroshi Senju, whose New York studio I managed while he was completing a historic commission for the

temple. On 9/11, after my wife and I gathered our family safely in my studio, ten blocks north of the smoldering remains of the Twin Towers, my next order of business was to cover all of Hiroshi's Daitoku-ji paintings with cloth, as I feared the smoke would damage them. Hiroshi was in Paris at the time, unable to fly back. One of the paintings we covered was of Sen no Rikyu walking in the desert.

Daitoku-ji is made up of many subtemples, including Juko-in, where Hiroshi's paintings are located, all worthy of attention. Two of the small temples in particular stood out to me as I visited the temple to do research for this book.

Suiho-in, around the bend of the gravel path from Juko-in, is dedicated to the warlord Sorin Otomo. It was built in 1535. A plaque recounts its history: "A priest named Tesshu Sokyu of the Daitokuji Temple was designated as the founder of the temple, and the new temple was named Zuihoin after Sorin's Buddhist name. He is also known as a Christian warlord who was later baptized." Then the plaque described what I would encounter in one of the stone gardens in the temple:

> There are renowned dry landscape gardens in the center of Kammintei Garden; there are four stones placed lengthwise as well as three stones placed sidewise and these stones cross the garden diagonally. If you see them from the east end of the garden, they look like a large cross.

It is rather startling to find this description on a plaque inside one of the most important cultural properties in Kyoto, in a Buddhist mecca like Daitoku-ji Temple. Otomo passed away before the persecution of Christians officially began, but perhaps he anticipated that Christian faith must be hidden beneath the symbolic language of Chinese stone gardens inside one of the central Buddhistic sites in Japan. I entered to admire the garden, amazed that this property and this message survived the 250 years of suppression and persecution, quietly speaking of faith. It seemed nothing short of miraculous.

Then, I walked toward Koto-in, another main purpose of my visit, to visit a *kasuga-dourou* (a stone lantern).

Koto-in, just a minute's walk from Suiho-in, is a temple renowned for being the final resting place of Tadaoki Hosokawa and his wife Gracia Hosokawa.[9] The stone lantern that marks their burial ground was noted to have been a favorite of Sen no Rikyu. Apparently, Hideyoshi asked for the lantern, and Rikyu refused, saying that the lantern was damaged. As the story goes, it was Rikyu himself who damaged it—he struck the lantern corner with a hammer, breaking it. When he received the order to commit seppuku, Rikyu gave this broken lantern to his friend Hosokawa, one of Rikyu's seven key disciples. Hosokawa proceeded to break the corner further, thereby honoring his master.

Another of Rikyu's disciples, the outspoken Christian martyr Ukon Takayama, was canonized by the Roman Church in 2015. Takayama was a daimyo, one of the great warlords of the feudal era, second in rank only to a shogun, and yet he refused to abdicate his faith. He was exiled to Manila, where he died as a result of years of poverty and persecution in Japan. Thus, Rikyu was surrounded by Christians, and the art of tea reflects that Christian influence.

As I stood to admire the moss-covered lantern, sparkling after a morning rain, I thought of the world in which Rikyu lived and died, and the story of *Silence*.

This is where silence and beauty meet: in the broken lantern of Rikyu. Here, the fumi-e culture is also birthed, and the remnant of faith survived the years of persecution.

I stood in front of this lantern and had an epiphany. I realized a deeper meaning behind the title of this book: in Japan, silence *is* beauty.

Rikyu's refusal to be a puppet of the dictatorial powers, his insistence on personal expression to communicate peace, led to the breaking of the lantern. The broken corner represents not just an individual's resistance to the power of the day but the last attempt to counter the

overwhelming reality of what was to come, the looming reality of sakoku and 250 years of persecution. Yet this lantern survived, and so did Hosokawa's garden, speaking quietly of the faith of the past. They also are testimonies to the alliance of those who, though not Christians themselves, nevertheless stood with those filled with faith, often knowing that it might cost them their lives.

Gracia Hosokawa died refusing to be captured by an invading rival faction (led by Mitsunari Ishida) while her husband was away in a battle. Rather than submit to capture, she ordered her servant to kill her and burn her home down. This shifted the winds of war and gave her husband the needed advantage. Her earlier conversion to Christianity is very well documented: she was guided into faith by Father Gregorio de Céspedes. The plaque under the lantern at Koto-in honors her along with her husband, which is unusual in the cultural context of seventeenth-century Japan. It seems that Tadaoki Hosokawa requested that the couple be honored together with Rikyu's stone lantern. We do not know the faith of Tadaoki Hosokawa or Rikyu, but one thing is true, they are now united in spirit under the broken lantern of seventeenth-century Japan, and the bright green moss, grown over centuries, speaks quietly. Tadaoki saw the journeys of Gracia and Rikyu as a common journey. In the days of persecution stone lanterns came to symbolize, like the Underground Railroad quilts of African American slaves, a secret way to communicate Christian presence. Oribe, another major disciple of Rikyu, created a stone lantern particular to Christians with a unique cross at its base, and this tradition continued throughout the persecution years as the Christian community became increasingly hidden. In Koto-in, Rikyu's lantern serves as a precursor to Oribe's. Oribe, Hosokawa and other disciples must have seen something very significant in the broken stone lantern of Koto-ji. This lantern echoes fumi-e, a worn-smooth surface of feudal struggles, to reveal what Hosokawa and Rikyu valued

the most. Gracia literally was sacrificed for Hosokawa's welfare; Hosokawa's psychology must have been like someone stepping on a fumi-e. A wife's willing sacrifice led to his victory. Endo compared stepping on fumi-e to "stepping on something beautiful, or someone you value," and this story of sacrifice leads to beauty.

Rikyu knew that the persecution was to come. It was not just to persecute Christians but a persecution against free will. Therefore, he hid in the broken lantern, in the black lacquerware, in this aesthetics to prepare for a type of enduring art that would survive the persecution era. In missional terms, we may note that he took a path opposite of the imperialistic communication of religious messages; he hid the message of peace and communal force of resilience in the art of tea, embedding into Japanese culture and the notion of beauty itself the very seeds of freedom and goodness. But this notion must remain silent, as even an attempt to speak of the purpose of tea would be antithetical to the deeper convictions and aesthetic. Endo uncovers this mechanism through his portrayal of trauma in *Silence*. Through fumi-e Endo discovers a universal symbol of trauma, a universal symbol of how we betray the most important and the most beautiful existence of our lives. To step on such a symbol, to betray the deepest recess of our love, can only be done in silence.

In considering Rikyu, then, in terms of missions, we must ask, What cultural forms and practices can we weave into universal symbols of freedom? In considering *Silence* we may ask, What are our own fumi-es?

The stone lantern of Hosokawa leads into his small tea room, just enough to lay down two and a half tatami mats, similar to many tea rooms that Rikyu designed. In the far corner is nijiri-guchi, identical to Rikyu's invention. Japanese beauty captured in the lantern is accentuated within the silence of the tea house as well. Here, the beauty of sacrifice is expressed through small gestures: a single flower or a small scroll painting echoing the seasons, or a simple calligraphy scroll in the *tokonoma*, the

narrow chamber in the back of the tea house. But a visitor cannot ignore the violence of the time captured in the broken stone lantern itself. Thus, in the refined Japanese beauty seen through the darkness, what remains is the powerful witness of a broken lantern through which humble beauty is communicated through silence.

THE REDEMPTION OF
FATHER RODRIGUES

I am completely at peace. Our hut is full of light; I can hear
the cock crow from the foot of the hill; the red flowers are
in bloom, spread over the earth like a beautiful carpet.

Father Rodrigues in Silence

Before Endo named his novel *Silence*, he considered another title. His
original title was *Hinata no Nioi*, which can be translated as "The Aroma
of the Sunshine" or "The Scent of the Sunshine." His publisher balked at
the title and suggested instead *Silence*. Endo later complained that this
revised title has caused readers to misunderstand the main point of the book.
"I did not write a book about the Silence of God; I wrote a book about the
Voice of God speaking through suffering and silence," he noted in the later
documentary about the writing of *Silence*.[1] The discrepancy between the
original title and *Silence* is worth pondering. *The Aroma of the Sunshine*

is hardly what one would expect of a novel with the accursed theme of violence and torture: the sun rarely appears; the novel is dominated by darkness, rain and fog. I began to ponder this discrepancy as I walked about Sotome, where Endo first envisioned *Silence*. It was a very muggy, sunny day. Just like in Kyoto, it had rained in the morning, inviting small crabs with orange claws to come out to bathe into the sun, climbing onto the concrete banks of the river flowing into the ocean.

Japan is Nippon (Sun Pillar), which has been called the "Land of the Rising Sun" after their flag of Hinomaru (Sun Circle).[2] One can infer that Endo originally planned to refer to sunshine in his title in order to create a link with a particular psychological reality of Japanese history. He intentionally juxtaposed the image of the sun against the main story line of darkness, trauma and the fears that dominated his day and the broad arc of Japanese history.

As he wrote the tale that would become known as *Silence*, it is possible too that with that title in mind he was mimicking the master he idolized—Graham Greene. Greene's masterpiece *The Power and the Glory* also has a perplexing title. Endo's British contemporary Greene had a profound effect on Endo, beyond even that of Kawabata or of any other Catholic writer of the day. Greene's endorsement of Endo's *Silence*, which appears on the cover of almost every translated edition of Endo's books—"Endo, to my mind, is one of the finest living novelists"—may have had an impact on the writer's international career more than any other single line of endorsement in literary history. Many years after writing *Silence*, while traveling in London, Endo ran into Greene in an elevator. He recounts later that the encounter, and Greene's willingness to offer a deeper friendship, had an impact on his faith in the providence of God. While working on *Silence*, Endo reread Greene's *The Power and the Glory* many times, and in his notes he remarked on many overlaps between Greene's novel and the narrative he was working on.[3] A Catholic writer in postwar Japan took his inspiration from another Catholic writer

of postwar Britain. Greene opened the path for an objective, steely and sinister view through the lens of faith.

The protagonist of *The Power and the Glory* is a whiskey priest, a missionary to Mexico whose failures are notable and whose faith is weak; there is neither power nor glory in this character. Yet although Endo and Greene depict humanity at its worst and faith at its weakest, their more insistent theme is that through such a broken lens the light of God's grace and power is refracted into the world.

Greene's unnamed padre sees his life and his ministry as utter failures:

> The glittering worlds lay there in space like a promise—the world was not the universe. Somewhere Christ might not have died. He could not believe that to a watcher there this world could shine with such brilliance: it would roll heavily in space under its fog like a burning and abandoned ship. The whole globe was blanketed with his own sin.[4]

That the world could at the same time glitter and be blanketed by fog crystallizes the padre's experience and the story of *Silence*. In Greene's novel too there is a voice of stillness, of silence, a language filled with despair and pathos. The priest's sense that "the whole globe was blanketed with his own sin" captures Endo's sense of his own failures, and captures Father Rodrigues's pain at the end of *Silence*. But just like the rays of sunshine after a storm, Greene's language, and Endo's, cleanses the scene, clearing the way for grace to operate. Endo saw in Greene how a Catholic writer could depict this world as "blanketed with his own sin." Endo sets the scene with a bleak assessment of the world, but beyond the fog we may begin to detect the aroma of the sunshine and to see the possibility of the Golden Country of Japan, a country filled with rice paddies, a muddy swamp now resplendent with golden hues of the abundant harvest.

What Graham Greene wrote of his "whiskey priest" could be said too of Endo's protagonists and even of Endo himself:

He was a man who was supposed to save souls. It had seemed quite simple once, preaching at Benediction, organizing the guilds, having coffee with elderly ladies behind barred windows, blessing new houses with a little incense, wearing black gloves. . . . It was as easy as saving money: now it was a mystery. He was aware of his own desperate inadequacy.[5]

These psychological vacillations fascinated Endo: a priest who struggles with his faith, carrying his shame and lostness into another culture, crossing borders to escape with the same self-hatred and resignation possessed facing his whiskey bottles, yet navigating boldly into foreign lands. Endo himself desired as a teen to become a priest, and such early identification with priesthood is integrated with jarring, sadistic recounting of trauma. Japanese history, Endo wants readers to remember, is a history of such traumas, centered on the culture's denial of Christ. This historical fact, woven through 250 years of persecution, left an indelible impression, creating vacillating ambiguity and a culture that *hides* the most valued treasures of the heart.

THE MAP

On the cover of the first edition of Endo's *Silence* is a map that Portuguese missionaries would have used to navigate to Japan. Endo wrote *Silence* specifically to identify with the outsider looking into Japan as an island that the missionaries considered to be literally the end of the world. The missionaries sent to Japan were educated, intrepid and gifted. When they read what Christians call the Great Commission—Jesus' command in Matthew 28:18-19 that upon the authority of the resurrection, Christians are to "go and make disciples of all nations, baptizing them in the name of the Father and of the Son and of the Holy Spirit"—the missionaries saw Japan as the literal end of this mission.

A particularly intriguing dimension of *Silence* is that it describes two journeys: explicitly, the journey of an outsider into Japan, and implicitly,

the journey of a Japanese Catholic writer finding his true voice as an exile from his own culture. Rather than revert to the nationalistic imperialism of some of his contemporaries, most notably Yukio Mishima (a writer Endo admired greatly), Endo turned toward the empathy of an outsider. Therefore, Endo sets up in the reader's mind the same kind of identity reversal that takes place in Father Rodrigues's heart at the end of *Silence*. By stepping on the fumi-e, Father Rodrigues inverts into his genuine faith, faith not dependent on his religious status or on his own merit, but a faith in grace—grace that, like the rays of sunshine after a rainy day, provides an aroma of the light. He knows too that by stepping on the fumi-e he will set aside his identity as a Portuguese and, at least superficially, subsume his identity into Japanese culture. When the character takes that literal and conceptual step, his mindset closely resembles Japanese groupthink, focusing on his responsibility to the group rather than his own fate or his own faith. Father Rodrigues—or Okada San'emon, the Japanese name that will be given to the apostate priest by a magistrate—must live out the rest of his life in Edo (present-day Tokyo), sequestered and wholly dependent on his enemies.

Such reversal in fortune and identity resembles the experience of an exile, like Endo himself, who suffered greatly with various illnesses and physical challenges. The anatomy of that dependency is filled with wounds that require constant care by others. Endo's wife recounts how her responsibility was to suffer with him, nursing him back to health many times; his mother, who endured the punishing reality of wartime and bleak postwar Japan, encouraged her son to pursue writing despite his father's refusal to support such an impractical journey. These two constant female voices were his companions during his own physical internment during debilitating illnesses. But, in the unexpected journey of Shusaku Endo, out of such limited conditions came a book that speaks powerfully of the liberation of the soul. His imagination and language transcend the cultural and geographical barriers of the world.

Through his description of trauma, Endo succeeded in portraying a story that generatively opens up to the world; it moves the reader toward healing, toward the good news of the Bible. A reader familiar with a typical critique of *Silence* may be startled to read this pronouncement: *Silence* is a profoundly missional novel, despite the fact that it describes the failures of faith. Its mission is not about triumphantly regarding the island of Japan as an imperialistic exploit; rather, it is the mission of entering deeply into the psyche of Japanese hearts struggling with trauma. By doing so, Endo captures the possibility that the good news of the Bible can heal that trauma and provide a way for Japanese to be truly liberated. Endo also enters the heart of the darkness, the Ground Zero of the universal realm of trauma reverberating in the twentieth century. Thus, through the Japanese psyche of silence a story of a universal realm of trauma is unveiled. Endo points to the possibility of the sun breaking through to the common ground of suffering.

Silence portrays Japan as the end of Father Rodrigues's journey. It also offers a genesis moment, if you will—a starting point toward the twenty-first-century global reality now scarred with trauma and past failures of faith. Father Rodrigues's voice, quashed by dictatorial power, today is no longer silent but has, through Endo, become a most ubiquitous voice for the persecuted in the world. Thus, through a weakened voice of a failed priest, Endo shouts from the rooftops to the world. At the end of *Silence* Father Rodrigues must remain silent, but through the best-selling novel, and now the major motion picture, millions will continue to read and watch and hear Father Rodrigues's voice. The prophet Isaiah spoke of the silent offering of a Savior to come:

> He was oppressed and afflicted,
> yet he did not open his mouth;
> he was led like a lamb to the slaughter,
> and as a sheep before its shearers is silent,
> so he did not open his mouth. (Isaiah 53:7)

This silent voice that paradoxically speaks the loudest is also the voice of Christ, Christ who remained silent in front of King Herod facing his execution (see Luke 23:8-9). Often, God speaks through silence.

That "aroma of the sunshine" can also light the way for a recovery of the identity of the Japanese as a gathering of diverse seafarers, as a multicultural and religiously diverse nation at the endpoint of the Silk Road and as the island at the end of the world. We can see the Ground Zero of Nagasaki and Hiroshima as a point of departure into a new journey. Endo's arc as a writer, from *White Man* to *Deep River*, suggests that the Japanese can introduce a missional vision into the global consciousness. The popularity of works such as *Deep River* (which I am told is as much read outside Japan as *Silence*) suggests that Endo succeeded in penetrating the sphere of Western audiences. Out of Japan's torturous past came a story that deeply probes Western consciousness, because the story depicts so well the power of such an inversion, a failure of past religions to take root in the "muddy ground" of Japan. At the same time *Silence* depicts a new outlook much like our twenty-first-century understanding of global Christianity. Rather than a triumphant Western faith, *Silence* depicts God in more ambiguous and empathetic terms. This God, seen through a Japanese sensibility, experiences pain through God's children, works through weakness rather than strength, communicates by dependence more than independence, and introduces a voice of Christ that flows out of the fumi-e, an icon of failure and betrayal.

Every reader of *Silence* initially assumes that Kichijiro is a Judas figure. But at the end of the novel this assumption is turned on its head; Kichijiro turns out to be a reluctant and unexpected agent of change. In him readers find a minute grain of hope that in the years following Father Rodrigues's denial of his faith, Kichijiro will experience Peter-like repentance instead of Judas-like remorse. The transformation of Kichijiro, which may escape the notice of all but the most careful reader, comes through the sacrifice

of Father Rodrigues's own attachment to his Western faith. In that searing vision of grace, Endo injects hope through weakness, a uniquely Japanese concept, back into the world.

Art, refracted through broken shards, flows out of the dull aching of Father Rodrigues's foot as it steps on the worn-smooth face of Christ. Such sacrifice is beautiful, embedded and hidden in Japanese culture. Unexpectedly, the voice of the Christ of the fumi-e becomes the most powerful expression of the voice of Christ in Japanese literature, and Kichijiro, no longer the voice of Judas, becomes a singular voice of hope in the wilderness of trauma. Christ can speak to all those who face despair and a crisis of faith, looking over their Ground Zero experiences of trauma. As they experience failures and losses, they discern a voice, one that only the weak and the vulnerable can hear; as it turns out, it is the voice of Father Rodrigues himself, recounting the tale of *Silence*. His voice, through his own silence, is powerful and beautiful. Such is the true redemption of Father Rodrigues.

THE APPENDIX

In the appendix to *Silence*, Kichijiro is found to be in possession of an object of Christian adoration, an amulet case with carvings of St. Paul, St. Peter and Francis Xavier.[6] In a concrete way, therefore, Kichijiro possesses and preserves faith, though like the crypto-Christian's faith, it is hidden. But when asked how he came upon the object, instead of denying his faith again Kichijiro protects Father Rodrigues and his attendants from this discovery of an object that someone "dropped." Even from these scant details, it's clear that Kichijiro is no longer filled with fear; he has grown beyond his past, which was full of betrayals. His last act of faith is to stand on his claims of faith. What an extraordinary shift in character! Furthermore, it is clear from the story that even after Father Rodrigues steps on the fumi-e, he never ceases to be a Padre to Kichijiro. In the hidden reality that *Silence* portrays, Father Rodrigues, at the end, becomes

fully immersed in the Japanese way of hidden faith. Stripped of his priestly collar and his religious credentials, imprisoned for life, he becomes a quiet witness even under Inoue's watchful eye. He is the image of Endo's ideal leader: one who has fallen and lost all his credentials and respect from the institution of the Christian church, but who nevertheless has kept his personal faith and continues to minister without any reward or credit. Behind the veil of secrecy, delicate trails of misinformation and the fog of history, Father Rodrigues not only survives the seventeenth-century persecution, he perseveres through the cruel mind game of Inoue, and dares to minister as an underground priest—not only to Kichijiro but to many. Like the meaning of the stone lanterns in Toko-in, the redemption of Father Rodrigues is hidden in *Silence*.

Just as Kakure Kirishitan continued to honor God despite their survival response of stepping on the fumi-e every Oshogatsu (New Year's Day), Father Rodrigues must have learned to dance, ever so carefully, his new identify as Okada San'emon. He must have learned covert ways to keep his faith, through what Kichijiro told him about the crypto-Christians operating in the communities he knew. And perhaps Kichijiro was able, eventually, to recognize his own failures as genesis points of discovery. Instead of finding himself isolated, as he was before, it is likely that he found others like himself, weak and unable to withstand torture, who like him betrayed their faith by stepping on the fumi-e. He must have learned their art of hiding their faith, and he may have discovered that such a path could lead him back to his relationship with his Padre. At that point, then, Kichijiro became a teacher of the ways of these crypto-Christians.

Father Rodrigues must have earned a modicum of trust from Japanese officials he needed to survive. He clearly stopped short of persecuting Hidden Christians, the type of persecution Chuan (the former Father Ferreira) continued to participate in. In a culture that was simultaneously cruel and kind, Father Rodrigues chose the Japanese nature based in

compassion, kindness and stoic resistance to the darkness. He seemed to choose at the end a path of nonviolent resistance by starving himself to death. (In Endo's account San'emon refuses to eat at the age of sixty-four; the historical figure the character is based on did so at eighty-four; in the movie he dies at seventy-four.) Fatalistic thinking can lure us to believe that the closed system of nature and the world is all there is. When the trapdoor shut behind Father Ferreira and Father Rodrigues, in Inoue's mind the formality of recantation was the ultimate violation that even God himself could not reach beyond. Inoue was wrong. The power of forgiveness can break through any imprisonment and torture.

Father Rodrigues was pulverized, and the layers of prismatic, pulverized fragments, the layers of betrayal and lost hope were the beginning of his new journey of grace. He was trapped by circumstances, but he never surrendered his spirit. He never wrote the document that he was ordered to write, a thesis denouncing Christianity, as Chuan had done earlier. He managed to live out his faith by somehow convincing the authorities to recuse him from such a duty. To accomplish this he must have developed an extraordinary capacity for understanding the nature of Japanese thinking, and he must have relied on his faith for guidance. Did his remnant of faith bring his soul the freedom to withstand the torture he suffered? Forgiveness and redemption are available to all, regardless of circumstances. Once the soul is set free, the imagination can reach beyond one's limited circumstance and imprisonment. The prison cell can then become a tea house for contemplation; the light coming through the cell windows can carry the aroma of hope. To Endo imprisonment may have seemed familiar. He did a great deal of his writing in and out of hospital beds, even during recuperation at home from the illnesses that dogged him throughout his adult life, and devoting his limited energy to his art must have made his life's journey an arduous one. Instead of Tokugawa enforcers testing Father Rodrigues's faith, Endo's own body entrapped him in despair and pain. He could have

chosen to give himself to such despair, but instead he chose to allow his soul to be set free and to use his imaginative capacity to depict the unflinching reality that life is shot through with pain and suffering, and yet ends in a certain hope filled with compassion.

From my viewpoint as an artist trained in nihonga, I have speculated about another fanciful reality for Father Rodrigues (or the historical character of Giuseppe Chiara). The neighborhood of merchants where he lived, Shita-machi, is where I now shop for nihonga materials, and I happily wonder whether he lived in proximity to artisans of his time, artisans working to layer pulverized pigments, learning the art of hidden beauty, the beauty born of sacrifice. In the later play that Endo wrote titled *Golden Country*, Father Ferreira is said to have picked up painting after his apostasy. Endo would have known of another Giuseppe who was a Jesuit missionary—Giuseppe Castiglione, who ended up in China early in the eighteenth century. He was a painter too; his masterful depiction of a horse (*Horse Zizaiju* [1743]) is in the collection of the Imperial Treasures of the Palace Museum in Beijing. Jesuit priests received some of the finest education of that time, and my fanciful speculation reaches toward the possibility that Giuseppe Chiara also may have known and appreciated paintings and art. The visual descriptions of Japan that Endo has Father Rodrigues deliver indicate that the author understands this character to have a visual diction. Given the nature of Father Rodrigues's house arrest, meeting with local artisans would have been impossible; he was not to be allowed even a glimpse into the wider world. But I wonder whether, as part of his new identity, he would have done well to paint (as he did not have much to do, being under house arrest). At the point in history when the novel concludes, the Japanese style of painting was quickly becoming one of the most refined expressions of beauty in the world through the Kano schools and early Rinpa designs. Most of the artisans of the time were hosted and patronized by the Buddhist and Shinto temples, even though they themselves were of quite independent minds and hearts. At the Kosho-ji Temple in Kamakura

and others elsewhere, some Buddhist monks clearly risked their own reputations and lives by harboring Hidden Christians. Many of the artists in Kyoto were associated with Sen no Rikyu, who injected a dose of egalitarian, individual freedom into the heart of culture, and for their link with him they were ultimately seen as troublemakers. The merchant class, increasing in power, commissioned artists like Korin to paint images displaying their wealth, but also showcasing their sense of independence from the magistrates. Artists like Tohaku Hasegawa, an adherent of Kyoto's Buddhistic sect of Nichiren, were targeted by Ieyasu and Hideyoshi as dangerous. Artists and artisans began to paint hidden messages in their art, some intentionally but others quite unconsciously. Father Rodrigues would have found these artists to be aesthetic comrades in his own secret journey of grace. But such thoughts, as I freely admit, are fanciful.

There is no question that Father Rodrigues would have heard of Sen no Rikyu. He might also have been aware of the Michelangelo of his time, Tohaku Hasegawa, and others such as Tawaraya Sotatsu and the Kano school of master painters. While it would have been impossible for him to see any of Hasegawa's works or those of other luminaries of the time, he might have been told of the courageous Christian followers and disciples of Rikyu, persecuted and exiled as Father Rodrigues was. One of them, Ukon Takayama, who was canonized by the Catholic church in 2015, was exiled to Manila some fifteen years before Father Rodrigues would have landed, thus the news of his demise and Rikyu's influence would have been well known even by outsiders. Both Koetsu, calligrapher, and Hasegawa, painter, were linked to Rikyu's circle; Rikyu and Hasegawa were close friends, and Oribe (one of Rikyu's seven disciples) was a calligraphy disciple of Koetsu. And on the other side of the coin it is possible—even probable—that artisans of the time heard about apostates such as Chiara. After all, Father Chiara was the last priest to remain in Japan, and especially with Chiara's recanting of his priesthood, Inoue would have made sure that news of him would have been spread all over Japan to create fear among the Hidden Christians.

THE BLACK MOON

Tohaku Hasegawa's famed byobu screens *Ryu-kyou-suisha-zu* (*The Watermill at Willow Tree Bridge*) in Hyogo prefecture's Kosetsu Bijutsukan would have been painted prior to Father Rodrigues's time in Japan. Here again my speculation moves beyond what is provable in art-historical perspectives. But what follows is connected with Rikyu's black tea bowl, and I do not think that it is fanciful; it is probable.

Rikyu's black bowl signifies a language of hidden power. By "hidden messages" I do not mean crypto-symbolism like some claim is present in da Vinci's mural paintings of the Last Supper, a code of insurrection against church authorities. What I am speaking of is highly intuitive language of hiddenness in a culture that is oppressed, and in many cases traumatized, and must remain stoic about that trauma.

On a recent visit to the Tokyo National Museum (the same museum where I saw the fumi-e displayed), I saw Hasegawa's screen painting *Ryu-kyou-suisha-zu*. I stood before it mesmerized by its details. The work has a unique silver moon. Silver tarnishes over time, and the moon is now completely black. I know from works of earlier artists that the late 1500s, when Hasegawa painted these screens, was a period when use of silver became popular and artisans sometimes used it knowing it would tarnish and turn black. It is unclear which images artists created with a desire for the silver to turn black, but I suspect that Hasegawa used silver for this moon with that intention.

It is a waning gibbous moon, the phase in which a bit more than half of the moon's illuminated surface is visible from earth, and it appears to bulge out on one side. In *Ryu-kyou-suisha-zu*, Hasegawa's moon is turned about 30 degrees from the norm. What's curious is that it is impossible for a moon to look this way, except in the very early morning, and even that only rarely. Historical records of the moon cycles tell us that such a moon could have appeared in the last days of Sen no Rikyu. When

Hideyoshi ordered Rikyu to commit seppuku, Rikyu took a late evening boat out of Kyoto. His last poem is about the moon—perhaps the moon he observed that night. (His poem does not share the shape.) Given that silver is known to tarnish, could it be possible that Hasegawa intentionally painted the gibbous moon in honor of Rikyu? Could this be an influence of Sen no Rikyu's famed black tea bowl, as the depiction of the moon is rather oddly cut off in a corner of this artwork? Silver is the hidden color (the "third color" of my mentor Matazo Kayama) of the seventeenth century, and artists and artisans used silver to express deep sentiments of lament, *mono-no-aware* (pathos of things), and trauma by creating beauty of pathos.

In a 2015 exhibit of Japanese paintings at the Metropolitan Museum of Art in New York City, I was astounded to find a moon of the same shape in a work by another renowned artist of the time. Tawaraya Sotatsu (at least, it is attributed to his school) painted it, it seems, a few years later.[7]

I began to speculate: Could it be that this unusual moon, darkened to black with age, painted by Hasegawa, Sotatsu and their disciples, also was a tribute to Sen no Rikyu? When it was painted the silver would have been untarnished, and therefore few would have surmised any connection to Rikyu's famed black bowl. But it was certain that oxidation would take place and that perhaps fifty years later it would reveal the hidden message. There is, of course, no collaborating evidence from historians of Japanese art supporting this speculation. What I am suggesting here will be treated as an impossible notion in Japanese circles. But as I stood at the Metropolitan Museum that day looking at the gibbous moon of the Sotatsu school, I could not help but to ask these questions. Was this an homage to Rikyu? Were both Sotatsu and Hasegawa secretly communing with the tea master?

Art reveals the power of the intuitive, capturing the reality hiding beneath the culture.

The black, foreboding moon symbolizes the hidden light of Japanese beauty. In this refined aesthetic, what is ephemeral and tarnishing sym-

bolizes their humanity. Yasunari Kawabata began his Nobel speech by quoting from a Zen poem by Myoen (1173–1232):

The winter moon comes from the clouds to keep me company.
The wind is piercing, the snow is cold.

Myoen's moon is a bright, clear light, shining on him to keep him company on dark, clear nights. But the clouds move in and out, creating ambiguity; beauty moves in and out of deep despair. Kawabata himself describes as "the eyes in their last extremity" the type of despair-filled beauty about which Ryunosuke Akutagawa, an author admired by both Kawabata and Endo, wrote in his suicide note. Sen no Rikyu's vision had a deep influence on Kawabata: the moon is darkened, and the mysteries of a liminal space define the Japanese aesthetic. Fumi-e culture is a culture of lament, and the art of Japan, especially after Rikyu, reflects the language of trauma hidden deep beneath Japanese culture.

<p style="text-align:center">❧ ❧ ❧</p>

Many point to *Shorinzu-Byobu* (*Pine Forest Screens*), another screen painting by Tohaku Hasegawa, as one of the greatest masterpieces of Japanese art. The multiscreen piece in the collection of the Tokyo National Museum is painted with only sumi ink; it depicts a pine forest with trees almost disappearing into the fog. Some say it expresses the "sound of silence." This masterpiece of seventeenth-century art is shrouded in mystery, but recent scholarship narrates the background story of *Shorinzu-Byobu*. Tohaku painted the famed image after Rikyu's death, and also as an homage to his own son, Kyuzo, also an artist, who died young.

Before he passed at the young age of twenty-six, Kyuzo painted an indelible image of cherry blossoms, which is placed next to his father's major commission at Chishaku-in in Kyoto. What is outstanding about the younger Hasegawa's work is that he used, perhaps for the first time in the history of Japanese art, a unique technique of mixing sand into oyster-

shell paint, creating what looks like a scalloped design as in European interiors. Some have speculated that this new way of painting was directly influenced by viewing Western icons and religious paintings. Historically this link makes sense; many books recount young Hasegawa's interest in Western culture and his encounters with Western doctors and nurses who came to Japan as missionaries.

In the raised, bumpy surface of cherry blossoms, Hasegawa intimates the beginning of fumi-e culture. The blossoms are three-dimensional, literally protruding. In an artistic tradition in which the surface of paintings was flat, this technique is a dramatic variation; elements of the painting literally stick out of the conventional norm. In the centuries that followed, Japanese art would pursue a direction toward what contemporary artist Takashi Murakami identifies as a "Super-Flat" aesthetic. Yet, Kyuzo literally pushed his aesthetic toward a different path. Some speculate that Kyuzo's precocious talent made him an easy target of the rival Kano school of painters. Kyuzo was at work on a major commission when the scaffolding he was standing on collapsed. Could it be that the scaffolding had been compromised to damage the apparent heir of the Hasegawa school? Even that speculation by some scholars is revealing; this rivalry may have been more than jealousy between two artistic schools. The Kano school, in its infancy at that time, represented long years of nationalistic painters who catered to dictatorial forces and increasingly wealthy merchants in Edo. They were, in essence, a school that trained artists to thrive in the era of dictatorial oppression. Rikyu favored the more idiosyncratic expressions of Tohaku Hasegawa. Thus, the two schools, Kano versus Hasegawa, began to represent opposite ends of the spectrum of art making in the feudal era.

The scalloped images of Kyuzo Hasegawa's cherry blossoms resemble the surface of fumi-e. Visually, in my mind, they overlap as two tragic expressions of the early Tokugawa era. Kyuzo's father's lament would be expressed in *Shorinzu-Byobu*, the masterful painting of a pine forest

filled with empty spaces and foggy ambiguity. Tohaku chose to paint in a style markedly different from Kyuzo's protruding surfaces; he used ample sumi ink on a water-saturated calligraphy brush to paint not just pine trees and the mountains of his youth, but to paint silence. This painting explores depth by depicting a world disappearing into the mystery of the fog. In this work silence and beauty are connected, fused together by his lament for his son and for the foreboding darkness that would ensue after the death of Rikyu. The age of lament began at this point in history: deep, dark, foggy longing that would over time create in Japan what Endo called the "mud swamp," and ultimately what I call fumi-e culture. This is the sentiment and experience that Rikyu and his disciples tried to capture in their tea houses and in their stone gardens, a sentiment they tried to preserve and protect, a reality of shalom in the face of the trauma of their day.

<p style="text-align:center">☙ ☙ ☙</p>

Human expression and imagination can never be trapped within the closed walls of dictatorial forces. History has shown that in prison the likes of Alexander Solzhenitsyn and Martin Luther King Jr. crafted words that broke through the oppressive reality of their day. Words and images are powerful. In the highly visual culture of Japan, such quiet rebellion would most likely start from a visual artisan's hand. These aesthetic revolutionaries would have found people like Father Rodrigues intriguing as intimations of liberation, and from the viewpoint of the likes of Father Rodrigues the aesthetic revolutionaries would likely have been sources of comfort as informants of the world of grace.

In the bright, decorative beauty of Edo screens, Father Rodrigues would have found healing in rays of sun created with layers of pulverized minerals and sheets of gold, rays appearing to shine through Japanese culture. He would have found his identity in the darkening silver moon, a black hole created against the sky, foreboding yet powerfully beautiful.

If he ever had seen screens like this, it could only have been in situations in which he was under duress—perhaps in a New Year's celebration (when he would, no doubt, be asked to step on the fumi-e again). But even in such a glimpse the golden surfaces would have been to him, as they are to me, representations of the city of God descending on the city of humans, a city made of wicked denial of Christian faith; and expressions of what was suppressed, whether consciously or unconsciously; and paths leading into the culture of the floating world of enchantment. Though Endo would not have speculated to this end, this scene would have been truly a vision of the "aroma of the sunshine," a golden vision of a "Golden Country." Like *Shorinzu Byobu*, to a sharp observer Father Rodrigues's visage would have been shrouded in mystery, hiding behind the fogs of Japanese culture of lament.

St. Paul speaks of the aroma of Christ:

> We are to God the pleasing aroma of Christ among those who are being saved and those who are perishing. To the one we are an aroma that brings death; to the other, an aroma that brings life. And who is equal to such a task? (2 Corinthians 2:15-16)

To Endo, the aroma of the sun pointed to Christ as it burst out of the Satome hills in Nagasaki, with dragonflies all about and the evaporating water puddles mixing with pungent ocean. This Christian vision for Japan has been misunderstood by many Japanese as "an aroma that brings death." In no uncertain terms, on the day that the atomic bomb exploded in Nagasaki, that act by a Western nation seen as a Christian nation deepened the wounds of the Japanese soul. The detonation brought the light of death, a human-made sun of destruction. In Endo, the Ground Zero reality of Nagasaki is a cancellation point, a point of stillness, silence filled with toxic aroma; the faces of the martyrs overlook the valleys where incalculable suffering took place. More Christians died in the atomic destruction at Nagasaki (an estimated 8,500, as the

bomb hit while Christians were gathered for Mass) than those tortured during 250 years of persecution. Thus far, the Roman Catholic Church has canonized 188 as martyrs from the persecution era.[8] As the bells of Nagasaki toll for all of us, so the effectual prayers of the saints of the past and present mediate the suffering, speaking toward the future as they atone for the past.

MARTIN SCORSESE AND *SILENCE*

During my graduate studies, my wife and I became friends with a small group of missionaries in northern Tokyo, and I gratefully count myself as one of those who benefited from their missionary activities. As a new believer in Christ I had much to learn, and I was eager to. I attended prayer meetings and parachurch mission gatherings for students, and volunteered at many outreach events.

One Sunday as my pastor greeted congregants heading home, he held out a petition form. "Do you know about the awful film called *The Last Temptation of Christ*?" he asked. I told him that I had heard about the controversy, but I had not seen the film. "Don't see it; here, sign this petition to boycott the film," he urged me.

At that moment I fell into the cultural gap between my missionary community and the art world. As I hesitated, my wife stepped in. "Artists may have other roles to play than to boycott the film," she said. I agreed, and my pastor, though disappointed, understood.

An artist is often pulled in two directions. Religiously conservative people tend to see culture as suspect at best, and when cultural statements are made to transgress the normative reality they hold dear, their default reaction is to oppose and boycott. People in the more liberal artistic community see these transgressive steps as necessary for their "freedom of expression." An artist like me, who values both religion and art, will be exiled from both. I try to hold together both of these commitments, but it is a struggle.

The Last Temptation of Christ was a fumi-e moment for me. In the late 1980s conservatives used the film as a fumi-e-like litmus test to force people to choose sides. To my conservative friends a decision not to boycott the film would have been perceived as a betrayal. Fortunately, my pastor did not push me to sign that petition.

<p style="text-align:center">∽ ∽ ∽</p>

When I first met Martin Scorsese in 2013, we spoke of *The Last Temptation*. I wanted to know whether he saw the *Silence* project with the same mindset as *The Last Temptation*. After speaking with him for over an hour, it was clear to me that the projects were of different tracks and motivations. He told me of his encounter with Endo's *Silence*. When *The Last Temptation* debuted in 1988, Scorsese scheduled special screenings of it in New York City for religious leaders there. In that context the Episcopal archbishop of New York approached Scorsese and gave him a copy of *Silence*.

In what seems to have been a divine coincidence, Scorsese left soon afterward for Japan to work on Akira Kurosawa's last film. He took *Silence* with him and read it on the plane. Thus, around the time that I was asked to boycott his film, Scorsese was immersed in the *Silence* journey and was in Japan. "By the time I landed in Tokyo," he told me years later, "I knew that this is the work I must make. I have been trying to do so for the last twenty-five years."

In an essay in a 2015 book exploring new perspectives on *Silence*, Scorsese writes,

> Cinema is the telling of stories with images and sounds—or, in the case of avant-garde cinema, the embodiment and conveyance of emotion with images and sounds. But that's just a job description. I think that every truly great work of art orients you toward what isn't there, what can't be seen or described or named. It happens differently

in different forms of art. In music, in poetry, in painting, universes of emotion and mystery are circled over and felt, like feeling the contours of a passageway in the darkness. In the novel, what is said and described opens the way to what isn't, that which can only be intimated, sensed (I'm thinking of the title of one of Samuel Beckett's novels, *The Unnamable*). In the greatest movies, what we see points the way to what we don't see, what we can't see.[9]

Typically, in Protestant missionary culture, a book or film like *Silence* can seem questionable. How can the story of a church leader who abandons faith be edifying? Isn't the whole point of our mission to keep our faith?

What is faith? How does art help us to journey on? What makes Endo's work so indelible and enduring? What compelled Martin Scorsese to create a film of it that he calls his "life-work"? Why does *Silence* continue to haunt me?

After twenty-five years of thinking about these issues, I have come to understand that *Silence* drives a reader (or a viewer of the film) to wrestle deeply with faith, art and culture. It provides an essential link between our journey of faith and our experience within culture. *Silence* creates a possibility of a nondualistic world, one not framed by an oversimplified, black-and-white assessment of the nature of faith. Ultimately, faith is not forced on any of us; it is a gift of grace given to us by a gratuitous God. God does not need us. He created us for this gratuitous love, and therefore we are loved deeply by the master Artist. Although Endo understood this implicitly, throughout his life he continued to struggle with the nature of suffering. He was, therefore, an ideal storyteller to create a threshold experience for the reader or viewer, whether religious or not. *Silence* probes deeply into the psyche of our conflicted time and the post–Ground Zero reality of twenty-first-century lives. The worn-smooth surface of every fumi-e still speaks the voice of the suffering Christ, and at the same time embosses impressions of persecution on our hearts. The mystery of God's

presence, the reality of darkness and our journey into suffering are melded into the paradox of beauty (美)—not cosmetic superficialities, but beauty connected with suffering, the kind of beauty that defines Japanese culture.

What intrigued Martin Scorsese about *Silence* is how it gets to the hiddenness of true reality, or its "suppression" as he calls it in his essay. Creating a film that expresses this reflects the same impulse that drove Tohaku Hasegawa to depict a pine forest, and that drove Hasegawa and Tawaraya Sotatsu to paint silver gibbous moons they knew would blacken. Cinema, as a medium of hiddenness, continues the great Japanese tradition of hidden beauty. Scorsese continues in his illuminating essay,

> Endo's novel confronts the mystery of Christian faith, and by extension the mystery of faith itself. Rodrigues learns, one painful step at a time, that God's love is more mysterious than he knows, that He leaves much more to the ways of men than we realize, and that He is always present . . . even in His silence. . . . [Rodrigues] will not be following in the footsteps of Jesus. He will be taking a less revered path, and therefore playing a very different role. This is the most painful realization of all.[10]

Martin Scorsese's faith journey is, and should be, a mystery; like Endo, we do not need to force every faith journey into an institutional category. The author was, and the filmmaker is, a reliable artist committed to his craft. Over and over both have proved that they find integrity in the art process. Now, that does not mean that Martin Scorsese will make a film, including *Silence*, devoid of offensive elements or morally objectionable content. Endo himself caused quite a stir with his book *Scandal* (which has a plot that involves sexual transgressions, but is at its heart about perception of the psychological identity of a public figure). It is important for us to notice what is hidden between Endo's words, behind the obvious. Likewise, to watch Scorsese's *Silence* is to ponder what he means by "the mystery of faith itself."

In a world where religious freedom is increasingly considered a frontline issue, we will do well to learn from the multifaceted stories that Endo crafted to deal with such a time as ours, whether on a page or on a screen. Cinema can create a cultural moment, an opportunity to step into some of the most pressing issues of the day. The timing of the release of Martin Scorsese's *Silence* may prove to be a divine moment for those who seek to highlight the ongoing religious persecution around the world. Every day in the media we come face to face with fearful realities of evil and death, and being a Christian can be a tenuous existence in such an anxiety-filled landscape. But Christians are to hold to hope in the midst of suffering and to face these circumstances with a different perspective. While the world runs away from conflicts and wounds, Christians can run toward them. We need not fear our own demise, as God has already taken care of our fate. This is the "cross that we must bear" as followers of Christ: "With his wounds we are healed" (Isaiah 53:5 ESV). During the fourteenth-century black plague Christians were known to have cared for the sick, to such an extent that their witness became equated with compassion and care. This does not mean that those marked by Christ will not suffer or that we have different rules than the rest and so we can act without prudence. But our sufferings will have meaning, and we will experience that "perfect love drives out fear" (1 John 4:18).

What Endo gets at, and repeatedly obsesses over in all of his writings, is the fate of those who are pushed beyond the normative categories of experience. Martin Scorsese's script, very faithful to the book, reveals the deeper, artful way of pushing us out of normative categories of experience as well. Endo seems to argue that none of us are exempt from the possibility of complete failure if we face extraordinary torture and dehumanization. Scorsese translates this trauma to a hidden, and therefore more powerful, view of fear. Neither of them discounts the possibility that even in such circumstances one may rise above all the darkness and achieve heroic heights—or true martyrdom. But Endo's focus is on the weak, those who

cannot rise above their fears and whose circumstances expose their inner demise. Given the worst scenario, the most nightmare-filled turn of events, what virtue and faith remain?

Endo created, and Scorsese translates to film, a narrative that runs counter to the usual heroic storyline. Endo and Scorsese strip the characters of *Silence* of all they have desired and depict a worst-case scenario for them. The novel and the film expose the dehumanized, the corrupt, the cruel in the world. Yet what appears beyond such a torturous path is not despair and nihilistic cynicism. It is worth repeating that of all the postwar writers of Japan—so many of whom died by suicide, including Kawabata, Akutagawa, Mishima and Dazai—Endo remains, with Oe, among the few who did not succumb to utter despair. Endo, in that example, charts the path toward the next generation.

Dark, despair-filled works of art like Endo's writings or Scorsese's films lead us to an important question: given the reality of torturous conditions, can anything good come of them? What makes evil and suffering meaningful even when we cannot manage to remain faithful?

CHRYSALIS

A butterfly must go through the darkness inside a chrysalis; a seed must "die," to be buried, in the dark soil to germinate. A familiar Christian liturgy says, "Dying you destroyed our death; Rising you restored our life." Darkness, nature tells us, is necessary for life and for the beauty of a generative existence. Darkness, Jesus tells us, is a necessary condition for our resurrection. Even if one is not a Christian, if natural reality attests to this cycle of death and life, why do we modern humans resist this? Art ventures into an arena of human experience that normative reality ignores. Art probes deeply into the darkness and reaches beyond nature at times to reveal what is truly beautiful on the other side of darkness.

As an artist I notice over and over that the machinery that transmits the message of art, or even the ultimate message of the good news, has

been reduced to mechanisms. These fall far short of the fullness of human experience. Consumerism will always reduce the human experience to marketable soundbites. These mechanisms will not allow our souls to be transformed from caterpillar to butterfly. Artists, on the other hand, often truthfully depict both the exterior and interior language of life and fully amplify an experience by giving wings through their imagination. Yet the mechanisms of publishing, the gallery scene and the entertainment world not only dilute that truthful message but often betray the story's vitality. Curiously, what happens to artists parallels the gospel transmission in modern times. In many quarters communication of the good news is a consumer-driven, mall-like experience that plays to people's escapist fantasies; going to church or attending a Christian concert often is a reprieve from the ills that face us. Works like *Silence* seem harsh and stark, and they seem to hit home too deeply in an entertainment-filled world. Rarely do we encounter art that gives attention to the complexity, paradoxes and mysteries of life without falling into the abyss of despair.

Silence is an antidote to the morphine-like numbness of our culture. It can and should shock us to see the deeper reality beyond the normative reality. If we care to know how deep the suffering of Christ goes—and how vast and even violent is the restoration process through Christ's suffering—then we had better start with knowing the dark, cruel reality of the fallen world. If we care to embrace hope despite what encompasses us, the impossibility of life and the inevitability of death, then we must embrace a vision that will endure beyond our failures. We should not journey toward a world in which "solutions" to the "problems" are sought, but a world that acknowledges the possibility of the existence of grace beyond even the greatest of traumas, the Ground-Zero realities of our lives. In such a journey evil is no longer equal to the good, but the stench of death all around us, pulverized by even atomic powers, will remind us that it is despite ourselves that grace and restoration can take place. In a surrender to the inevitable we dethrone evil of its power.

Evil is not a very good teacher. Some Christians promote the idea that evil and suffering exist as mechanisms to teach us to trust God or to become better human beings. I disagree. Evil is a parasite; it lurks just beyond what appears to be good and noble, and will take advantage of our propensity to trust. Suffering that stems from evil cannot be justified as a means to "become a better human being." However, evil fundamentally erodes any heart it lodges in. Those who make evil a schoolmaster and regard it as somehow ordained by the good God to provide a classroom experience of growth will logically have to assume that evil was created by God.

Since God is by definition uncreated but lies beyond what we can discern from the natural mechanism of the universe, it would be absurd to bring God into a limited human conception of creation. The very existence of the historical Jesus, God incarnate, seems absurd to some but true to others.

Father Rodrigues and the historical character of Father Chiara remain obscure. *Silence* amplified a silent voice never heard in history until Endo wrote, and now that voice is being heard in America's most influential culture, Hollywood. Father Rodrigues's hidden voice now has become the most powerful, resonant voice of the persecuted.

THE AROMA

Toward an Antidote to Trauma

Western observers have done important work in recent years to help Americans understand the impact of past trauma still powerfully present in Japanese culture today. In 2006 journalist Michael Zielenziger published *Shutting Out the Sun: How Japan Created Its Own Lost Generation*, which merges political and economic analysis with social commentary about issues of meaning and identity for young people in Japan today. Duke University anthropologist Anne Allison's *Precarious Japan* (2013) recounts more recent stories we rarely hear that reveal the deeper trauma and malaise of Japan. They are two of the most important books on contemporary Japan in this era, and they helpfully describe the psychological, economic and sociological reality that haunts Japan today. Both of these important works deserve a close look here because they amplify our understanding of fumi-e culture. In a brief analysis of them I will suggest ways toward healing of the Japanese psyche that may lead to a thriving Japanese culture.

T. S. Eliot noted that culture can be defined as "that which makes life worth living." Eliot understood that in every culture Christianity is a catalyst working to reset the culture toward full human thriving, and he understood that the biblical view of liberation includes all of humanity, not just those who are Christians. The purpose of this book is to take Eliot's definition and apply it to Japanese culture. What type of reality would create an optimal condition for a thriving Japan? Does *Silence* point the way to such an outcome, despite Endo's proclivity to focus only on the trauma of Japan's historical past? *Shutting Out the Sun, Precarious Japan* and other perceptive works help us to identify the challenges through which such thriving becomes possible.

Just as Ruth Benedict effectively analyzed the motifs of the chrysanthemum and the sword in postwar Japan, Zielenziger and Allison trace cultural themes of late twentieth and early twenty-first-century Japan—the causes and effects of Japan's well-documented postbubble economy of the 1980s. Independently, they come to similar alarming conclusions about the effect of wealth and materialism and the absence of spirituality in Japanese culture.

Zielenziger begins *Shutting Out the Sun* by recounting the story of Masako Owada—better known as Princess Masako. Even before she married Crown Prince Naruhito in 1993, she stood out by any standard as a model of the new face of Japan. A Harvard graduate, Masako Owada could have been one of the bicultural voices that would navigate effectively between multicultures. In her high school in Japan she led the National Honor Society; as an undergraduate at Harvard she became the chair of the Japan Society. The daughter of a diplomat, she navigated effectively between cultures and understood the ins and outs of international relations. After college she became a trade negotiator in the Japanese Foreign Ministry—one of only twenty-eight hired that year from an applicant pool of more than eight thousand, and one of just three women in that group. At the time of her marriage to Crown Prince

Naruhito, she was celebrated as a symbol of modernity—an attractive Japanese ambassador of culture who could communicate the best of the Japanese past while opening up new ways for a woman to be in a key international role.

But a decade later things looked very different. Zielenziger captures what happened to Princess Masako, and notes that it was a harbinger of things to come to many Japanese youth:

> Eleven years later, in the spring of 2004, the Imperial Household Agency acknowledged that the crown princess—now forty, the mother of a young daughter, and mysteriously absent from public view—was suffering from an "adjustment disorder" whose symptoms included sleeplessness. She would, the agency advised, be kept out of sight indefinitely while undergoing unspecified medical treatment.[1]

What happened? It is widely believed that Princess Masako's inability to bear a male heir caused this shutdown. But becoming part of the imperial family and transitioning into a highly restrictive environment constraining her clear leadership abilities also must have contributed to a perfect storm of tension. In a culture that forbids the expression of free will, a woman of such exceptional ability will stand out, and any effort by her to represent her country will be seen as "a nail that sticks out," an unwelcome intrusion in the established order.

Shutting Out the Sun recounts the tale of this "adjustment disorder" to give a face to the dysfunction of the entire culture of Japan. Princess Masako's plight is only the tip of the iceberg. Japan is experiencing an epidemic of adjustment disorder among youths who are literally shutting out the sun in what is now well known as *hikikomori* syndrome.

> Frustrated and disaffected, many young Japanese just abandon their homeland. Hundreds of thousands of others wander like nomads outside the rigid traditional system, refusing to work, go to school,

or accept job training. Even more disturbing—perhaps most disturbing—is the cadre of more than one million young adults, the majority of them men, who literally shut themselves away from the sun, closing their blinds, taping shut their windows, and refusing to leave the bedroom in their home for months or years at a time. Thus the anguish the Imperial Family discreetly confronts behind stone walls reflects a crisis now being visited on the wider family of Japan.[2]

Shutting Out the Sun is prescient in linking Princess Masako and the hikikomori youths. Perhaps it takes a foreign journalist to spot the obvious link in a fumi-e culture unable to diagnose itself. He notices that in response to such intractable reality, the Japanese often resort to the word *shikata-ga-nai*, "there is nothing you can do"; it is a statement of resignation to fate. Even in such a casual, everyday statement, an important attitude is exposed.

The Japanese—speaking of this people in the broadest sense, spanning centuries—have entrapped themselves in a corner by isolating their culture from the outside influence. Thus, the routine repetition of shikata-ga-nai is a fulfillment of the cultural trajectory that started with the seventeenth-century edict to close Japan to outside influences, an echo of magistrate Inoue's pragmatic appeal to reject the form of Christianity. But the puzzle is that today, in the free society that Japan has become, the Japanese still choose not to break the shackles of the past. They also continue to imprison those who could offer the way out. Today, instead of Father Rodrigues, we have a princess symbolically entrapped in the fumi-e culture, a culture that refuses to release individuals to thrive. Even today those who clearly have the gift of leadership to lead Japan out of its malaise, individuals like Princess Masako, are perceived by many as a threat to the status quo, and when the Japanese criticize her, their implicit disregard for her humanity is an extension of the torturous imprisoned reality that Endo depicts in *Silence*. The dictatorial voices of

the Tokugawa shogunate still whisper into the Japanese heart in a never-ending vortex of self-annihilation; they create invisible walls that the Japanese cannot scale. "Shikata-ga-nai," the Japanese say, and stoically move on, without daring to challenge the status quo or care for those who are unable to endure. In the end there is only Darwinian survival, but survival for what purpose? Hikikomori youths have seen the end of that game and have rejected it.

Given the shikata-ga-nai psychology, a restrictive mindset and fatalism, there are only two paths for Japanese youth: to live as if your sole significance is in stoic resignation or to run toward hedonism in that limited-resource environment, to seek pleasure knowing it will not last. As Zielenziger attests, Japanese culture displays both tendencies. There is, on the one hand, the business "salaryman" who gets up every morning at five to go to work, not to return home until late at night, after an obligatory *nomi-kai* (drinking binge) to bond with his bosses and coworkers. On the other hand, there are Japanese girls who stand in line for hours on New Year's Day to secure their Louis Vuitton handbags in the shops of Omote-sando, to spend their precious savings on *that* handbag that they *must* have. The salaryman exemplifies the old-school path of stoicism and denial; the shoppers are emblematic of the path of hedonism, which spirals into futility and creates envy rather than relationships. Hikikomori youth reject both paths.

Princess Masako once had dreams and aspirations to make a difference in the world. Now she has been withdrawn from the world's stage; she is insulated by a system said to protect her, but really is a form of imprisonment to avoid embarrassment. She must have lost her hope in the future, her own and her children's, as well as the country's. Many in Japan understand and sympathize with her plight. But they will still say "shikata-ga-nai."

There is a world beyond such resignation, a light beyond the darkness. The Japanese tradition does not imprison Princess Masako; nor is it her role as a princess. Instead, the Japanese people are resigned to the idea that they

cannot see beyond an invisible wall erected a long time ago by a dictatorial system. That curse is so pervasive that all who live there must see themselves as serving that voice and feel the limitations of that culture. The culture is not the problem; the curse of that repeated resignation is. Fumi-e are but a symbol of the past, but fumi-e culture still exists, and the Japanese soul must be liberated from it in order to find new hope and identity.

There exists a Japanese culture beyond the forced rejection of Christianity of the Tokugawa era—far more substantial layers of Japanese culture that the Japanese can embrace. Rikyu points to that reality. Japan is an invaluable, unique culture full of integrated value toward awareness, empathy and beauty. One need only read the speeches of Kawabata and Oe to be persuaded that Japan can regain a purposeful and persuasive leadership role in the world. There is a Japanese culture *beyond* the seventeenth-century edict that banned Christianity, and that reality smolders underneath the malaise. Beyond the rubble and ashes of Hiroshima and Nagasaki, beyond Martyrs Hill, lies a country of the sun that the Japanese can still take hold of. But to get there, we must be liberated from the bondage of seventeenth-century Japan. *Silence* points to that possibility, and the messages of the Bible confirm such a path toward liberation.

Zielenziger notices something subtle but important: the Japanese see their country and their living conditions as *semai*, which means "confined." People in other cultures and countries that have similar population density, and even less land—such as Korea or the Netherlands (or many of the Polynesian cultures)—would never use that expression to describe their living conditions. Semai refers, therefore, more to a psychological landscape than to a literal one. This confinement exists separate from mere geographic density. Semai points to psychological boundaries that still exist, after all these years—of gonin-gumi or mura-hachibu that do not allow individual Japanese to move beyond those boundaries. Consider again Princess Masako, a highly educated individual who spent much of her youth in America, but who upon returning home found herself in the

role of a dutiful heir; even such a person is not allowed to make a simple statement of her own. Fumi-e culture still dominates, and anything she says at this point is perceived through the false and cruel dichotomy of Japanese culture. Her choices are bleak: to step on an invisible fumi-e and deny Japanese culture, a culture she loves, or to be subsumed by the culture's demands, becoming no longer herself.

Shutting Out the Sun has a startling paragraph worth pondering as we think about the future of Japan. It is a candid confession by Zielenziger comparing Japanese culture to Korean culture:

> In my somewhat conventional coverage of the political and economic character of these two competing societies while working as a journalist, it had never dawned on me that the role religion played could prove so decisive in altering a people's attitudes toward self-esteem, individuation, or communal responsibility. Nothing in my background or disposition as an American Jew prepared me to accept that the rise of Western religion—and especially the Protestant Church—had served as a vital force crucial in transforming South Korean society. It may be too simple to argue that exposure to Christianity alone has changed Korean consciousness. Yet the churches have coached the Korean people in forming social networks, building trust among strangers, and accepting universal ethics and individualism in ways that served as powerful antidotes to the autocratic worldview their grandparents—and, indeed, the Japanese—had been taught.[3]

Zielenziger's admission in the pages of his own book is rather astonishing given his background. But he would be incorrect to assume that if Japan were to embrace the Protestant Christianity of Korea, the same transformation would take place. Japan's wounds are unique, and its potential and beauty are unique on the world's stage. So, what will liberate Japan from its "bondage to decay"?

Many cultures, such as African American culture, Native American cultures, Protestant and Catholic cultures, were going through similar repression of their faiths and ways of life during the same time that Japan was going through its years of persecution. Oliver Cromwell led Britain to persecute Catholics in the seventeenth century. The Pilgrims pushed out Native American cultures, and Baptists were being executed in certain parts of America as late as the early nineteenth century. One must wonder why, as a simple sociological reality, these dark journeys into oppression, slavery and persecution strengthen people's faith in certain countries or regions, and may even lead to greater freedom of faith in the long run—while in some other cases the culture has not been able to move beyond them.

This comes to mind as one walks about Hiroshima and Nagasaki. Their devastation by atomic bombs came just three days apart, but the paths they chose over the ensuing seventy years diverge dramatically. Hiroshima tried to rebound by constructing modern shopping malls and a baseball stadium. Nagasaki went in a different direction, rebuilding its churches and communal infrastructures; prayers of the faithful bathed the reconstruction process, and the people of Nagasaki continued to welcome outsiders, even the foreign forces once seen as their enemies. Hiroshima's Ground Zero museum features mushroom cloud photos and thousands of images of the unthinkable reality of the atomic blast and the subsequent horrors, as it should. In Nagasaki the Ground Zero museum features a melted-down church. In other words, Hiroshima tried (and tries) to recover by remembering the trauma, and then trying to move past it through modern expressions of commerce and entertainment; Nagasaki recovered by moving into the trauma through prayer and forgiveness toward the past.

Zielenziger's conclusions confirm my own: In order for Japan to recover, the culture must follow Nagasaki's example. Endo walked about Nagasaki pondering how he, as a novelist, might capture this resilience,

to give voice to the voiceless; the result of that pilgrimage was *Silence*. *Silence*, therefore, is as much about contemporary recovery from trauma as it is about the seventeenth-century persecution of Christians. Recovery will take resilient prayer and forgiveness. There is great hidden faith residing in the hearts and culture of Japan. That faith proved itself worthy of our attention in Nagasaki. It can prove to be worthy again as it faces not only the darkness of "shutting out the sun" but also, now, its hauntingly precarious Japan.

PRECARIOUS JAPAN

An enlightening complement to Zielenziger's book is Anne Allison's *Precarious Japan*, in which she depicts modern Japan from a sociological perspective. She traces similar tales of the hidden plight of Japanese society and pinpoints the spots at which the surface of Japan's stoic, reserved façade is cracking. Her descriptions of some recent incidents in Japan are literally horrifying; the trauma of *Silence* was only a precursor of greater ills to come. Elderly folks are found starving to death in their own homes, abandoned by family and the government—or even found dead and decomposing, months after a relative last bothered to check in. The young are either trapped in hedonism or paralyzed by anxiety, and they tell of bullying that is more akin to wartime torture rooms than playgrounds. As she says, "Japan was slipping into the mud."[4]

Allison also recounts the story of singer and actress Yukiko Shimizu, a TV personality who in 2009, in middle age and "exhausted from taking care of her invalid mother, attempted to kill her mother and herself in a would-be double suicide." She died from the poison, but somehow the mother survived. Allison writes,

> Yukiko's sister Yoshiko recounts how stunned she was upon hearing the news. Never complaining nor letting on that she'd sunk into such despair, Yukiko had seemed the consummate caregiver: selfless,

cheerful, compassionate—the perfect daughter. Too good to be true until the goodness wore [her] out.[5]

Allison paints a bleak but realistic picture of the Japanese culture that rarely captures the attention of the mainstream media: "Suicide rates are now so high that the government, and communities, are taking measures to intervene. Withdrawal is noteworthy as well: another form of refugeeism that has become only too 'ordinary' these days in Japan and is symptomatic of the times."[6]

Allison's book reads at times like a diagnostic list of illnesses affecting the Japanese, which are mostly hidden from the media and even from the Japanese themselves. Loneliness and despair are most pronounced today, and the suicide rate is high across all demographics: the elderly and children, housewives and businessmen. On her post-3/11 journey to northern Japan Allison spoke with people who saw their homes literally sinking in the mud. She saw where they dug through that mud in desperate hope of finding anything of value, digging for hope amidst irreversible despair.

Allison quotes a Japanese woman interviewed for the book:

Tsurumi: I think the level of despair (*zetsubo*) about the future will increase. We're no longer a society that can rely on the corporation; the family is falling apart; individuals are more on their own, making connections through the Internet. . . . Somehow we'll have to figure out how to get along. We have no other choice.[7]

Quoting philosopher Gaston Bachelard's *The Poetics of Space*, in which he considers the power of poetic vision in a limited space, Allison implores the Japanese to consider a future path:

In order to be an impetus for action and for a person to move out of the present and beyond oneself, daydreams need to be shaped into images. This is the utopian potential of literature and art: to imagine

a future that challenges, but also rearranges, the present sociopolitical reality. How we inhabit the world in the circumference of home forms part of this "anticipated Illumination" . . . envisioning a home that, while tapping into our experience of actual homes, also transcends reality and illuminates new possibilities.[8]

What Endo described as Father Rodrigues's fate has now become the daily reality of Japanese youth who choose to withdraw as hikikomori. Father Rodrigues was imprisoned under house arrest, Inoue's form of persecution; what is imprisoning the Japanese today? What is our hope? What will lead us out of despair?

ANNE OF GREEN GABLES: FROM AN ORPHAN TO A PRINCESS

Virtually every movie created in Japan has some allusion to the despair-filled reality of cultural entrapment and alienation. And yet they also suggest a way out of malaise. *Spirited Away* and *Departures*, which won Academy Awards in the United States, are good examples. The Japani-mation master Hayao Miyazaki, the creator of *Spirited Away*, seems obsessed with children's discovery of a hidden world abounding in fanciful creatures. His memorable first film, *My Neighbor Totoro*, tells that kind of story. It introduces story lines and themes that weave through all of Miyazaki's work, starting with children's postwar journeys away from devastated cities (and away from the effects of atomic destruction) into the country, where they rediscover the hospitable spirit world of nature. Nature is benevolent in Japanese culture, even in times of horrific natural disasters; when Hidden Christians escaped to the mountains of Nagasaki, implicit in that choice was the sense that in those mountains they would find protection from the dehumanizing influence of the cities. Totoro is an ambling, nurturing spirit who comes and goes with a protective umbrella to shield children from the rain (is it tainted with radiation?) as

they try to cope with the absence of their mother, who was taken away because of an illness (is it postnuclear illness?).

While *My Neighbor Totoro* is an homage to the innocence of a Japanese past, the same filmmaker's *Spirited Away* tackles the hedonism of the Japanese bubble economy. The heroine, Chihiro, seems to be a positive projection of the Japanese woman leader. Monstrous ghosts are calmed by her presence as she navigates and tames a netherworld of the spirits. From *My Neighbor Totoro* to *Spirited Away* the master animator Miyazaki skillfully and positively depicts the Japanese psyche. Some may argue that it is wishful thinking to depict such an ideal in a movie, but history tells us, and as Allison agrees, that what we do with our imaginations—how we face the despair of present darkness but rename that experience toward the future—is critical in how a culture is to find its own liberation.

Another Academy Award–winning Japanese film is the extraordinarily poignant *Departures*. Here's a brief introduction to it, from a review I wrote shortly after the film debuted in 2008:

> *Departures* tells the story of a frustrated young cellist returning to his hometown in Yamagata prefecture in northern Japan with his wife. When he applies for a job he thinks is with a travel agency, a strange tale begins to unwind. The master *nokanshi* (the art of preparing a dead body), played by veteran actor Tsutomu Yamazaki (known to play warlord Hideyoshi in films, and who was also in Kurosawa's masterpiece *Kagemusha*), begins to work on Daigo, the main character (splendidly played by Masahiro Motoki, who produced the movie). The viewer is invited to witness a subtle act of persuasion, and the acting allows a deeper story, undulating beneath the surface, to reveal itself.[9]

Like Miyazaki's films, *Departures* leads the viewer through the despair and alienation of modern Japanese lives, but guides the viewer into a place of hope. We can read in Allison's book, in the abstract, about the power

of imagination to inhabit one's bounded reality; watching *Departures*, we see it literally being played out.

On a recent flight from Nagasaki to New York, I saw a movie called *The Snow White Murder Case*. It begins with the murder of Noriko Miki, a beautiful Japanese office worker whose coworkers envied her as the Snow White of the office. The film's suspense comes from the misperceptions of her friends and coworkers (as well as social media misused by a journalist), who pronounce judgment on a suspect, a coworker of Noriko. As it fleshes out the identity of this scapegoat figure, starting from her childhood, the film reveals many of the darker realities of contemporary Japanese society, including hikikomori. The Canadian novel *Anne of Green Gables* plays a significant part in the story: first as a fantasy for the victims of ijime culture to escape to, but ultimately as a source of hope in the movie.

Here, a reader unfamiliar with Japanese culture may wonder what the story of a red-haired girl on Prince Edward Island could have to do with Japan or *Silence*. The attention given to such foreign narratives and art forms that endures in Japanese culture seems, on the surface, to be incongruent to Japanese culture. It seems even more incongruous when we consider what a strange variety of works of art, literature and music have a significant if not fanatical following in Japanese culture. Consider this list:

- *Anne of Green Gables*
- Vincent van Gogh
- Johann Sebastian Bach
- Beethoven
- Georges Rouault
- black gospel music

The Japanese take their fascination to a level rarely matched in other cultures. Literally thousands of Japanese flock to Prince Edward Island to trace the path of *Anne of Green Gables* and to Arles, France, to see the

landscapes that entranced Vincent van Gogh. They attend religiously concerts of the music of Bach and Beethoven and wait in line to see Georges Rouault's paintings, and there are hundreds of gospel music clubs where housewives audition to sing in a choir.

What do all of these diverse forms of art have in common? They are the highest refined art expressions that overlap with the Christian faith. All of the art forms reflect a specific Christian faith as a major formative experience in the process of creation. While these artists may not be strictly orthodox in their Christianity, like Endo, to others they come across as deeply religious.

If an alien were to see the previous list and analyze the behavior of Japanese, an alien might conclude that this nation must be—at least culturally if not formally—a Christian nation. Japanese culture has a particular affinity to Christianity and the expression of beauty. If I, like Francis Xavier, were sent to observe this culture objectively as an outsider and recommend what churches in Japan should look like, this is what I would recommend: create each church as an artwork, full of beauty, with a message that would call out to orphaned hearts and invite them to be adopted as princes and princesses of God. Churches like that would nurture communities of people who, just like in *Anne of Green Gables*, diligently work through their differences to face challenges together head-on. Instead, postwar churches of Japan imitated the gray utilitarian pragmatism of the West, and instead of a joyous community of forgiveness and friendship, many Japanese congregations I have observed have adopted legalism and a pronounced hierarchy.

Japan's public broadcasting network did a survey decades ago in which people were asked, "If you could chose a religion, what would you chose?"[10] Over 30 percent said they would choose Christianity. We might ask, then, why less than 3 percent of the Japanese population claims to be Christians. No doubt some people's answers reflected their enthusiasm for cultural forms they associate with Christianity. Unfortunately, many

Japanese churches I have visited do not possess the beauty and hope that these art forms reflect. The more a Japanese believer is involved in a typical church, the more that believer will be imprisoned in the duty-bound, legalistic system. We must do better.

AN ORPHAN BECOMING A PRINCE: THE CHRISTIAN GOSPEL

You may remember the story of *Anne of Green Gables*: Anne is an orphan sent to a family in Prince Edward Island by mistake. Matthew and Marilla Cuthbert desire a boy but instead receive a red-haired, verbose girl full of energy and imagination. The tale parallels our journey toward discovery of God. The Christian story is one of adoption and embrace into the family and the royalty of God.

In the epistle to the Romans, St. Paul writes of his own journey from a "wretched" state to his new identity as a "son of God." This transformation (documented in Romans 7–8) is central to what I understand to be the good news of the Bible. It is not unlike the transformation of an orphan into a prince or a princess as part of our new identity as a royal priesthood of God. In the following passage from the end of Romans 7 and the beginning of Romans 8, note in particular the flow of language—the shift from the confessional tone of Romans 7, in which Paul acknowledges his "wretchedness," to the glorious freedom of the language of Romans 8. Notice the link between the two states in Romans 8:1.

> So I find this law at work: Although I want to do good, evil is right there with me. For in my inner being I delight in God's law; but I see another law at work in me, waging war against the law of my mind and making me a prisoner of the law of sin at work within me. What a wretched man I am! Who will rescue me from this body that is subject to death? Thanks be to God, who delivers me through Jesus Christ our Lord!

So then, I myself in my mind am a slave to God's law, but in my sinful nature a slave to the law of sin.

[8:1] Therefore, there is now no condemnation for those who are in Christ Jesus, because through Christ Jesus the law of the Spirit who gives life has set you free from the law of sin and death. For what the law was powerless to do because it was weakened by the flesh, God did by sending his own Son in the likeness of sinful flesh to be a sin offering. And so he condemned sin in the flesh, in order that the righteous requirement of the law might be fully met in us, who do not live according to the flesh but according to the Spirit. (Romans 7:21–8:4)

"Therefore, there is now no condemnation for those who are in Christ Jesus." This is Paul's conclusion after wrestling with his own wretchedness in the previous verses. Theologians have noted that two types of sin haunt us: sin of *commission*, which is behavior we know to be displeasing to God, and sin of *omission*, the ways we unknowingly omit goodness (and, I would add, the beauty of God) from our lives. St. Paul was a religious Pharisee, a rabbi with the highest quality of moral keeping, and even he could not escape the dilemma of his sinful nature, doing exactly the opposite of what he desired to do to please God. Paul confesses, "I do not understand what I do. For what I want to do I do not do, but what I hate I do. And if I do what I do not want to do, I agree that the law is good. As it is, it is no longer I myself who do it, but it is sin living in me" (Romans 7:15-17).

This depth of awareness is not available at first to the young Father Rodrigues in the beginning of the *Silence* journey. Father Rodrigues seems full of desire to please God, but he does not yet understand the depth of his own sin or the prideful, imperialistic outlook of his mission. His desire to prove his mentor's innocence and the triumphant faith he has in the power and victory of Christ crumble before him as he is captured and

tortured. While his zeal is admirable, losing his faith and identity as a priest finally may bring him to the point of which Endo writes. In Father Rodrigues there is an echo of the dejected rabbi Saul, as St. Paul was known before his profession of faith in Jesus Christ.

In the glorious freedom of Romans 8, then, we may see the reality of freedom from our wretched state. In these passages of hope, then, the persecuted Christians—including Father Rodrigues—can find freedom. Of course, in the storyline of *Silence* there is no account of this internalization of gospel freedom. But it is significant that the epilogue of the story recounts Father Rodrigues's steadfast ministry after stepping on the fumi-e.

Romans 8 is the key to understanding the true faith that can persevere in suffering. In Romans 8 we see the transformation of those who rejected faith, those who failed to reach the standard they set to please God. The critical transition word is *therefore*.

"Therefore, there is now no condemnation . . ." In the original Greek the word we read in English as "therefore" is a comprehensive term that refers both to the thesis laid before and what is to come. What a surprising way to transition into facing our darkest moments. The word I would have used to verbally transition from darkness to light might have been *but*, *nevertheless* or *however*—certainly not *therefore*.

Therefore faith can include our failures, even multiple failures. Like the crypto-Christians who must step on the fumi-e every New Year's Day, followers of Christ, even those of weaker faith, can resonate with this comprehensive word to encapsulate our experience and draw us to deeper faith.

Such a view is a comfort not only to diligent followers of Christ but to *all* people. The Bible leads us in the way of salvation and lays a path toward human flourishing. Therefore, I believe that one faithful soul who remains in the land can have impact on the rest of the culture, however oblivious or hostile it is to faith. That one soul can become an antidote to

betrayals and many sins of commission. God embraces us, just like the father in the story of the prodigal in Luke 15, despite our many sins of omission. Father Rodrigues's journey can unexpectedly be part of our liberation from the bondage of the Japanese past. Faithful presence can reverse the two centuries of indentation left by persecution, and contribute to healing the wounds of the Japanese. I also believe that ultimately this presence is what Shusaku Endo desired to depict in his book and not the "silence of God."

Endo felt abandoned by his father, and his mother set the path for his life; she recognized his gift for storytelling early on and encouraged him to pursue being a writer. The orphan mentality can arise in many who grow up fatherless. In a culture like Japan's, in which the father's influence is minimized, transformation from being an orphan to becoming an adopted children of God requires a new experience of male leadership. For Japanese to be liberated from their built-in cultural malaise, they will need to experience the everyday presence of God the Father.

<center>✑ ✑ ✑</center>

As the only nation that has experienced atomic destruction, Japan could have been a global leader in the nuclear-freeze effort. Instead, fumi-e culture, dominated by amae, created dependence on other power bases, and Japan has been unable to lead in this critical discussion. Today the perpetrators and the tortured alike can share in the shame and fear of being exiled from their own past. It took a Catholic writer to remind the Japanese of their own past, and Endo's work, like a fumi-e worn smooth from so many feet stamping on it, reveals what shame, fear and repeated betrayals can erase from a culture.[11]

MYTH BECAME A FACT

Anne of Green Gables is, of course, not the only tale in which such transformation of a wretched individual is recounted. In *Beauty and the*

Beast a beast turns out to be a prince. In *The Frog Prince* a frog turns out to be a prince. In *Jane Eyre* an orphaned girl becomes an heir of great wealth. In the Chronicles of Narnia the Pevensie children, evacuees from war-torn London, have an adventure through a magic wardrobe and discover their identities as the princes and princesses of Narnia. J. R. R. Tolkien's *The Lord of the Rings* recounts how small inhabitants of the Shire, the Hobbits, creatures of insignificance, are thrust into the great battles of good and evil, and the story ends with the wedding of Aragorn the king and the celebration of the Hobbits' courage and perseverance. Great mythical tales, including the movie *Star Wars*, all end in a coronation. So many tales speak of this rags-to-riches story. Thus, many have argued that the Bible too is a myth created to satisfy a deep longing in our hearts.

These rags-to-riches stories have universal appeal, but in Japan they become particularly resonant as the Japanese readers see the character's liberation as something worth holding onto; yet, paradoxically, in other arenas of life they deny consistently that human liberation is achievable. In Japan's modern era, myths and stories are typically met with suspicion, as ultimately unrealistic and even false and antirational. Endo's notion of fumi-e as not just a religious icon but a universal symbol of what each person loves and yet betrays is an indication of how these universal myths can be transformed to have greater impact for the Japanese.

J. R. R. Tolkien spoke of this idea with then-atheist C. S. Lewis. Lewis's resistance to Christianity was that the power of myth can be deceptive, and that myths are ultimately not truthful. Myths, Lewis claimed, are "lies, even though lies breathed through silver."

Tolkien, anticipating Lewis's objection, guided him to a deeper journey into the world of myths.

> Tolkien resumes, arguing that myths, far from being lies, were the best way of conveying truths which would otherwise be inexpressible.

"We have come from God [continued Tolkien], and inevitably the myths woven by us, though they contain error, will also reflect a splintered fragment of true light, the eternal truth that is with God." Since we are made in the image of God, and since God is the Creator, part of the imageness of God in us is the gift of creativity. The creation—or, more correctly, the sub-creation—of stories or myths is merely a reflection of the image of the Creator in us. As such, although "myths may be misguided, . . . they steer however shakily towards the true harbour," whereas materialistic "progress" leads only to the abyss and to the power of evil. . . .

Listening almost spellbound as Tolkien expounded his philosophy of myth, Lewis felt the foundation of his own theistic philosophy crumble into dust before the force of his friend's arguments. . . .

Tolkien developed his argument to explain that the story of Christ was the True Myth, a myth that works in the same way as the others, but a myth that really happened—a myth that existed in the realm of fact as well as in the realm of truth. In the same way that men unraveled the truth through the weaving of story, God revealed the Truth through the weaving of history. Tolkien . . . had shown that pagan myths were, in fact, God expressing Himself through the minds of poets, using the images of their "mythopoeia" to reveal fragments of His eternal truth. Yet, most astonishing of all, Tolkien maintained that Christianity was exactly the same except for the enormous difference that the poet who invented it was God Himself, and the images He used were real men and actual history.[12]

If the gospel is an announcement from outside time and space, then it would make sense that the communicator (God) had to condescend to communicate with the hearer (us). The grand message has to be attuned to our time, our space. That is why God sent Jesus. Jesus is

the embodiment of God's love to us. God did this without resorting to any sort of reductionism, as it is impossible for God to reduce the infinitude of God's presence and power. But it is possible to deposit within creation a seed of that infinitude into a finite realm. In God's gratuitous gesture to us, God created a generative point in condescending rather than creating simply an objective convergence. Therefore, Jesus is fully God and fully human.

If you are reading this, and you read the previous paragraph without much reaction, you did not get what I am trying to say. If you read the previous paragraph and either got very upset or started to dance on the floor, then you are getting the point. This is simply the most outrageous claim! This claim, staked in the historicity of the existence of Christ, his journey toward the cross and the validity of the resurrection (also a seemingly outrageous claim), does not merely prove God's existence and God's goodness; Christ's presence fantastically or annoyingly, depending on your view, overturns the knowledge about reality, or at least injects a healthy suspicion that perhaps all that we know is not the mere cosmos. The application of the preceding point to any discipline, starting from arts and sciences, is most profound. I consider that this stance is what *began* our history of arts and sciences. I might even argue, with T. S. Eliot, therefore that Christianity, properly understood, can be a catalyst for all people and culture to thrive. While this train of thought will go beyond the scope of this book, we need to understand the radical nature of the Christian message in order to try to be a vessel through which such promises are carried into the world.

Johann Sebastian Bach's music has been said to be incomparable to any other music. One commentator noted that his music is not only the highest form of music, and every music ever since is a reduced attempt, but that Bach managed to create something purely uncategorical.[13] Bach's

music is extremely faithful to the mathematical and physical reality of vibrations made by an instrument, but at the same time it seems infinite. In this sense Bach's music might be the best representation of God made alive in Christ.

Bach composed toward the end of the seventeenth century, so his music would not have been available to the priests of the sixteenth century. We should note, though, that Bach's music came out of long generations of musicians, and a theological journey of the West, influenced by the Reformation of the sixteenth century. The seeds of what would become Bach were already in the air.

When Bach wrote at the end of his composition "Sola Dei Gloria" (Glory to God Alone) it was not just a sentiment or a spiritual embellishment. The words of the title meant to Bach exactly what they say: he wrote his music only to God. In some sense he was not making music, or composing music, but discovering the music already in God, and only by hard work and attuned listening would he be able to capture it. He composed not that he could be famous and many people would hear his music; he made and discovered music for God alone.

His music would not be available to us if he had not thought it was important to write down some of his compositions as a textbook to teach younger generations, and had it not been for Felix Mendelssohn, about a century later, rediscovering these textbooks. There was no notion at the time of individual fame in music or people playing music composed by now-dead composers. In contrast to the Japanese painters of the seventeenth century, who desired their works to leave a legacy, and the competing schools such as the Kano and Hasegawa schools, Bach wrote simply to the glory of God alone.

What does it mean to live and work to the glory of God alone? It may look like the image of Father Rodrigues at the end of *Silence*. Endo, like Mendelssohn, dug up a buried voice, and by doing so not only revived that voice but also preserved a faithful presence in the

context of history. This work to revive is also part of our *apologia* (defense of truth) and a marker of our journey toward beauty.

APOLOGIA

Father, we are not disputing about the right and wrong of your doctrine. In Spain and Portugal and such countries it may be true. The reason we have outlawed Christianity in Japan is that, after deep and earnest consideration, we find its teaching of no value for the Japan of today.[14]

Inoue's voice, so rational and pragmatic, is an authentic and universal voice of atheistic persuasion thwarting a believer's journey. It could be the same voice that Endo heard in postwar Japan—at that time not speaking of dictatorial powers but about the onset of utilitarian pragmatism in modern times.

Consider the options that Sawano Chuan (the postapostate identity of Father Ferreira) offers Father Rodrigues and many of the believers: step on the fumi-e to apostatize, or if you refuse, experience further torture. "It's just a formality," he notes. This "choice" is rational. But the choice is not really a choice but a reduced option being forced on the recipient, and therefore has nothing to do with free will at all. What makes this forced decision so effective is that it traps faith in a two-dimensional reality of a black-and-white "rational" decision. What is stripped is not only the possibility of faith itself but also rational free will; it is a shell game, a zero-sum game. Chuan never seems to understand that God cannot ultimately be denied, as if our choice makes the God of the universe go away. Chuan is simply trying to wield his power to lead others to join him in his entrapment, perhaps even to justify his own decision to apostatize. So his first argument is to convince Father Rodrigues of his own power to decide the fate of the younger priest, giving Father Rodrigues no choice in the matter. But this assumption is a deception of the most common kind; physical entrapment, torture by

force, cannot dictate one's inner compass. God's existence cannot depend on our ability to believe or even to keep our faith.

Participation in evil often appears as pragmatic and is made inevitable in Inoue's torture technique in *Silence*. A novelist must be faithful to that reality of torture, so through that process we may journey through to experience that darkness. Paradoxically, art can champion truth telling by telling stories of failures to tell the truth. Thus, even a writer's depiction of evil, whether it be Endo's Inoue or Shakespeare's Lady Macbeth, is done to contrast with what is good and holy by skillfully exposing that dark, evil realm.

The God of the Bible stands outside time and space. The so-called denial of God's existence actually is not about God at all; it comes first as a misplaced faith in the limited-resource, fear-driven reality that convinces our limited perspective that we believe we cannot escape. Domination by terror and fear can persuade the entrapped to be convinced that the physical walls surrounding them will ultimately define their fate and limit their faith. But human will, imagination and even rationality point to a wider vista, one that inspired Martin Luther King Jr. and Alexander Solzhenitsyn to craft from within their jail cells some of the most profound statements of human freedom. It is impossible for a physical cell to trap the human mind and heart, unless the victim actually believes that physical entrapment defines that person's worth, value and humanity.

Philosophers have called this limited-resource argument a materialist argument. A materialist argument is a closed logical loop that depends on the belief that the "cosmos is all there is and all there will be" (to quote Carl Sagan). Often, this belief (as it is impossible to prove such a statement) is accompanied by the notion that God cannot exist, but a careful materialist knows that this cannot be proven either; since a materialist's position depends on the limited resource of the material reality, one can say that, to a materialist, existence of a biblical God is inconsistent with the closed system of nature, but one cannot go beyond that. From a biblical perspective the ultimate proof of such an existence cannot be from within the limited

perspective of the finite mind or from evidences of nature itself. God, by the definition of the Bible, stands outside nature and is not a reality of human origin, but preexists time.[15]

Of course, materialist thinkers argue that God originated in the human mind. For a materialist this is the only plausible way to justify the human propensity toward religion, but such a position requires near-absurd twists of logic. That logic assumes that we can conceive of God (who is, by definition, beyond our finite minds) and dismiss that existence too, based purely on rational thought and limited data, while admitting to the great potential that humans possess. Such nimble dexterity of thinking accompanies the best of atheistic minds, and they are to be admired for their consistency. But Chuan is not one of them. Chuan's position is as sadistic and selfish as someone sinking in a quicksand asking for help and subsequently dragging into the quicksand any person who dares to help. If misery loves company, this form of narcissistic embezzlement is precisely what Jesus meant when he stated that it is better for those who lead children astray to have a millstone tied to their necks and be drowned (see Luke 17:2). Chuan is therefore the Judas figure in *Silence*, not Kichijiro.

If such a God exists outside time and space, and if God entered our domain through Jesus, then we cannot prove the ontological (what can be said to exist) entry point of that existence by relying strictly on observations and logic from within the closed system. We can reject this presence as not relevant to our lives, but if we do that we are positing that a rational reason can convince a superrational presence to disappear.

The existence of such a preexisting God is neither a reality we need to defend nor a proposition to be argued. A theist cannot ever win an argument with an atheist. Thus, much of the public debate between theists and new atheists, like Chuan's fumi-e, is based on a false dichotomy that will not get anywhere.[16]

Most of us live not thinking much about our rejection of Christ on a day-by-day basis. But for over 250 years the Japanese had to consciously

deny their ability to freely choose their faith journey. Every New Year's Day a family was to go before the magistrates and step on the fumi-e. Did they have a notion that this "foreign god," which was troublesome to the authorities, was a threat to the Japanese people, or by stepping on the fumi-e did they simply acknowledge that, like some sects of Buddhism, it was not allowed to exist? We do not know. But Japanese history's consistent and reliable denial of Christianity is like an atheist's journey to consistently and consciously deny God. Such rejection is much more restrictive than any daily rejection or forgetting of God's grace. Denial, it seems, will force us to, like the fumi-e, leave a deep impression in our hearts. The more we force the image of Jesus on the Japanese, the deeper, by the sheer consistency of that visual message, that image will become.

Father Rodrigues is offered a cruel game. But conversely Chuan is not able to deny Father Rodrigues's free will. Father Rodrigues steps over Chuan's schemes by submitting to the entrapment, but he still keeps his freedom and ultimately his faith intact. In the last few sentences of the narrative of *Silence*, after he steps on the fumi-e, he still describes himself as "the last priest in this land." He submits to the reductionism and even relativism of Chuan's argument, but he keeps the most important part of his being intact—his personal will and an internalized faith. And even though he will have to live the rest of his life under house arrest in Edo, he successfully creates a détente between the magistrates and his freedom of choice. While this is consistent with Endo's research about the historical Father Chiara (Endo's model for Father Rodrigues), what Endo may be after is not just what happened to Farther Chiara but a protest against a limited-resource argument, a reductionism symbolized in Chuan's schemes and reflected in the theological conundrums of the twentieth century. What is remarkable, however, is that this portrayal of Chuan as a modern enemy of faith comes close to the historical reality of the real person of the apostatized Father Ferreira. Chuan, as one of the finest of Jesuit priests, already in the sixteenth century possessed the Enlightenment objection to faith.

The apostate character of Chuan represents not just the Japanese denial of the Christian God but all forms of relativism that eat away at the center of faith in the world today. At the same time Endo speaks against imperialist Christianity that invades another culture at the expense of that culture's heritage, he also speaks for a new type of faith expression in modern reality, a nimble faith that is able to address the conditions of our day. Chuan is the voice of terror that strips away all freedom, including the freedom of faith, even today. In *Silence*, Chuan's voice is not merely about the historical account of seventeenth-century persecution of Christians in Japan: *Silence* is also about the twenty-first-century onslaught of reductionism, relativism and fear eating away at the core of Christian faith. If we can journey into this distinctively modern and postmodern experience through *Silence*, we may be able to gain some wisdom on how we may deal with increased enforcement of extreme ideologies that threaten to make faith a subject of fumi-e, a clear, visible line drawn in the persecuted age. How do we remain faithful in a context in which dying for Christ is possible, but living for Christ is made impossible?

Modernist assumptions create many false dichotomies. Reductionism lays a dualist track to a rational mind, an either-or entrapment, just like Chuan's fumi-e. There are new faces to the debate about whether God exists or not, whether to step on the fumi-e or not. In modern terms we may frame such a dichotomy as whether Darwin was right or debate the virtues of conservatism versus liberalism or what constitutes culture wars, with minute particulars, for example, of prolife or prochoice or pro–gay marriage or against. In such dichotomies we reduce the options to black-and-white categories, and, just like a fumi-e, present a moral quandary that is designed for denial of our full humanity. While in debates, defined camps are somewhat necessary (and certainly appreciated by the media to sell news), to assume that these options are the only options available to us is to submit to the restrictive premise, determined by what the philosophers would call epistemological assumptions and fault lines.

Epistemological positions, based on what we come to know as truth, or faith, are at the base of all of our decision making, and they have to do more with our faith than we realize. We often default to such reduced positions out of fear. We fear that, just like Father Rodrigues, we are already in a prison because of our circumstances. At that point of limitation we hold these ideological positions to be nonnegotiables without realizing that we have embraced the enemy's epistemological positions already by making an either-or choice. Epistemological questions ask instead what may be the question behind the question. What is the assumed ontological reality; where did that very question come from? We assume that we can create clear boundaries between these positions, and we disregard the possibility that a common ground can exist in between. Underlying these dichotomies is the notion that all knowledge is rational information. Philosopher Esther Meek notes of the deficiency in that path:

> With this knowledge-as-information approach, we tend to be "epistemological dualists." We distinguish knowledge from belief, facts from values, reason from faith, theory from application, thought from emotion, mind from body, objective from subjective, science from art. We readily overlay the first members of each pair— knowledge, facts, reason, theory, mind, objectivity, and science. And we set each first member over against its "opposite." We think we need to keep knowledge "pure" from these "opposites."[17]

This type of reductionism leads many Christians to see doubt as sin, which creates a false dichotomy of doubt versus faith. A work of art, deeply wrought in experiential reality that is more than mere information, lays a deeper track of epistemology. Endo, in describing Chuan, may be facing a specter of his own demons—one that pits Christian faith against Japanese culture, as if that information is valid enough to excise Christianity from Japanese culture as an island that is, in John Donne's words, "intire" of itself.

JAPAN AS CHRIST-HIDDEN CULTURE

The postwar surge of Japanese intellectuals turning to Catholic faith is indeed significant, and Endo was at the forefront of that movement. If one includes Protestant Christians, the list of cultural figures who have publicly identified with Christian faith is very significant. This list includes, beside Shusaku Endo, names such as Hisashi Inoue (writer), Hisao Otsuka (economist), Toyohiko Kagawa (social reformer, writer), Taro Aso (former prime minister), Hifumi Kato (Shogi, Japanese chess master), Ranjo Sanxuute (Rakugo comedian), Ayako Sono (writer), Inazo Nitobe (educator), Hideo Noguchi (scientist) and Ayako Miura (writer). Thus the percentage of Christian influencers in culture is much higher than what might be encountered in Europe, despite the low percentage of Christian population in Japan.[18]

Again, this proves that Japan is not a pagan culture but a Christ-hidden culture. Fumi-e culture hides the most precious reality of the inner journey, and often that individuality is so suppressed that it would be very difficult for Japanese to be conscious of it. Endo depicts in his writings how, on the surface, his characters hide their most glorious and hideous selves.

An integrated approach to culture, what I call "culture care" (as opposed to culture wars), allows for the nurturing side of faith to develop within the soil of Japanese culture. Within the integrated scheme of nature and culture, Japan can be an ideal incubator, unique in the world for its deep alliance with beauty, that can develop an already-formed ecosystem that connects care for its environment and care for its soul. In such an ecosystem the gospel can come alive in ways that we have not been able to fully experience in the West. Japanese beauty is the ideal spouse to Western rationalism.

It is true that Christianity is a katakana religion, but it is also true that katakana birthed a uniquely Japanese system of writing that led to the lyrical writings of hiragana. Japanese culture, integrated with theology, can

be a dynamic culture that combines both the feminine and the masculine, symbolized in katakana and hiragana.

In order for soil to become fertile, the ground must go through many a winter. The soil, as Walt Whitman attests, is layers of deaths, built over many years. Christian Wiman, one of the most significant poets of our time, writes, "We live in and by our senses, which are conditioned in and by our deaths."[19]

Death that is in layers, like the pulverized pigments layered over and over again, can multiply abundance and flourish a hundredfold. Japanese soil is like that, even with the trauma of Tokugawa era, Hiroshima, Nagasaki and now Fukushima, tainting the soil. Each death and trauma prepares Japan as an oasis for the gospel to find nourishment for the world.

HIRAGANA CULTURE
(TOWARD A HIRAGANA FAITH)

On December 7, 1941, Japanese Zero planes attacked Pearl Harbor at 7:48 a.m., thrusting America into the Great War. According to Endo, these stoic Japanese suicide bombers called out not to the emperor, to whom they had committed their allegiance and lives, but to "Okasan," a Japanese honorific and loving way to address their mothers, as they died. Endo mentioned this in many of his lectures, noting that it is not ultimately religious affiliations that matter to a person but what they cry out to at the end of their lives. To the Japanese, and to Endo, okasan is the most important reality, the precious value.

Thus, despite the intent of the Meiji restoration to center the new Japanese psyche toward the emperor, and although many of the soldiers pledged allegiance to and gave their lives for the emperor, even these stoic soldiers *hid* their true allegiance. Their cry of "okasan" indicates their true faith. As Endo suggested, Japanese hearts are drawn to the feminine mother figure rather than a masculine father figure as their image of God.

Instead of Christianity as a katakana (foreign) religion, I advocate movement toward hiragana (lyrical, poetic) faith. The gospel told through feminine eyes does not have to abandon the masculine but can be a lens through which the Bible can be read as a creative, generative document rather than descriptive, analytical proof of God's existence. The lyricism of hiragana culture can provide a path toward God that is full of allusiveness, and yet clear, rational explanation as well. After all there is no discernible difference in meaning between katakana and hiragana; what differs is a nuanced resonance of how a word is conveyed. In translation a text written in katakana and hiragana will mean exactly the same, but intonation, how a text is conveyed, is critical.

❧ ❧ ❧

Why is *Silence* so important? Jesus told his followers to go to the ends of the earth with his message, "baptizing them in the name of the Father and of the Son and of the Holy Spirit, and teaching them to obey everything I have commanded you. And surely I am with you always, to the very end of the age" (Matthew 28:19-20). Christians call this command the Great Commission, and every missionary goes out with the impetus and authority of this command. Japan, the island corner of the world, literally was the end of the world to the missionaries of the seventeenth century. *Silence* probes the reality of such an effort being thwarted, a failure of missionaries to fulfill this reality. But dictatorial oppression in Japan, unlike in other nations, did not result in removal of arts and beauty; it had the opposite effect, and even after the Meiji era, Japan has become, even postwar, one of the most refined cultures in terms of design, cuisine and technology. Japan imported cars, electrical products and fine cuisine in order to refine them. Japan is an island dedicated to refinement. On the other hand, Japanese culture today influences the world's cultures, inhabiting the imagination of youths all over the world. The complexity of cultures that has developed this art of compression can become an ideal

prototype for the future of the world. Japan may have been Westernized, but it is also true that the world has become *Japanized*.

Silence is relevant today in all places where devastations and torture occur. We certainly see parallels in the cries of freedom heard among the African American slaves in American history, as well as persecution of minority Coptic Christians today in Egypt, and over 100 million Christians who face religion-related violence in over thirty-five countries. We need deeper reflections on our humanity through our dehumanized conditions, whether we are stricken with civil wars in Sierra Leone, bullets in Newtown's elementary school or the reports of brutal torture of prisoners by waterboarding in post-9/11 America. Japan may be a mystery to unlock *all* of our soul's longings; in other words, while this book focuses on Japan, the mystery it solves may generate important conversations to find antidotes to the death and malaise of our souls in this postmodern, pluralistic era, and probe into the deeper mystery of the soul's journey into the refractive, prismatic faith of Endo.

Xavier was right in seeing the potential of Japan. Even beyond the 250 years of isolation and persecution, beyond the nationalism that defined, by positive and negative impressions, much of Japan's modernity, lies a promise of integration, perhaps unique in the world. I personally have been touched by that potential through living in Kamakura. My art is about such a hope for Japan. I reiterate Xavier's convictions, repeating them today: Japan may be the culture to lead us into abundance, thriving and true integration of culture and nature. In what may seem to some like over four hundred years of silence since the events of Endo's book, God may yet have deeper purposes, an unfolding plan that we can only access through this cultural estuary called Japan.

<div align="center">෧ ෧ ෧</div>

Japan, in its isolation tendencies, has become a hikikomori nation, a nation that does not seek to be *missional* (in the broad sense of that term, not just in religious commitment). Already, in the past few years we have

seen a marked decrease in Japanese students studying abroad. Endo por-
trays another Japan, one that is seeking reconciliation and peace, speaking
into the world of trauma, providing beauty back into the darkness.

What Japan offers that no other culture can offer is the integration of
nature with culture, and the distinct reality of 美 (kanji for "beauty"). 美
is also the hidden gospel, a *good spell* to liberate us from the curses of the
past, our current Ground Zero conditions. The hidden or crypto-Christian
culture of Japan can reveal itself through its art, music, theater, dance and
literature, but the vision must grow to include business, sciences, tech-
nology and politics. In what some have called a posthuman era, we must
recover the humanness of 美 and move toward the "greater sacrifice" that
leads to thriving in Japan; that movement could become the catalyst for
culture-care renewal throughout the world.

Even though Endo may not be the most reliable theological guide to
the orthodox claims of Christianity, he most certainly adhered to the doc-
trine of the presence of Christ as God who suffers with us in our lives, and
there is no evidence in his writing to argue otherwise. The proof of this is
not in the accuracy of his theological reflections but in the character de-
velopment in the novel itself. The imprint of Christ is significant and
undeniable, so much so that Endo may be, and should be, recognized by
the Protestant community as one of the great writers of grace of the twen-
tieth century. Endo acknowledged in his postscript to the second printing
of *Silence* that his understanding of faith may be more Protestant than
Catholic. He is a deeply *missional* writer, but to a missionary the end and
the failure of one journey is truly the beginning of another type of mission.
Endo depicts a world full of persecution, trials and denial of faith, and this
new mission leads us, in this new century, toward an integrated vision for
the Christian faith, a faith that will remain even if all is taken away.

- 9 -

MISSION BEYOND

THE WAVES

Silence is a statement of the finality of our being.

Richard Fleming, Evil and Silence

The famous image of the waves off Kanagawa was created by Katsushika Hokusai in about 1830. It is one of the incomparable images from a pilgrimage he made throughout Japan, depicting from various angles and locations thirty-six views of Mount Fuji: a journey, through the art of woodcuts, through post-sakoku Japan. This iconic image, often seen as one of the greatest representations of Japanese art, guides us into the mystery of Japan's mission beyond the waves, beyond the world that *Silence* depicts.

Looking at the original image of this woodcut at the Metropolitan Museum, I thought about the scene in *Silence* where Father Garrpe drowns in a futile, defiant attempt to reach the Japanese believers. For Christian believers the surging waves of persecution in the Tokugawa era were indeed overwhelming; they were eventually to swallow them

up into oblivion. Gazing at this woodcut now, I wonder, *What are the boatmen trying to attain? And where are they going?*

Notice that at the same time the boatmen are being swallowed up by the great wave, Mount Fuji too is dwarfed in the image. Hokusai takes advantage of the two-dimensional framework to show the symbol of Japan being threatened by the coming waves offshore. Did Hokusai intuitively anticipate the Meiji restoration era, in which Western influence would begin to take dominance? The woodcut reveals this anxiety and the stoicism of the Japanese, huddled together at the end of the narrow boats, just barely hanging on, struggling to keep from capsizing. In this moment of great flux, the woodcut freezes the motion in a moment of pause, in a moment of silence.

Richard Fleming, a philosopher, stated that "Silence is a statement of the finality of our being."[1]

If so, the finality of Father Garrpe and then of Father Rodrigues is captured in Endo's *Silence*. But at the same time Endo also captures the silence that, in a larger sense, is at the heart of our modern conditions. The phrase "finality of our being" posits both sacrifice and fear; it captures as well the silence of that woodcut, of the trauma and of the unknown future of the Japanese and all of us. Masterpieces of art capture all this and lead us into deeper reflections as a way to define that "finality of our being."

The Great Commission carried priests into the end of the world called Japan. I see another possibility for the Great Commission now that the centuries of persecution have lifted and more than a century of restoration has taken place. This vision for the future arises partly from Hokusai's genius: Japan can become a sending country, exporting its integrated beauty and the value of silence. Just as the admiration for Hokusai's image has reached the viewers of the Metropolitan Museum and various other museums today, the Japanese view of beauty can transform how we view the world.

Fulfillment of the Great Commission is not only the delivery of the gospel message to the "unreached." The Great Commission is fulfilled

when that message is integrated into the culture. The Greek word *baptizō* has more than a symbolic significance; it involves literal total immersion. We are all invigorated—made alive—when all of us see God more fully alive in culture. In Japanese beauty, the beauty of sacrifice, I see a critical framework for our deeper knowing of God. I offer *Silence* and Endo's many books as a path toward deeper knowledge of our Savior.

The typical reaction to the painful history of the past is to try to move forward by ignoring what happened. I was recently speaking to a German friend who confessed that he got so sick of rehashing Germany's Nazi past in school that as an adult he refused to return to Auschwitz or to visit places with a painful past, including Hiroshima and Nagasaki. But when he was confronted with the front-page news of the beheading of captives by terrorist groups in the Middle East, he realized that the past he was trying to avoid is in front of us now, and that the only way to move forward is to first recognize what happened in the history of trauma.

To make our way forward is to go back in history. To recover past trauma is to awaken to the pain, and we cannot heal until we see the narratives of the past renewed by faith and hope. We cannot move forward by ignoring the past. *Silence* is a work of art that renarrates past traumas, but in a way that sheds light on the present. The genius of an artist is to intuit the future by creating a work of imagination that inhabits the past.

THE ART OF BROKENNESS

The Lord's Supper, a holy sacrament for all Christian churches, is a rite that grew out of a New Testament passage written by Paul.

> I received from the Lord what I also passed on to you: The Lord Jesus, on the night he was betrayed, took bread, and when he had given thanks, he broke it and said, "This is my body, which is for you; do this in remembrance of me." In the same way after supper he took the cup, saying, "This cup is the new covenant of my blood;

do this, whenever you drink it, in remembrance of me." For
whenever you eat this bread and drink the cup, you proclaim the
Lord's death until he comes. (1 Corinthians 11:23-26)

In this passage, which is repeated during the administering of the Lord's
Supper, the theme of brokenness is emphasized. Different denominations
have different interpretations of this passage. In Catholic theology the
doctrine of transubstantiation declares that the bread broken literally be-
comes the body of Christ, and wine turns into the blood of Christ, holding
the same physical reality as the actual body and blood of Christ. Some
Protestant churches consider the rite to be mostly symbolic, representing—
re-presenting—in the bread and wine the resurrection reality of Christ.

These are important distinctions, but in Catholic and in many Prot-
estant churches alike the rite carries the same power. The Lord's Supper
provides a narrative and metaphorical journey into any experience of bro-
kenness. When we consider our journeys in and out of trauma, the most
important place of healing may be at the table of a gathering of a family,
in which bread is broken and wine is shared. So even at the rudimentary
level, setting aside the issue of the ecclesiastical power of the rite of Com-
munion, this Scripture guides us into the sociological and psychological
power of the act of breaking bread together.

Wheat is trampled to make bread; grapes are trampled to make wine.
Jesus clearly desired his followers to connect the sacrifices of nature to
make a feast possible.

Recently, I hosted a worship service that was part of an International
Arts Movement conference on art and faith. A friend who is an Episcopal
priest led the service. The gathering included several Catholic priests and
nuns. When the time came for Communion, my friend said, "We must
recognize that the body of Christ, the church, is not united. I wish we were,
but in order to honor these traditions, we must recognize the divide hon-
estly. So if there are those present who cannot share in the meal—whether

because you are part of another tradition of faith or not a believer yet—I invite you to still come up, but not take the elements (bread and wine), but instead give a sign by crossing your arms. I would like to pray for you."

As I saw my friend literally break the bread that day, I gained a new perspective on the Communion service. Other friends who are Catholic priests and nuns humbly went up, but not to receive Communion; their vows forbid them to receive Communion from an Episcopal priest. Instead they crossed their arms across their chests, making a sign of the cross; they asked to be prayed for.

Watching my dear friend Father Paul humbling himself to be prayed for by my other friend, a Protestant minister, opened up for me the reality of the brokenness of the church.

When Christ broke bread, he knew the church would be broken. Every Sunday, in what some call the "most segregated hour of the week," Christian denominations gather and celebrate the broken body of Christ. Never before had I felt so powerfully the import of Christ's words; not until that day had I felt the pain of his own observation. Christ's body is literally broken every Sunday. Yet at that same time Christ, by instituting the Lord's Supper, promises healing. This profound mystery is played out every time the rite is enacted.

Since I am a Protestant and my wife is Catholic, I attend worship at my wife's church but refrain from taking Communion. Instead, I enter into worship through the baptismal waters (sometimes literally by touching the water inside the baptismal font and touching my forehead and chest to make the sign of the cross). I watch the Communion service taking place in front of me and feel the brokenness of the body of Christ, the church. I think often then of Father Paul's humility in accepting such a divide. Christ speaks to me powerfully as I observe, as if to say, "I know how painful this is, my child; remember that my own body is broken every Sunday."

In a universal and generic way, when every family, every community sits down to have a meal, there is power in breaking bread together. What

is clearly a divide in the church becomes a means to lay a bridge toward the other. Thus, in a metaphorical sense, brokenness can lead to unity; a meal shared can become a way to overcome the divide.

Art offers, too, this metaphorical power of broken bread. Art is a cultural meal. It is served to be received in universal terms. Art can even be a rite, or at least a gesture, toward identifying the divide and then, possibly, offering a place of healing even in the midst of despair.

But whether we break bread together in worship, in a family or in the experience of art, at the center of the Table is the great death of Christ. And that leads us, finally, into a discussion of the final frontier of any missional activity—our deaths.

It has been said that in a family meal, it is a devastating and definitive fact that one person in that table will see the others die and will be left alone. Death is an inescapable reality that we are so reluctant to face, so eager to ignore.

"[Death] is a mainspring of human activity," Ernest Becker powerfully observed in *The Denial of Death*, "activity designed largely to avoid the fatality of death, to overcome it by denying in some way that it is the final destiny for man."[2]

Endo, in *Silence*, offers that "final destiny" as a starting point.

Endo's offerings, his words, are words of pain, of brokenness and of trauma. Father Rodrigues reaches the nadir of experience that any priest can go through. He ends in the deepest depths of darkness. But precisely in such a place a new beginning is possible. However faintly, however unexpectedly, Father Rodrigues retains his faith. There is now resiliency in his faith that did not exist before. What if death is not the end but a beginning of a new journey? What if the experience of reading a book like *Silence* allows us to make that new journey, a new mission, beyond the finality of death?

Rowan Williams, a former archbishop of Canterbury, spoke at a recent exhibit opening where I was present. I had the privilege of participating in a collaborative exhibit called Qu4rtets, and this opening marked the

beginning of its exhibition at the historic King's Chapel in Cambridge, England. The collaborative exhibit consists of visual, musical and written meditations on Eliot's *Four Quartets* by artist Bruce Herman, composer Chris Theofanidis, theologian-pianist Jeremy Begbie and me. Archbishop Williams delivered a meditation on death.

Our voyages are all about loss and death.

At the moment of our death, which could be any moment, how is my mortality to be made fruitful in the life of another? How may my loss and my suffering become a Word to others?

Might it be that poetry can be reclaimed in this embrace of what's mortal? Once again, reminded of the Word that echoes silently and unobtrusively throughout the Quartets, the Divine word which exists in mortal flesh, and which speaks most forcefully in death and silence.

The ultimate question that any of us, or any art, can ask is this: "How may I die generously?"

In Japan of old, cherry blossoms are considered most beautiful when they are falling.

I learned from a mentor in my nihonga journey that the cherry trees in Washington, DC, were brought here by an exchange of friendship between the US and Japanese governments.[3] The first batch the Japanese sent, unfortunately, were decimated by insects, and many of them had to be burned. Japanese horticulturalists sent branches from healthy trees to be grafted onto the remaining trees. This strengthened the trees in Washington; they have thrived. In foreign soil these trees invigorated by grafting developed a resistance to various ills. Thus, later on some of the trees have been reintroduced to Japanese soil. Even in the ephemeral beauty of cherry blossoms falling, we are reminded of a trans-Pacific crossing, a journey toward a far country.

Father Rodrigues became like this strain of cherries. By simply surviving persecution with faith, he became a graft, a transplant of authentic

faith that survived pernicious persecution.[4] Endo, by writing *Silence* and highlighting a voice that was silenced in history, embeds this new graft into a global consciousness of faith. Father Rodrigues's story was allowed, therefore, to be resurrected, and in Endo's prose his generous death speaks as a voice of compassion. Endo's words are sacramental: they echo the broken body of Christ and the wine of Christ's sacrificial blood flowing out of the cross of Calvary, flowing into our hearts. The ritual and the rite of brokenness begin our journey as we see that even the story of an apostatized priest, or of the most ignored and suppressed truth, can be the most powerful voice in the art of life. The image of fumi-e, too, as the most oppressed, worn smooth with so many feet stepping over it, has become the most powerful portrait of Christ.

"The way up is down," observes Tim Keller.[5] Every creative act can be a sacramental act to reach the divine and bridge the divide and brokenness created in society. Such acts, done in faith, can endure the test of time. They are, as N. T. Wright has written in *Surprised by Hope*, a deposit into the future of God's making:

> You are not oiling the wheels of a machine that's about to roll over a cliff. You are not restoring a great painting that's shortly going to be thrown on the fire. You are not planting roses in a garden that's about to be dug up for a building site. You are—strange though it may seem, almost as hard to believe as the resurrection itself— accomplishing something that will become in due course part of God's new world.[6]

The postresurrection appearance of Jesus is full of mystery. He appears physically and even invites his disciples to touch his new body, but at the same time Jesus is able to go through walls (John 20). He eats (John 21), so he is conjoining the old earth with the new. He seems not to prolong his presence, and most of the time, as soon his disciples recognize him (which takes a while, according to some passages), he disappears.

The Japanese aesthetic is suited to this postresurrection mystery; it pursues what is ephemeral and ordinary. We have been given a mark as the image bearers of the Creator God, and that mark of the great Artist carries the potentiality for healing, but we must start with understanding our own limited, ephemeral nature. We must understand too the pain of the One who instituted the Supper of the Lamb. Christ is present. He recognizes the pain and trauma of brokenness and is present with us when we, ourselves, get trapped in the schisms of life and the church, as Father Rodrigues experienced. But such recognition of brokenness is also healing. This is the path Endo lays out, a distinctively Japanese path into "part of God's new world." In the schism between the East and the West, Endo navigates by probing deeply inside the fissures of the divide, providing a unique perspective of God operating within an Asian mindset, reminding us that God is not simply a Western, foreign God.

<p style="text-align:center">❧ ❧ ❧</p>

The Bible is not strictly a Western book. Western civilization grew out of the biblical paradigm and certainly was heavily influenced by Judeo-Christian perspectives, but the Bible itself grew out of Eastern cultures: first, Hebraic culture, and later, in the New Testament, Jewish culture supplemented by Greek culture. Passages about the Lord's Supper make more sense in an Asian context, where to join a group sharing a meal is considered to be a sacred inclusion into a family.

Earlier, I spoke of wondering, as I began my journey of faith, "Why did God choose to reveal Christ to me while I was in Japan?" I felt isolated in that nation of non-Christians, and I struggled to find fellowship that understood both the experiences of the arts and the experiences of the church. I created International Arts Movement to try not to be alone. Writing this book serves as a testament to me of God's greater purpose in revealing Christ to me in Japan: I was to find Christ through the image of fumi-e and to write and wrestle with Endo's great work, connecting

his language to the beauty of seventeenth-century Japan. My journey of the past twenty-five years has been to connect beauty with silence. And it was the same with Martin Scorsese: to marry his filmmaking to *Silence* has been a twenty-five-year journey. It takes time to realize the fulfillment of the seed sown into our creative hearts. Such is the power and magnetism of Endo's masterpiece, sown into the hearts of all people seeking refuge from trauma in Endo's art of brokenness.

ᘓ ᘓ ᘓ

The conceptual artist On Kawara was a contemporary of Endo. Recently, the Guggenheim Museum in New York, a city in which Kawara spent much of his career, mounted a posthumous retrospective of his work. The title: "Silence." As I walked through the exhibit in the spiral of the Guggenheim, I considered the overlap between two artists whose careers would be defined by the word *silence*. In the catalog essay, the senior curator of the show, Jeffrey Weiss, notes, "To be sure, regarding the work of any artist, the things we choose to say are always haunted by the things we leave out. With Kawara, however, this aspect of interpretation is specifically, even strategically compounded by the work's evasive status."[7]

Endo's books could be just as evasive, and as I end this book I am also "haunted by the things we leave out." As I researched and wrote these passages, I became more and more aware of the depth of Endo's creativity—and that so much can be revealed that is hidden, deeply embedded, in the soils of his tilling. What is told of Father Rodrigues's confession in the last line of the story—"Even now I am the last priest in this land. But Our Lord was not silent. Even if he had been silent, my life until this day would have spoken of him"—can be said about my life, and this book is the result of that confluence, and the presence of Christ lived through our broken lives.[8]

Endo is ultimately an artist of compassion. A reader may find it quite surprising that strictly speaking there is no direct translation of the

English word *compassion* into Japanese. There is *awaremi* or *jihi*, but both connote a type of stooping down, a condescension to accommodate a need. One might find this to be strange because Buddhism is known in the world to be a compassion-centered religion. The English word *compassion* is "com-passion," an etymology signifying the "sharing of passion." In this word, then, Endo was a genuinely compassionate writer. Perhaps he came to know this type of empathy only by being a misfit in Japan and then experiencing his formative years abroad as an outsider. He desired to give a voice to the voiceless and marginalized. Compassion, then, to Endo, is what is beautiful.

Silence, one might say, is the penultimate statement of finality, the highest ideal in Japanese culture. Thus On Kawara's retrospective works are titled as such. The book *Silence* then is the penultimate compassionate statement of that finality, and Endo's book, thanks to his publisher, was appropriately titled as such. Perhaps in no other culture is a single word so relevant as *silence* is to Japan. In Japan, silence is beauty and beauty is silent.

Endo shows that God speaks through silence. "Even if he had been silent, my life until this day would have spoken of him." In the mystery of silence and beauty God speaks through our broken lives facing our Ground Zero. In the layers revealed through the worn-smooth surface of a fumi-e is a true portrait of Christ; Japan's unique hidden culture offers it as a gift to the world.

❧ ❧ ❧

He grew up before him like a tender shoot,
 and like a root out of dry ground.
He had no beauty or majesty to attract us to him,
 nothing in his appearance that we should desire him. (Isaiah 53:2)

ACKNOWLEDGMENTS

I am grateful for the pilgrimage that has made this book possible. First and foremost, I am grateful for Mark Rodgers, who kept on insisting that I write this book despite my initial reluctance. It was because of his generous introduction between me and Martin Scorsese that I finally felt compelled to begin this journey. I am grateful for initial readers including Dr. Gordon Graham, Philip Yancey, Dr. Thomas Hastings, Father Paul Anel, Father David Beebe, Deborah Fung, Dana Gioia, Bruce Herman, Dr. Jeremy Begbie and others. I am also grateful for Keiko Yanaka's invaluable assistance in Japan, Mark Joseph's encouragement, Ginny and Carl Chien's hospitality and patronage, and to MacLean Collins, Anne Smith and Peter Edman for their editorial assistance. I also thank Howard and Roberta Ahmanson for championing my creative journey and the Fieldstead Foundation for their funding a portion of Fujimura Institute's *Silence* efforts. Thank you to the board, staff and volunteers of the worldwide movement of Culture Care facilitated by International Arts Movement. For my men's group at All Saints Princeton and Redeemer Presbyterian New York City, I am also indebted.

Much of this book relies on the mysterious silver cord that spans centuries, threads of my family history as well as Endo's book. As I wrote these pages, I became more and more aware of the enormous gift of perseverance and creativity of my parents and the power of generational blessings passed on to me, even through the dark and traumatic past, literally through "Ground Zero" ashes.

As I write this, I am embarking on a new effort to bring the above activities into a "still point" of integration at the Brehm Center at Fuller Seminary. I am deeply grateful for the invitation to journey with President Mark Labberton and his staff at Fuller and for allowing me the time to work on this project, in partnership with Fujimura Institute and International Arts Movement.

Following Endo's trails is like going into a dark cave, a narrow but deep cave in which available oxygen is limited. But the pilgrimage rewards those willing to journey into the darkness, to discover the resplendent chambers filled with jewels, with prismatic colors refracting in the dim light. Dr. Graham told me, in commenting on the early manuscript, that it is not so much the details of the "journey" that we need to focus on, but instead the "transformation" we experience. In retracing the steps of Endo, I must say that I have been transformed greatly. Such a transformation never comes easily; many times I felt lost, and confused by Endo's complex maps of trauma. But in the end, I am convinced that Endo guides us toward the jewels of edification and compassion, through the dark corridors of confusion and despair. As of this writing, I have not seen the finished Martin Scorsese film version, but going from the fine, faithful script (I was asked to comment as a special adviser), the orchestration of the tight, disciplined unit at the filming in Taipei (I visited the set twice thanks to executive producer Matthew Malek, producer Gaston Pavlovich and their assistant Gabriel Hugobroom), and the knife-edged performance of the actors, I am persuaded that this film will be one for the ages. I want to thank

particularly multiple–Academy Award winner Francesca Lo Schiavo for her kindness to include me in the set to advise.

I want to thank InterVarsity Press and Al Hsu for taking on this task of publishing, and my wife for her enduring journey with me. Jesus' worn-smooth face on the fumi-e that I saw as a graduate student has left an indelible mark on my faith and my art. Ever since the community at Kurume Bible Church and Pastor Frank Bickerton helped me to see the Light, my transformation continues through life and art. May the de-bossed impression of Christ come through clearly in this book, even through the many tramplings we continue to inflict upon God's Son.

Finally, I want to dedicate this work to the memory of Kim Fox and to Father David Beebe ("Uncle Father"), who both played a significant role in lighting my path.

Appendix 1

ENDO AND KAWABATA

If Flannery O'Connor serves as an apt comparison of Catholic writers dealing with violence and death, another apt comparison is to contrast Endo to his contemporary Yasunari Kawabata. Kawabata, the first Japanese writer to win the Nobel Prize, was the standard bearer of Japanese literature as Endo began his career as a novelist. Yet Endo wrote, seemingly, in defiance of Kawabata's lyricism, depicting a quite different world with his jarring, even sadistic, literary style.

Kawabata's most famous work, *Snow Country*, begins this way: "The train came out of the long tunnel into the snow country. The earth lay white under the night sky. The train pulled up at a signal stop."[1]

Edward Seidensticker is one of the best translators of Japanese literature. And yet this translation loses poignancy and lyricism when the first words we encounter in the book are "The train." In Japanese the book opens with two Chinese ideograms, 国境 (*kokkyo*), which means "border of a country." This is absent from Seidensticker's sentence because "the long tunnel into the snow country" assumes the reader understands the train is crossing some sort of a border; by logic and analysis 国境 is a most

unnecessary word. But in Kawabata's case the first Japanese word, the most unnecessary word, is the most necessary; 国境 as an ideogram is a critical symbol to literally enter into the novel. Like Emily Dickinson's famed dashes, which an editor of her day would remove from her poems because they were unnecessary and confusing, this first word of Kawabata's *Snow Country* was removed by the translator for English readers.

Snow Country is about an awakening of one's heart toward the inner erotic zones of consciousness, where nature and culture are still integrated. 国境 (*kokkyo*) defines the borderlands between one country and another, which does not make sense to a translator because the main character, Shimamura, is not crossing out of Japan. Now, to a Japanese audience this word triggers multiple realities that have significant correlation to Endo's *Silence*. First, it designates that Japan used to be made up of multiple "countries" divided by warlords, and is a country that endured several attempts at invasion by foreign forces. Second, there is a psychological separation between cities (*tokai*) and the countryside (*inaka*), which this sentence guides the reader into. To a Japanese reader living in the reality of modern, industrial Japan, this 国境 (*kokkyo*) is Kawabata's invitation into a rural inaka for the heart longing for a true home of Japan. In this short sentence Kawabata invokes a womb: to cross such a border through a tunnel is to be born again into the Japanese past. Endo follows this trail, inviting his own character of Father Rodrigues to see this Japan, in its rural, agrarian past, as the point of entry as well.

By contrast to the original text, Seidensticker, in order to make sense of the beginning journey of the novel, replaces the first word 国境 (*kokkyo*) with "The train," which is not in Kawabata's first sentence at all. The Japanese reader, by associating 国境 (*kokkyo*) with トンネル, "tunnel" (in the foreign phonetic alphabet of katakana), already knows that we are in the train.[2] Not so in English, as the literal translation will read "Crossing the border, through a long tunnel, it was snow country" sounding more like an allusive haiku than a descriptive sentence to set up the narrative

of the novel. Thus the translator must begin by identifying clearly what is happening rather than leave the reader hanging till the end of the paragraph to find out that the setting is, in fact, in a train.

It is not Kawabata's fault that the translator has such complexity to grapple with in the very first sentence. This is how Japanese culture and language work. Even after reading an entire paragraph one may not know, descriptively, what is happening. So much depends on the reader's exercise of intuition and acceptance of allusive language. Thus, many of my American friends who read Kawabata's work—even the far more descriptive Nobel Speech "Japan, the Beautiful and Myself," also translated by Seidensticker—come away saying, "I read it, but I could not understand it."

Silence, by contrast, begins this way: "News reached the Church in Rome."

Significantly, in the Japanese text the reader encounters first the word *Rome*, written in katakana. Endo uses a foreign word as the first word, setting the tone for the whole book. In this deceptively simple, descriptive sentence, Endo immediately establishes the voice of objectivity, in the word *news*. The Japanese word translated by William Johnston as "news" is 報告 (*houkoku*), which can also be translated as "a note." But even with this slight discrepancy introduced by a translator, the opening words reveal Endo's instinct toward universal, descriptive, journalistic language. Endo's sentence points toward clarity of communication rather than ambivalence and haiku-like lyricism.

Endo strove for an independent voice almost in direct opposition to Kawabata; these two postwar writers saw beauty in quite different ways. Endo desired to depict beauty through sacrifice or in the darkness of human rapaciousness; Kawabata depicted Japanese beauty through loneliness, nature and eroticism. This lyricism and allusiveness make Kawabata's novels very difficult to translate. Endo wrote as if he consciously wished to make his writing *easy* to translate into other languages. His

novels can communicate throughout the multilingual world he experi-
enced as a cultural pioneer. To Endo, faith too resides in the dark recesses
of human experience. In his novels he often quotes the Old Testament
prophet Isaiah's prophecy of the coming Savior:

> He grew up before him like a tender shoot,
> *and like a root out of dry ground.*
> He had no beauty or majesty to attract us to him,
> nothing in his appearance that we should desire him. (Isaiah 53:2)[3]

The beauty of the Savior is defined in *via negativa*—in the paradoxical
opposite of the conventional view of beauty. This view of beauty born of
sacrifice, beauty that bears its true mark on the other side of suffering,
overlaps with the translatability of Endo's prose. What makes Kawabata
quintessentially Japanese in his poetic language is precisely what makes
Kawabata difficult for a Westerner to understand. What makes Endo's
brutal imagery difficult for us to swallow psychologically is precisely what
make Endo relatable in any culture. But Endo *hides* the beautiful behind
traumatic experiences, thereby capturing the genuinely Japanese beauty
of brokenness. In these hidden features of two Japanese authors, I also see
an important overlap—which this passage of Isaiah shares.

Both Kawabata and Endo write to accentuate the paradoxical nature
of beauty. Kawabata does so in the reaffirmation of Japan's past, a world
in which beauty is revealed through the darkness of hidden aspects of
relationships and nature, echoed here in Isaiah—"a tender shoot, and like
a root out of dry ground." Endo, by contrast, writes starkly to reveal
trauma, but sees the beautiful through a suffering Servant—whose
"beauty or majesty" is no longer—who is so disfigured by life that there
is "nothing in his appearance that we should desire him." I do not know
how much Kawabata would have known of Isaiah, but this vision
matches this notion of beauty.

Appendix 2

KENZABURO OE'S

"HUMAN LAMB"

In his short story "The Human Lamb," Kenzaburo Oe characterizes the dreaded in-between aimai state by describing an encounter between a Japanese youth and American occupation forces. In the story the youth is bullied on a bus full of American soldiers. They taunt him in a similar fashion as the children taunt Father Rodrigues at the end of *Silence*. In Oe's story they force him to take down his pants; the drunken soldiers sing "A lamb, a lamb, bang bang." An elementary school teacher on the bus witnesses the incident, follows the humiliated youth as he gets off the bus and tries to convince the youth to press charges. The youth refuses, fearing the consequences to himself and his family. The teacher tells him, "You need to become the sacrificial lamb."

Oe begins the story this way:

> It was the beginning of winter. Standing by the road in the deepening night, I felt the stinging of the fog as harsh powder hitting my cheeks and ears. I had held tight inside my outer jacket the

French textbook I had used earlier for private tutoring. I waited, with my body contorted because of the cold, for the last bus toward the suburbs, which swayed like a ship in the fog.[1]

Reading Oe's work, one is not sure whether the story is a remembered nightmare or, like Endo's writing, a description of historical reality. Oe's writing hovers somewhere in between; details seem surreal, like Kafka's *Metamorphosis*, and we are uncertain of the vantage point of the voice telling the story. Oe intentionally crafts in an ambiguous form, making the reading difficult, even in—especially in—the Japanese language. In the original Japanese text of the passage translated earlier, for example, he mixes Western words and images into Japanese; a literal translation would have the character "wearing [his] Western cloth"—which adds symbolic meaning when in the story he is forced to take it off. These layers of language and meaning create a rhythmical dissonance. To Japanese readers this dissonance is jarring and is compounded by Oe's habit of omitting quotation marks in conversations, leading to sentences that read like a stream of consciousness; readers cannot be sure what the character's thoughts are and what passages are spoken. And the details of the song that the American soldiers sing as they taunt the teenager *seem* American, but it could also be a mistranslation of some American song.

Though in the ensuing years most Japanese would look to the postwar occupation by Americans as a positive influence that led to economic vitality, in the unstated reality of their historical memory the occupation is still perceived as an invasion of the *wa* (harmony) of Japanese communities, a forced dance in which the level of dissonance is never discussed. The enduring concept of gaijin denotes clearly what (and who) does not belong in the inner circles of Japan. Imports are always separate from the Japanese consensus. In Oe's "Human Lamb," this dichotomy of an insider and an outsider is revealed through the bullied character, as he refuses to press charges.

There is a quiet trauma operating deep within a Japanese society, a residual fear of the outsider. In such an ongoing state of trauma, the temptation is to dwell in the liminal, never committing to one decision or another. Bleak hopelessness sets in, and lack of clarity about the future becomes the normative reality of every day. The river flows, and it is better to float along without causing a stir; it is better not to swim against the current. In this passive state it is impossible to form an opinion, to argue for change or to disagree. The only rule seems to be not to disagree and remain silent. A nation that resolutely accepts fate is destined to be taken advantage of, bullied and usurped by dictatorial forces. Oe's writings identify and describe the mud swamp of Japan, not just in the seventeenth century but in the twentieth century and beyond. If the character of the teacher in "The Human Lamb" embodies Oe's point of view, then Endo represents the bullied youth who witnessed the depravity of the human condition but, in keeping with the Japanese psyche, suppressed this observation.

In Oe's depiction of Japanese present darkness, he attempts to move beyond the limitations of the Japanese language to create multiple perspectives. His style is highly sensory, surreal and shocking. Like Picasso's cubism, in his art he heightens the edges of reality; one must piece together characters and events from fragments of the narrative. His language is a counterpunch to Kawabata's lyricism: it matches Kawabata's ambiguity and nuance, but forcefully moves beyond them into a black hole of language and dehumanization of modern conditions. His writing also serves as a helpful companion to Endo's works. The ambiguity they express is one reality of a traumatized, orphaned culture. One might say that Kawabata remains lyrically hopeful in the age between *The Tale of Genji* and Sen no Rikyu, attempting to resurrect the sense of Japanese beauty into the present; Oe sees that approach as an impossibility in post-Hiroshima Japan. Oe presents Japan not just as a victim but also as a perpetrator, resurrecting the memory of Japan's past invasions of China and Korea, and the blind march of nationalism to Pearl Harbor.

A SUMMARY OF *SILENCE*

BY SHUSAKU ENDO

by Sherri and Peter Edman

The novel in English consists of a helpful translator's preface by William Johnston, a prologue, ten chapters and an appendix. Chapters one through four are presented as letters from Father Rodrigues, the central character. The rest of the novel uses an omniscient narrator and extracts from the journals of various officials. This summary is based on Johnston's translation.

PROLOGUE

Around 1635, during a century of severe persecution of Christians in Japan, news arrives that the senior Jesuit missionary Christovao Ferreira has apostatized after undergoing torture. Three Portuguese priests—Ferreira's former students Sebastian Rodrigues, Juan de Santa Marta and Francisco Garrpe—petition their superiors for permission to go on a mission to Japan and investigate the rumors. They journey to the Portuguese territory of Macao in south China.

CHAPTER 1

Rodrigues writes that the Jesuit superior in Macao is unwilling to allow their mission to continue. They are warned of terrible persecution, particularly at the hands of the magistrate Inoue. The three plead that Japanese Christians who have lost their priests would be "like sheep without a shepherd" and that they have a duty to discover the truth about Ferreira. The superior at last relents, although Santa Marta has fallen ill and must stay behind. They begin to research Japan, aided by an alcoholic Japanese national named Kichijiro. Kichijiro denies being a Christian, but wishes to return home and offers to guide them. Rodrigues thinks Kichijiro untrustworthy, but reasons, "Our Lord himself trusted his destiny to untrustworthy people."

CHAPTER 2

Rodrigues, Garrpe and Kichijiro make their way to Japan aboard a Chinese junk. As they sail through fearful storms, the priests catch "cowardly" Kichijiro praying the Hail Mary. He still denies being a Christian. When the ship finally reaches a Japanese island, Kichijiro wades ashore. The priests hide and speculate on whether cowardice has caused him to flee or whether he has gone, like Judas, to betray them. Kichijiro at last returns with an old man, a Christian who welcomes and hides them in his village. They discover that Japan's Christians have organized laypeople to administer sacraments in the absence of priests. The priests settle into a routine of offering Mass at night and waiting in a mountainside hideout during the day to minister to anyone who seeks them.

CHAPTER 3

The Christians in Tomogi, the village where the priests are hiding, are subsistence farmers crushed under a huge tax burden. Rodrigues speculates that Christianity made such inroads because the priests treated the people with charity and kindness. The Christians are faithful but must

practice in secret; the district lord perpetually inspects the villages, offering fabulous rewards to anyone who reports a Christian—and more for a priest. The priests are startled when two strange peasants appear, begging them to come to the Goto Islands. They have learned of the priests' presence from "a Christian of our village": Kichijiro. He had apostatized when the rest of his family were martyred for refusing to tread on a fumi-e—a picture of Christ or the Virgin Mary. Rodrigues agrees to minister in Goto for five days. On returning, escorted by Kichijiro, Rodrigues is feeling happy about his work in Japan until a villager warns him to hide. Someone has gotten wind of the priests, and guards are in the village.

CHAPTER 4

The people of Tomogi foil the officials by hiding away all suspicious objects and pretending to be mere peasants. Rodrigues is pleased with the outcome, although concerned that someone has betrayed them. He reiterates the miserable condition of the Japanese under the feudal lords. After a sudden break in the letter, he tells of another surprise inspection. Officials take Kichijiro and two villagers hostage. Kichijiro, terrified, asks why God would bring this trial on them. Rodrigues interprets the question as a lament over the "silence of God" during the many years of persecution.

Under interrogation the hostages follow Rodrigues's advice and agree to trample the fumi-e. Their interrogators are not fooled and insist that the hostages spit on the Virgin and call her a whore. Kichijiro submits, is freed and disappears. The two villagers refuse, confess that they are Christians and are publicly martyred.

Rodrigues and Garrpe agree to leave Tomogi and part ways so their work can continue. Rodrigues walks alone down the road, struggling with the troubling silence of God. He realizes that someone else is walking ahead of him. Eventually he catches up and finds it is Kichijiro, who

promises to take him to a Christian village. On the way he offers the starving priest some dried fish, which makes Rodrigues terribly thirsty. When he begs for water Kichijiro runs away, ostensibly for water, but really to report Rodrigues. As Rodrigues is captured he sees the officials throw at Kichijiro "a number of tiny silver coins."

CHAPTER 5

Rodrigues is imprisoned with five other Christians. An interpreter debates with him about Christianity and Buddhism. Finally he tells Rodrigues that unless he renounces his faith the five Christians will be hung upside down in a pit. The interpreter adds that he knows Ferreira and that he is indeed an apostate, living with a wife in Nagasaki. Rodrigues is distraught at this, fearing that if his great teacher faltered under torture then so might he. He is taken to Nagasaki. During the journey he catches glimpses of Kichijiro, who appears to be following him.

CHAPTER 6

Rodrigues is imprisoned in Nagasaki, at first alone, then with other Christians. He is brought before the magistrate Inoue, the force behind the persecution, and they debate on whether Christianity can take root in Japan. Rodrigues struggles internally with self-doubt and faith while still ministering to the Christians with him. Kichijiro comes to see him in prison, begging for absolution, and is imprisoned when he tells the guards he too is a Christian. The next day all the Christians except the priests are called to trample the fumi-e; four refuse and one is beheaded. Kichijiro treads the fumi-e and is released.

CHAPTER 7

Rodrigues is called again before Inoue, who compares the burden of Christianity in Japan to the burden of "persistent affection of an ugly

woman for a man." In prison Rodrigues continues his inward turmoil. He is taken to observe Garrpe, who has also been captured, as Garrpe is told to apostatize lest the remaining Christians in the Nagasaki prison be rolled in straw and dropped into the sea. Garrpe dies when he plunges into the sea in a futile effort to save the Christians. Rodrigues's mental distress increases.

After several months Rodrigues is taken to a temple and at last meets Ferreira, now at work for Inoue writing a refutation of Christianity. Ferreira is under orders to get Rodrigues to apostatize. He warns him that the Japanese version of Christianity is not what they had thought, that the God worshiped by the Japanese is not their God. Rodrigues returns to prison and his internal struggle.

CHAPTER 8

Rodrigues is again told to trample the fumi-e and refuses. He is paraded through the streets of Nagasaki for the people to abuse and insult. He spots Kichijiro among the crowd, following along and watching him. He is then put in a tiny cell with a urine-covered floor. As the night passes, he is at first amused by the sound of a drunk guard snoring, but after several hours it grows intolerable. Finally the interpreter comes with Ferreira to ask what is wrong, and they reveal that the snoring is actually the moaning of Christians hanging in the pit. Ferreira tells Rodrigues that he apostatized not because of his own three days' torture in the pit but after hearing the moans of others like these, "for whom God did nothing." Ferreira's apostasy was driven by the same silence that tortures Rodrigues; he was told the Christians' suffering would only end if he would apostatize. Ferreira takes Rodrigues to the office and tells him, "You are now going to perform the most painful act of love that has ever been performed." A fumi-e with a picture of Christ is given to Rodrigues, and as he prepares to trample it he recalls all the times he has meditated on Christ's face, until it seems to him that the face at his feet tells him to

"Trample! It was to be trampled on by men that I was born into this world! It was to share men's pain that I carried my cross!"[1] As Rodrigues tramples the fumi-e, dawn breaks and the cock crows.

CHAPTER 9

Rodrigues is living under house arrest in Nagasaki. His job as a servant of the magistrate is to examine foreign objects to tell whether or not they are Christian and thus forbidden. He is forbidden from meeting Ferreira freely, but they often are called to the magistrate's office together. Rodrigues resigns himself to living the rest of his life in Japan, disgraced in the eyes of the Church.

CHAPTER 10

Inoue "awards" Rodrigues the wife of an executed man and moves him to Edo (present-day Tokyo), and also gives him the man's Japanese name, Okada San'emon. Kichijiro finds Rodrigues once again and begs to make confession. As Rodrigues struggles to make sense of Kichijiro's weakness, and absolves him, the last words of the novel in his voice are, "Our Lord was not silent. Even if he had been silent, my life to this day would have spoken of him."

APPENDIX

The book concludes with important notes from a Japanese officer from which it can be inferred that almost all the servants and members of Rodrigues's household, including Kichijiro, were secretly Christians. Rodrigues passes away at the age of sixty-four.

NOTES

INTRODUCTION: A PILGRIMAGE

[1]Officially, sakoku lasted from 1633 to 1853, but the closing of the ports to merchants and the persecution of Christians began in the late sixteenth century. Some recent scholars have attempted to retire the term "the closing of Japan," as Japan was not completely cut off to Dutch merchants; but sakoku was a psychological reality, and cultural bars to the practice of freedom of thought and religion are still, as I will show, operative today.

[2]Hans Rookmaaker, *Modern Art and the Death of a Culture* (Downers Grove, IL: InterVarsity Press, 1970), 248.

[3]I was recently appointed director of Brehm Center at Fuller Seminary in Pasadena, so I will have two studios, one in Princeton and one in Pasadena.

[4]See Makoto Fujimura, *Culture Care: Reconnecting with Beauty for Our Common Life* (New York: Fujimura Institute, 2014).

[5]I am indebted to Father Gordon Graham at All Saints' Church in Princeton for this observation on Holy Saturday.

CHAPTER 1: A JOURNEY INTO *SILENCE*

[1]This title, "The Resurrection," may jump out as a strange juxtaposition to some. Those unfamiliar with Christianity or to the history of fumi-e may miss such a connection to the installation; those with Christian faith find Endo to have theological limitations, especially in regards to the supernatural reality of the resurrection, which is a bodily rising of the dead, different from an appearance of a ghost, but a physical fusing of heaven and earth that Christ's body attests to. Endo deals with the historical and theological significance of what happened three days after the death of Jesus at Calvary (Good Friday) and the resurrection morning (Easter) in his book *A Life of Jesus*, and I will discuss some details later on. I intentionally named the installation "The Resurrection" to amplify my comments on Endo's theology and to bring what may be to some be a strange reality into the world of art.

[2]Philip Yancey, "Japan's Faithful Judas, Part 1," 2think.org, accessed November 2, 2015, www.2think.org/endo.shtml.

[3]Endo's mother studied music at Tokyo University of the Arts, the same university I attended.

[4]Much of the biographical detail in this chapter is from Muneya Kato, *Shusaku Endo* (Tokyo: Keio-Gijutsu Daigaku Shuppan, 2006). Available in Japanese only.

[5]Françoise eventually followed Endo to Japan, living in Hokkaido (the northern island) far from Endo's Tokyo residence but eventually finding a way to teach in Tokyo in Dokkyo University. Endo refused to see her, but according to many accounts he provided the funds necessary for Françoise to receive treatment for her diagnosis of breast cancer, an illness that would take her life rather suddenly. Interestingly, his wife consented to the release of his writings loosely based on his relationship with Françoise, opening up a series of new questions of Endo's earlier romance.

[6]The best compilation of interviews, all in Japanese, is the CD set released by ArtDays (Tokyo, 2002).

[7]The earliest known fumi-e were on paper, until the magistrates found them to be too fragile and possibly less effective. There are different accounts of Endo's first encounter with fumi-e, even in his personal accounts. Some books indicate a friend brought him a newspaper article about fumi-e during one of his many hospitalizations.

[8]Shusaku Endo, *Nagasaki Pilgrimage with Shusaku Endo* (Tokyo: Geijutsu-shincho, 2006), 9; translation mine.

[9]There are certainly more authors, especially French authors like François Mauriac, who directly influenced Endo. My purpose in contrasting these authors is to contextualize Endo in both Japanese and American literatures.

[10]Paul Elie, *The Life You Save May Be Your Own: An American Pilgrimage* (New York: Farrar, Straus & Giroux, 2003), 135.

[11]See Ralph C. Wood, *Flannery O'Connor and the Christ-Haunted South* (Grand Rapids: Eerdmans, 2005).

[12]Shusaku Endo, *Journeying Together: Conversation Between Shusaku Endo and Yasumata Sato* (Tokyo: Kodansha Bungei, 1991), 25; translation mine.

[13]Recently, scholars have speculated that Xavier may have known that Japanese folk tales and myths have many biblical allusions. Many Buddhistic temples, especially those of the messianic sect, include versions of the Ten Commandments. The ideogram (kanji) of the word *ship* comprises a boat

with eight mouths, which corresponds to the number of people that Genesis reports were saved from the flood by Noah's ark. Recently, scholars have found evidence of an influx of Christianity into Japan in the eighth century, due to Nestorian influence. Since Japan was the endpoint of the Silk Road (the route for silk trade between the Middle East, India and Japan), it seems likely that Japan also would have been a depository of the world's cultures and religions. (See "Religious Sites, Relics Indicate Christ Beat Buddha to Japan," *Buddhims Today*, accessed November 3, 2015, www.buddhismtoday .com/english/world/facts/108-japan.htm.)

[14]For further exploration of the work of Oribe, Rikyu's main disciple, see Souren Melikian, "The Aesthetics of the Imperfect," *New York Times*, November 22, 2003, www.nytimes.com/2003/11/22/style/22iht-melik_ed3_ .html.

[15]See details of this journey in the excellent book by John Dougill, *In Search of Japan's Hidden Christians* (North Clarendon, VT: Tuttle, 2012), 80-108.

[16]"And whoever does not carry their cross and follow me cannot be my disciple" (Luke 14:27).

[17]C. S. Lewis, *Mere Christianity* (New York: HarperCollins, 2001), 215.

[18]Flannery O'Connor, *Collected Works: Wise Blood / A Good Man Is Hard to Find / The Violent Bear It Away / Everything That Rises Must Converge / Essays and Letters* (New York: Library of America, 1988).

[19]Finch's character has been challenged by the recent release of Harper Lee's "prequel" to *To Kill a Mockingbird*, but this line still is a significant marker of the type of empathy that Atticus taught the young Scout. See my *Refractions* essay "From Mockingbird to Watchman," at www.makotofujimura .com/writings/from-mockingbird-to-watchman.

CHAPTER 2: A CULTURE OF BEAUTY

[1]Yoshihiko Amino, *What Is "Japan"?* (Tokyo: Kodansha, 2000), 26; translation mine.

[2]See Makoto Fujimura, *Culture Care: Reconnecting Beauty for Our Common Life* (New York: Fujimura Institute, 2014).

[3]Makoto Fujimura, *Golden Sea,* a documentary by Plywood Pictures, 2013, http://iamculturecare.com/video.

[4]Yasunari Kawabata, *Japan, the Beautiful and Myself* (Tokyo: Kodansha, 1969), 69, 68.

[5]This tenderness of Endo's Japanese is often not as directly relatable in English. The nuances present in some of his expressions get lost, despite the high level of descriptive, prescriptive language.

[6]Yasunari Kawabata, *Japan, the Beautiful and Myself* (Tokyo: Kodansha, 1969), 63-64.

[7]Tomonobu Imamichi, "Poetry and Ideas," *Doyo Bijutsu* 2, no. 114 (1994): 42; translation mine.

[8]Matazo Kayama, *Mugen no Kukan* (*Infinite Space*) (Tokyo: Shogakkan, 1994), 41; translation mine.

[9]Ibid., 53; translation mine.

[10]Conversation with Muneya Kato, Endo's biographer, December 23, 2014, at Hotel Okura.

CHAPTER 3: AMBIGUITY AND FAITH

[1]Ruth Benedict, *The Chrysanthemum and the Sword* (New York: Mariner Books, 2005), 2.

[2]Kenzaburo Oe, "Japan, the Ambiguous, and Myself," Nobelprize.org, December 7, 1994, www.nobelprize.org/nobel_prizes/literature/laureates/1994/oe-lecture.html.

[3]Ibid.

[4]William Butler Yeats, "Vacillation," quoted in Oe, "Japan, the Ambiguous, and Myself."

[5]Bernard Petitjean, quoted in John Dougill, *In Search of Japan's Hidden Christians* (Tokyo: Tuttle, 2012), 183-84.

[6]Dougill, *In Search of Japan's Hidden Christians*, 221.

[7]William Johnston, preface to Shusaku Endo, *Silence* (New York: Taplinger, 1980), xvii.

[8]Both Endo and Oe rely on psychological ambivalence to depict their contemporary world filled with trauma, but Endo sets up the narrative toward a specific faith, while Oe's writings remain ambiguous about the possibility of hope.

[9]Shusaku Endo, *The Voice of Silence* (Tokyo: President Company, 1992), 86.

[10]Shusaku Endo, *For Those Who Wrestle Against Dying: That's Quite OK, Isn't It?* (Tokyo: Kairyusha, 2014), 51; translation mine.

[11]Shusaku Endo, "The Mysteries of the Heart and Life," 1993, *Shusaku Endo Lecture Selection*, Art Days, Tokyo, CD, disc 5.

[12]Thanks to Isumi Araki for this illumination.

[13]Shusaku Endo, quoted in Philip Yancey, "Japan's Faithful Judas, Part 2," *Books & Culture*, January-February 1996, 3, 6-7.

[14]Dana Gioia, *The Catholic Writer Today* (Milwaukee: Wiseblood, 2014), 33.

[15]Don E. Saliers, "Beauty and Terror," *Spiritus* 2, no. 2 (2002): 181.

CHAPTER 4: GROUND ZERO

[1]David Bentley Hart, "Tsunami and Theodicy," *First Things* 151 (March 2005): 6-9, www.firstthings.com/article/2005/03/tsunami-and-theodicy.

[2]Makoto Fujimura, *River Grace* (New York: Poiema Press, 2007), 7-9. Used with permission.

CHAPTER 5: FUMI-E CULTURE

[1]Shusaku Endo, "On Silence," 1966, *Shusaku Endo Lecture Selection*, Art Days, Tokyo, CD, disc 1.

[2]Takeo Doi, *The Anatomy of Dependence* (Tokyo: Kodansha International, 1971), 42-43.

[3]Ibid., 59.

[4]Ibid., 60.

[5]Tokugawa feudal powers forced isolation on the Japanese geographically, politically and personally. Dependency on the shogunate systematically undercut all movement toward individual freedom and independent thought. Meiji "restoration" opened Japan's borders in 1868, but it never restored a sense of individual freedom. Doi argues that the Meiji era successfully maintained a culture of dependence by linking the nationalistic vision to the imperial family.

[6]In her recent book *Imaging Disaster: Tokyo and the Visual Culture of Japan's Great Earthquake of 1923* (Berkeley: University of California Press, 2012), Duke scholar Dr. Gennifer Weisenfeld describes how the Japanese depicted the postearthquake conditions of Japan:

> Alongside the virtual space of the mass media, the Japanese produced real spaces to exhibit the images and objects of the catastrophe. These venues were also used to present propositions for rebuilding the nation's capital. Public and private organizations, most prominently the Tokyo metropolitan government, sponsored major exhibitions, and eventually a permanent memorial hall and museum, to narrate the story of disaster and reconstruction. The exhibitionary logic of these spaces yoked the agonistic somatic associations of the venerable debris of the quake to

the visual rhetoric of progressive urban planning, thereby enfolding mourning and memory into reconstruction and modernization. Yet the deformed personal objects on display continued to serve as powerful material witnesses to the tragedy, metonymically communicating the presence of the dead and eliciting an intensity of communal be-reavement that could not be eased simply by the progressive ideology of the new modern metropolis. (p. 10)

Fumi-e also "serve as powerful material witnesses to the tragedy, met-onymically communicating the presence of the dead and eliciting an in-tensity of communal bereavement." They started Endo on his journey toward writing *Silence*, and my journey toward writing this book. Those who create displays of fumi-e may simply have history in mind, and not the "progressive ideology" of postquake Japan. Nevertheless, visual evidence of the past does invoke the "presence of the dead." Fumi-e, in other words, can only be used in a highly visual culture, a sophisticated culture that attributes significance to images as much as it does to words.

[7]Shusaku Endo, *The Voice of Silence* (Tokyo: President Company, 1992), 18.
[8]Ibid.
[9]Shusaku Endo, *Silence* (London: Peter Owen, 1976), 133.
[10]Yoshiro Nagayo, *The Bronze Christ* (Tokyo: Iwanami, 1927), 165; translation mine.
[11]Perhaps due to what happened to Hagiwara, later fumi-e are less refined, perhaps because the artisans may intentionally have held back on their craftsmanship lest they meet a similar fate. These later fumi-e may be the most unsophisticated Japanese objects ever made. Today, they speak of the determination with which the authorities forced their will on people. The carvings were done by craftsmen who were given only a few days to accomplish the task. They most likely were trained to carve Buddhistic statues of wood and cast bronze; the same training that cast the faces of compassionate Buddhas was used to create crude instruments for the per-secution of Christians. One should note, though, that placement of a round bronze image of Christ within a wooden block (such as the fumi-e that inspired Endo) is a particular innovation of a visual culture. The bronze image alone would be an object of representation, a symbol of faith, a threshold of betrayal of one's Christian faith. A wooden block to house the object forces one to cross a second threshold—a stage, if you will, of suf-fering and denial. And this is the stage that Endo found himself moved by and desired to depict. In Japanese culture presentation is highly valued, and

whoever crafted the fumi-e knew how to amplify the significance of the embedded image by conveying the crossing of a threshold.

[12]Yuri Kageyama, "Japan Mourns Kenji Goto as Caring and Courageous Reporter," Associated Press, February 1, 2015, http://news.yahoo.com/japan-mourns-goto-caring-courageous-reporter-052244871.html. In the article, the word *cuddling* is used as a translation, but I believe *embrace* is a better translation.

[13]John Marks and Peter Mallat, "The Nail That Sticks Out," *New Internationalist* 231 (May 1992), http://newint.org/features/1992/05/05/nail.

[14]Yoshihiko Amino, *What Is "Japan"?* (Tokyo: Kodansha, 2000), 36-37; translation mine.

[15]"Japanese Katakana," *Omniglot*, accessed November 6, 2015, www.omniglot.com/writing/japanese_katakana.htm.

CHAPTER 6: HIDDEN FAITH REVEALED

[1]On this point I rely on Ayako Miura's novel *Rikyu and His Wives* (Tokyo: Shincho-bunko, 1980), which, based on scant historical references, portrays Oriki as a convert. The author's depiction makes sense in light of a range of circumstantial evidence, but there is no historical document to prove Oriki's conversion. What is evident is that Rikyu frequented gatherings where missionaries were also present, and many writings attest to Rikyu being influenced by Christianity.

[2]Tenshin Okakura, *The Book of Tea*, (New York: Dover, 1964), 26.

[3]Historians, though, keep finding evidence of Rikyu's connection with Christianity. See, for example, Muan Yamada, *Christian Rikyu* (Tokyo: Kawada-Shobo, 1995) (in Japanese only). The accompanying image by Naizen Kano in the book is intriguing. It shows an elderly man with a black hat known to have belonged to Rikyu, with a Rosario on his left hand and a walking stick that is known as *Ju-ji-Tsue* or a "cross walking stick," walking among Franciscan priests. Painted after Rikyu's death, this painting, among other works, may point to Rikyu's identity as a Christian.

[4]Okakura, *The Book of Tea*, 41.

[5]Tenshin writes: "Before a great work of art there was no distinction between daimyo, samurai, and commoner. Nowadays industrialism is making true refinement more and more difficult all the world over. Do we not need the tea-room more than ever?" (ibid.).

[6]Ibid.

[7]Tadachika Kuwata and Tetsuo Owada, *Sen no Rikyu* (Kyoto: Miyaobi, 2011), 98.

[8]まきたあわじのかみ 蒔田淡路守

[9]There is some dispute about where Gracia is buried; several sites are possible, notably in Sozen-ji in Osaka. It's most likely that this Koto-in site commemorates their spirits, dedicated to their memory, more than the actual burial site.

CHAPTER 7: THE REDEMPTION OF FATHER RODRIGUES

[1]Yoichi Onaka, *The Voice of Silence* (Tokyo: President Publishing, 1992).

[2]There are variants on Japan's name, such as *Nihon* and *Nippon*.

[3]The original handwritten draft of *Silence* is at the Shusaku Endo Museum in Sotome, and it is in this draft that Greene's *The Power and the Glory* is mentioned several times.

[4]Graham Greene, *The Power and the Glory* (New York: Penguin Classics, 2003), 29.

[5]Ibid., 82.

[6]As I noted earlier, there is no appendix section delineated in the Japanese version.

[7]Tawaraya Sotatsu, "Moon and Autumn Grasses," Metropolitan Museum of Art, accessed November 11, 2015, www.metmuseum.org/exhibitions/view?exhibitionId=%7b4BC8E27D-9844-40C6-B97D-9289701377CE%7d&oid=48923&pkgids=286&pg=2&rpp=90&pos=146&ft=*.

[8]Sandro Magister, "Nagasaki, the City of the Atomic Bomb—and of the Christian Martyrs," Chiesa.espressonline, October 30, 2007, http://chiesa.espresso.repubblica.it/articolo/173602?eng=y&refresh_ce.

[9]Martin Scorsese, afterword to *Approaching Silence: New Perspectives on Shusaku Endo's Classic Novel*, ed. Mark W. Dennis and Darren J. N. Middleton (New York: Bloomsbury, 2015), 387-98.

[10]Ibid., 398.

CHAPTER 8: THE AROMA

[1]Michael Zielenziger, *Shutting Out the Sun: How Japan Created Its Own Lost Generation* (New York: Doubleday, 2006), 261.

[2]Ibid., 9.

[3]Ibid., 261.

[4]Anne Allison, *Precarious Japan* (Durham, NC: Duke University Press, 2013), loc. 1058.

[5]Ibid., loc. 946.

[6]Ibid., loc. 1521.

[7]Ibid., loc. 2767.

[8]Ibid., loc. 1706.

[9]Makoto Fujimura, "*Departures*: The Art of Transformation," *Curator*, May 29, 2009, www.curatormagazine.com/makotofujimura/departures-the-art-of-transformation.

[10]Mark R. Mullins, *Christianity Made in Japan: A Study of Indigenous Movements* (University of Hawaii Press, 1998), 192.

[11]In a PhD thesis, Princeton Seminary student Sarah Chae compares Erik Erikson's stages of development with Korean Christian history. In each of the stages the student identified that Korean culture has chosen (with some wrestling) trust over mistrust, autonomy over shame and doubt, initiative over guilt, industry over inferiority and so forth. I noted to her that Japanese culture has chosen the negative of these terms and therefore has over time become immersed in despair.

[12]Joseph Pearce, *C. S. Lewis and the Catholic Church* (Charlotte, NC: Saint Benedict Press, 2013), loc. 989.

[13]See Bernard Chazelle, "Discovering the Cosmology of Bach," *On Being* (blog), November 13, 2014, www.onbeing.org/program/bernard-chazelle -discovering-the-cosmology-of-bach/7026.

[14]Shusaku Endo, *Silence* (New York: Taplinger, 1980), 108.

[15]See Thomas Nagel's arguments in *Mind and Cosmos: Why the Materialist Neo-Darwinian Conception of Nature Is Almost Certainly False* (New York: Oxford University Press, 2012).

[16]As David Bentley Hart recently observed in *The Experience of God* (New Haven, CT: Yale University Press, 2013), neither side is speaking of the preexisting God outside time and space. If this divine reality is to be known, we can only enter with humility and awe. Chuan's method is entirely within the closed system of nature; the decision of whether or not to step on fumi-e has nothing to do with the possibility that this closed system itself is sufficient to answer to the existence of God.

What Hart argues for rather exquisitely in *The Experience of God* is that denial of the existence of God must be done rationally, without depending

on the belief in the birth of rationality in a closed system sufficient to itself. In other words, one must be willing to "have faith" in this assumption that "the cosmos is all there is and all there will be" and argue from the closed system to disprove the existence of God who, by definition, stands outside such an assumption. If you trace this loop honestly, this path requires the most absurdly restrictive reasoning and must be pursued with consistent denial of the obvious. In order to do so, furthermore, we must use deduction, and empirical reliance on natural laws which govern us, to argue for human imagination that can depict a God who stands outside that declared limited scope. Therefore, such denial of ontology may reject the presence of God within that closed natural system, and within propositional reasoning, but cannot conclude, and sufficiently prove, a presence outside such a system. A deep-water sea creature that has never surfaced may never know that a seagull exists, but that does not prove that a seagull never existed; it's simply swimming deep in the realm of aquatic experience and rational (if such a creature had rationality) purview, but that "knowledge" does not prove or disprove anything regarding the aerial reality.

[17]Esther Lightcap Meek, *A Little Manual for Knowing* (Eugene, OR: Wipf & Stock, 2014), loc. 68.

[18]A recent survey sponsored by NHK (the Japanese BBC) noted that 13 percent of those surveyed "felt closest to Christianity" among all religions. This number is astonishing given that less than 1 percent identified themselves as a Christian. This discrepancy may not exist in other cultures. (See Kumiko Nishi, NHK/ISSP research, 2008.)

[19]Christian Wiman, *My Bright Abyss* (New York: Farrar, Straus and Giroux, 2013), 117.

CHAPTER 9: MISSION BEYOND THE WAVES

[1]Richard Fleming, *Evil and Silence* (Boulder, CO: Paradigm, 2009), 92.

[2]Ernest Becker, *The Denial of Death* (New York: Free Press, 1973), ix.

[3]"Cherry Tree History," *National Park Service*, accessed November 12, 2015, www.nps.gov/cherry/cherry-blossom-history.htm.

[4]Christ created a new path toward entering into faith. Paul likens this entry by non-Jewish believers to grafting:

But some of these branches from Abraham's tree—some of the people of Israel—have been broken off. And you Gentiles, who were branches

from a wild olive tree, have been grafted in. So now you also receive the
blessing God has promised Abraham and his children, sharing in the rich
nourishment from the root of God's special olive tree. (Romans 11:17 NLT)

[5]Timothy J. Keller, "The Girl Nobody Wanted: Genesis 29:15-35," in *Heralds of the King*, ed. Dennis E. Johnson (Wheaton, IL: Crossway, 2009), 70.

[6]N. T. Wright, *Surprised by Hope: Rethinking Heaven, the Resurrection, and the Mission of the Church* (San Francisco: HarperOne, 2008), 208.

[7]Jeffrey Weiss, "Bounded Infinity," in *On Kawara—Silence*, ed. Jeffrey Weiss with Anne Wheeler, 26, 2015, published in conjunction with the exhibition "On Kawara—Silence" shown at the Guggenheim Museum in New York.

[8]Shusaku Endo, *Silence* (New York: Taplinger, 1980), 298.

APPENDIX 1: ENDO AND KAWABATA

[1]Yasunari Kawabata, *Snow Country*, trans. Edward G. Seidensticker (New York: Vintage International, 2013), 3.

[2]See the discussion on Japanese phonetic alphabet system starting on page 106.

[3]The book of Isaiah is included in the Christian Bible as one of the Old Testament prophetic books and was written around 740 BC during the Babylonian captivity of the Jews. Isaiah is the prophet Jesus quoted the most.

APPENDIX 2: KENZABURO OE'S "HUMAN LAMB"

[1]Kazabura Oe, "The Human Lamb," in *Lavish Are the Dead* (Tokyo: Shinshobunko, 1959), 162; translation mine.

APPENDIX 3: A SUMMARY OF *SILENCE* BY SHUSAKU ENDO

[1]The word translated "trample" is the Japanese *Fumu-ga-yoi*. The Japanese is a permissive word and not an imperative command. It would loosely be translated as "you may step on it."

GLOSSARY OF JAPANESE TERMS

aimai. Ambiguity

amae. Dependence

awaremi. Condescension to accommodate a need

byobu. Japanese folding screens

daimyo. Warlords

enryo. Constantly deferring to the other's wishes

fumi-e. "Stepping images," relief bronze sculptures sometimes set into wooden frames

gaijin. An outside person or foreigner

gonin-gumi. "Band of five," local accountability groups used to enforce the edict that banned Christianity

hataraku Kami. Active and moving God

hikikomori. Shutting out the sun

hiragana. A Japanese phonetic alphabet created to identify objects and people native to Japan

hon-ne. "True voice"

ijime. Bullying

inaka. Countryside

jihi. Condescension to accommodate a need

kaimamiru. To "see between"

Kakure Kirishitan. Hidden Christian

kanji. Japanese ideograms imported from China

kasuga-dourou. A stone lantern

katachi. "Form" or "formality"

katakana. A Japanese phonetic alphabet created to identify foreign objects and people

Kirisuto-kyo. Christianity

kumohada. The largest hand-lifted Japanese paper made in Imadate, Japan, of hemp and mulberry fibers; literally translated "Cloud-Skin" paper

majime sugiru. Too serious

mono-no-aware. Pathos of things

mukyokai. "No church"

mura-hachibu. Village of 80 percent

nakai-san. Attendant

nakama hazure. To "exclude one from a group" or brand the person as a misfit

nihonga. A traditional Japanese painting technique

nijiri-guchi. A small square entry port designed for the guest to enter the tea house

nikawa. Japanese hide glue

nomi-kai. Drinking binge

Okasan. Honorific and loving way to address Mother

omote. Front

omote-nashi. Hospitable to strangers

otaku **culture.** A culture of dependence

rakudai-bozu. An abject and comical failure

ryokan. A traditional Japanese bed-and-breakfast inn

sabi. Rust

sakoku. The period of 250 years when Japan was closed to outside influences

semai. Confined

shikataga-nai. "There is nothing you can do"

shiki-shi. A square mounted paper

tate-mae. The public face used to please the group

tokai. Cities

tokonoma. The narrow chamber in the back of the tea house

ura. "Back" or "hidden"

wa. Harmony

wabi. Things wearing away

wabi sabi. Enduring beauty can be found in death and the ephemeral

ABOUT THE AUTHOR

Makoto Fujimura is an internationally renowned artist, writer and speaker who serves as the director of Fuller Theological Seminary's Brehm Center for Worship, Theology, and the Arts. He is also the founder of the International Arts Movement and served as a presidential appointee to the National Council on the Arts from 2003 to 2009. His books include *Refractions: A Journey of Faith, Art and Culture* and *Culture Care.*

Recognized worldwide as a cultural shaper, Fujimura has had work exhibited at galleries including Dillon Gallery in New York, Sato Museum in Tokyo, The Contemporary Museum of Tokyo, Tokyo National University of Fine Arts Museum, Bentley Gallery in Arizona, Taikoo Place in Hong Kong and Vienna's Belvedere Museum. In 2011 the Fujimura Institute was established and launched the Qu4rtets, a collaboration between Fujimura, painter Bruce Herman, Duke theologian/pianist Jeremy Begbie and Yale composer Christopher Theofanidis, based on T. S. Eliot's *Four Quartets.*

A popular speaker, Fujimura has lectured at numerous conferences, universities and museums, including the Aspen Institute, Yale and Princeton Universities, Sato Museum and the Phoenix Art Museum. Among many awards and recognitions, Bucknell University honored him with the Outstanding Alumni Award in 2012, and the American Academy of Religion named him as its 2014 Religion and the Arts award recipient. He has received honorary doctorates from Belhaven University, Biola University, Cairn University and Roanoke College.

IMAGE CREDITS

NAME AND SUBJECT INDEX

SCRIPTURE INDEX